We'Moon 2020
Gaia Rhythms for Womyn

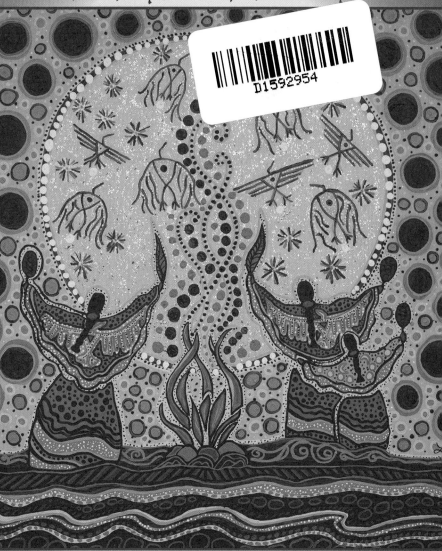

Moon Dancers © *Leah Marie Dorion 2018*

WAKE UP CALL

39TH EDITION OF WE'MOON
published by
Mother Tongue Ink

WE'MOON 2020: GAIA RHYTHMS FOR WOMYN
SPIRAL, STURDY PAPERBACK BINDING, UNBOUND & SPANISH EDITIONS
© MOTHER TONGUE INK 2019

Mother Tongue Ink
Estacada, OR 97023
All Correspondence:
P.O. Box 187, Wolf Creek, OR 97497
www.wemoon.ws

We'Moon Founder/Crone Editor: Musawa, *Special Editor:* Bethroot Gwynn
We'Moonagers: Sue Burns, Barb Dickinson, *Graphic Design:* Sequoia Watterson
We'Moon Creatrix/Editorial Team: Bethroot Gwynn, Sequoia Watterson, Sue Burns, Leah Markman, Barb Dickinson, *Production Coordinator:* Barb Dickinson *Production Assistant & Retail Sales:* Leah Markman *Proofing:* EagleHawk, Sandra Pastorius, Kathryn Henderson, Becky Bee, Amber Torrey *Promotion:* Leah Markman, Sue Burns, Susie Schmidt, Barb Dickinson *Accounts Manager:* Sue Burns *Order Fulfillment:* Susie Schmidt, *Shipping Assistant:* Dana Page

This eco-audit applies to all We'Moon 2020 *products:*

Hansol Paper Environmental Benefits Statement:

We'Moon 2020 is printed on Hansol Paper using 60% recycled content: 50% pre-consumer waste, 50% post-consumer waste, with solvent-free soy and vegetable based inks with VOC levels below 1%.
By using recycled fibers instead of virgin fibers, we saved:
114 fully grown trees
45,717 gallons of water
31 million BTUs of energy
2,695 pounds of solid waste
8,066 pounds of greenhouse gasses

As a moon calendar, this book is reusable: every 19 years the moon completes a metonic cycle, returning to the same phase, sign and degree of the zodiac.

We'Moon is printed in South Korea by Sung In Printing America on recycled paper using low VOC soy-based inks.

Green America
APPROVED FOR PEOPLE AND PLANET

Order directly from Mother Tongue Ink
To Order see p. 230. Email: weorder@wemoon.ws
Retail: 877-693-6666 or 541-956-6052 Wholesale: 503-288-3588

We'Moon 2020 Datebooks: • $21.95
Spiral ISBN: 978-1-942775-19-5
Sturdy Paperback ISBN: 978-1-942775-20-1
Unbound ISBN: 978-1-942775-21-8
Spanish Edition ISBN: 978-1-942775-22-5
In the Spirit of We'Moon • $26.95
Paperback ISBN: 978-1-890931-75-9
Preacher Woman for the Goddess • $16
Paperback ISBN: 978-1-942775-12-6

The Last Wild Witch • $9.95
Paperback ISBN: 978-1-890931-94-0
Other *We'Moon 2020* **Products:**
We'Moon on the Wall • $16.95
ISBN: 978-1-942775-23-2
Greeting Cards (6-Pack) • $11.95
ISBN: 978-1-942775-24-9
Organic Cotton Tote • $13
We'Moon Cover Poster • $10

2020

JANUARY
S	M	T	W	T	F	S
			1	2	3	4
5	6	7	8	9	10	11
12	13	14	15	16	17	18
19	20	21	22	23	24	25
26	27	28	29	30	31	

FEBRUARY
S	M	T	W	T	F	S
						1
2	3	4	5	6	7	8
9	10	11	12	13	14	15
16	17	18	19	20	21	22
23	24	25	26	27	28	29

MARCH
S	M	T	W	T	F	S
1	2	3	4	5	6	7
8	9	10	11	12	13	14
15	16	17	18	19	20	21
22	23	24	25	26	27	28
29	30	31				

APRIL
S	M	T	W	T	F	S
			1	2	3	4
5	6	7	8	9	10	11
12	13	14	15	16	17	18
19	20	21	22	23	24	25
26	27	28	29	30		

MAY
S	M	T	W	T	F	S
					1	2
3	4	5	6	7	8	9
10	11	12	13	14	15	16
17	18	19	20	21	22	23
24	25	26	27	28	29	30
31						

JUNE
S	M	T	W	T	F	S
	1	2	3	4	5	6
7	8	9	10	11	12	13
14	15	16	17	18	19	20
21	22	23	24	25	26	27
28	29	30				

JULY
S	M	T	W	T	F	S
			1	2	3	4
5	6	7	8	9	10	11
12	13	14	15	16	17	18
19	20	21	22	23	24	25
26	27	28	29	30	31	

AUGUST
S	M	T	W	T	F	S
						1
2	3	4	5	6	7	8
9	10	11	12	13	14	15
16	17	18	19	20	21	22
23	24	25	26	27	28	29
30	31					

SEPTEMBER
S	M	T	W	T	F	S
		1	2	3	4	5
6	7	8	9	10	11	12
13	14	15	16	17	18	19
20	21	22	23	24	25	26
27	28	29	30			

OCTOBER
S	M	T	W	T	F	S
				1	2	3
4	5	6	7	8	9	10
11	12	13	14	15	16	17
18	19	20	21	22	23	24
25	26	27	28	29	30	31

NOVEMBER
S	M	T	W	T	F	S
1	2	3	4	5	6	7
8	9	10	11	12	13	14
15	16	17	18	19	20	21
22	23	24	25	26	27	28
29	30					

DECEMBER
S	M	T	W	T	F	S
		1	2	3	4	5
6	7	8	9	10	11	12
13	14	15	16	17	18	19
20	21	22	23	24	25	26
27	28	29	30	31		

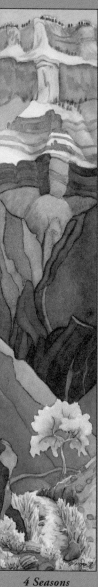

4 Seasons
© Serena Supplee 2010

⬤ = NEW MOON, PST/PDT

⚪ = FULL MOON, PST/PDT

3

COVER NOTES

Lioness © *Saba Taj 2014*

Lioness is part of a series of portraits of Muslim American women, titled An-Noor, or The Light. These works challenge the dehumanizing, hegemonic representations of Muslim women as oppressed and Other, and in need of liberation. Truly, Muslims are a combination of many parts, ever changing, complicated by diaspora. *Lioness* references the famous Norman Rockwell painting Rosie the Riveter. The holy book in the subject's lap is adorned with a pattern inspired by the reproductive system, but the most impactful component of this piece is the subject herself. Her confidence radiates through her posture and her gaze.

Crescendo © *Cheryl Braganza 2010*

This piece was inspired by a demonstration of women in Mumbai, Braganza's birthplace. "Women were demonstrating in a long procession, shouting slogans, carrying sticks, and demanding that the government offer better sanitary conditions for these women—clean water and toilets. I wanted to record the vitality of these women, let people hear the thunder in their voices and feel the earth tremble under their feet. After all, what they were screaming for was the basic human right that all women be given the respect and consideration they so rightly deserve."

DEDICATION

Every year, we donate a portion of our proceeds to an organization doing good work that resonates with our theme—bringing positive change to the world and to the lives of women. *Wake Up Call*, this year's theme, is a call to action to rebalance and remediate. With 2020 as a presidential election year in the US, we could think of no better way to energize our intentions than by naming *VoteRunLead* this year's dedicatee.

"VoteRunLead trains women to run for office. And win. With more than 33,000 women trained to run for office, VoteRunLead is the largest and most diverse campaign and leadership program in the country. We work to equip women with the right know-how, trainings and how-to's to help them enter politics with a purpose. We believe that by empowering women to run as they are, they will build a campaign based on their own passion, their own ideas and their own values. This is a historic time, when women are stepping up in droves to run for office and make impactful change."

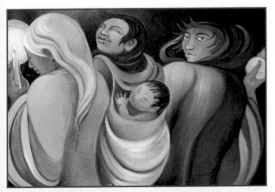

We at We'Moon are thrilled by the massive movement among women to run for public office, and it delights us to put some money where our passions are. Learn more at voterunlead.org

© *Mother Tongue Ink 2019*

Muses II
© *Toni Truesdale 2002*

TABLE OF CONTENTS

INTRODUCTION

MOON CALENDAR: WAKE UP CALL

APPENDIX

WE'MOON 2020 FEATURE WRITERS:

We'Moon Wisdom: Musawa; **Astrologers:** naimonu james, Heather Roan Robbins, Sandra Pastorius, Gretchen Lawlor, Susan Levitt, Mooncat!, Beate Metz; **Introduction to We'Moon 2020:** Bethroot Gwynn; **Holy Days:** Oak Chezar; **Lunar Phase Card:** Susan Baylies; **Herbs:** Sue Burns; **Tarot:** Leah Markman

What Is *We'Moon*? A Handbook in Natural Cycles

We'Moon: Gaia Rhythms for Womyn is more than an appointment book: it's a way of life! We'Moon is a lunar calendar, a handbook in natural rhythms, and a collaboration of international womyn's cultures. Art and writing by wemoon from many lands give a glimpse of the great diversity and uniqueness of a world we create in our own images. We'Moon is about womyn's spirituality (spirit-reality). We share how we live our truths, what inspires us, and our connection with the whole Earth and all our relations.

***Wemoon* means "we of the moon."** The Moon, whose cycles run in our blood, is the original womyn's calendar. We use the word "wemoon" to define ourselves by our primary relation to the cosmic flow, instead of defining ourselves in relation to men (as in wo*man* or fe*male*). We'Moon is sacred space in which to explore and celebrate the diversity of she-ness on Earth. We come from many different ways of life. As wemoon, we share a common mother root. We'Moon is created by, for and about womyn: in our image.

We'Moon celebrates the practice of honoring the Earth/Moon/Sun as our inner circle of kin in the Universe. The Moon's phases reflect her dance with Sun and Earth, her closest relatives in the sky. Together these three heavenly bodies weave the web of light and dark into our lives. Astrology measures the cycle by relating the Sun, Moon and all other planets in our universe through the backdrop of star signs (the zodiac), helping us to tell time in the larger cycles of the universe. The holy days draw us into the larger solar cycle as the moon phases wash over our daily lives.

We'Moon is dedicated to amplifying the images and voices of wemoon from many perspectives and cultures. We invite all women to share their work with respect for both cultural integrity and creative inspiration. We are fully aware that we live in a racist patriarchal society. Its influences have permeated every aspect of society, including the very liberation movements committed to ending oppression. Feminism is no exception—historically and presently dominated by white women's priorities and experiences. We seek to counter these influences in our work. We'Moon does not support or condone cultural appropriation (taking what belongs to others) or cultural fascism (controlling artistic expression). We do not knowingly publish oppressive content of any kind. Most of us in our staff group are lesbian or queer—we live outside the norm. At the same time, we are mostly womyn who benefit from white privilege. We seek to make We'Moon a safe and welcoming place for all wimmin, especially for women of color (WOC) and others marginalized by the mainstream. We are eager to publish more words and images depicting people of color created by WOC. We encourage more WOC to submit their creative work to We'Moon for greater inclusion and visibility (see p. 234).

Musawa © Mother Tongue Ink 2008

HOW TO USE THIS BOOK
Useful Information about We'Moon

Refer to the **Table of Contents** to find more detailed resources, including: World Time Zones, Planetary and Asteroid Ephemeris, Signs and Symbols, Year at a Glance, and Month at a Glance Calendars.

Time Zones are in Pacific Standard/Daylight Time with the adjustment for GMT and EDT given at the bottom of each datebook page.

The **names and day of the week and months** are in English with four additional language translations: Bengali, Spanish, Irish and Mandarin.

Moon Theme Pages mark the beginning of each moon cycle with a two-page spread near the new moon. Each page includes the dates of that Moon's new and full moon and solar ingress.

Susan Baylies' **Lunar Phase Card** features the moon phases for the entire year on pp. 226–227

There is a two-page **Holy Day** spread for all equinoxes, solstices and cross quarter days, from a Northern Hemisphere perspective. These include writings by a different feature writer each year.

Astro Overview gives a synopsis of astral occurrences throughout the year from one of our featured astrologers, Heather Roan Robins, on pp. 12–14.

Read the **Astrological Horoscopes** for your particular sign on the pages shown on the right —>

♒	p. 45
♓	p. 57
♈	p. 69
♉	p. 79
♊	p. 93
♋	p. 105
♌	p. 119
♍	p. 131
♎	p. 145
♏	p. 155
♐	p. 167
♑	p. 181

Astrology Basics

Planets: Like chakras in our solar system, planets allow for different frequencies or types of energies to be expressed. See Mooncat's article (pp.204–205) for more detailed planetary attributes.

Signs: The twelve signs of the zodiac are a mandala in the sky, marking off 30° segments of a circle around the earth. Signs show major shifts in planetary energy through the cycles.

Glyphs: Glyphs are the symbols used to represent planets and signs.

Sun Sign: The Sun enters a new sign once a month (on or around the 21st), completing the whole cycle of the zodiac in one year. The sun sign reflects qualities of your outward shining self.

Moon Sign: The Moon changes signs approximately every 2 to $2^1/_2$ days, going through all twelve signs of the zodiac every $27^1/_3$ days (the sidereal month). The Moon sign reflects qualities of your core inner self.

Moon Phase: Each calendar day is marked with a graphic representing the phase of the Moon.

Lunar Quarter Phase: At the four quarter-points of the lunar cycle (new, waxing half, full and waning half moons), we indicate the phase, sign and exact time for each. These points mark off the "lunar week."

Day of the Week: Each day is associated with a planet whose symbol appears in the line above it (e.g., ☽☽☽ for Moon: Moonday)

Eclipse: The time of greatest eclipse is given, which is near to, but not at the exact time of the conjunction (☉☌☽) or opposition (☉☍☽). See "Eclipses" (p. 22).

Aspects (□△☍☌✶⚼) are listed in fine print under the Moon sign each day, and show the angle of relationship between different planets as they move. Daily aspects provide something like an astrological weather forecast, indicating which energies are working together easily and which combinations are more challenging.

Transits are the motion of the planets and the moon as they move among the zodiacal constellations and in relationship to one another

Ingresses (→): When the Sun, Moon and planets move into new signs.

Moon "Void of Course" (☽ v/c): The Moon is said to be "void of course" from the last significant lunar aspect in each sign until the Moon enters a new sign. This is a good time to ground and center yourself.

Super Moon: A Super Moon is a New or Full Moon that occurs when the Moon is at or within 90% of perigee, its closest approach to Earth. On average, there are four to six Super Moons each year. Full Super Moons could appear visually closer and brighter, and promote stronger tides. Personally, we may use the greater proximity of Super Moons to illuminate our inner horizons and deepen our self-reflections and meditations.

Apogee (ApG): The point in the Moon's orbit that is **farthest** from Earth. At this time, the effects of transits may be less noticeable immediately, but may appear later. Also, **Black Moon Lilith**, a hypothetical center point of the Moon's elliptical orbit around the Earth, will be conjunct the Moon.

Perigee (PrG): The point in the Moon's orbit that is **nearest** to Earth. Transits with the Moon, when at perigee, will be more intense.

Equilibrium © *Gaia Orion 2014*

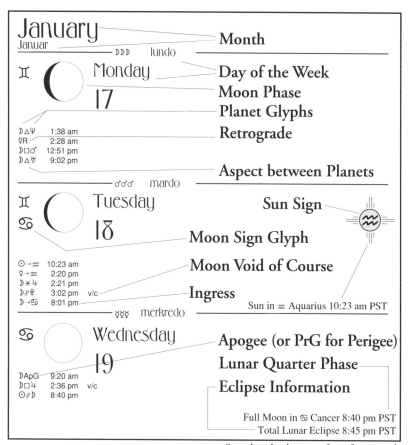

Month

Day of the Week

Moon Phase

Planet Glyphs

Retrograde

Aspect between Planets

Sun Sign

Moon Sign Glyph

Moon Void of Course

Ingress

Sun in ♒ Aquarius 10:23 am PST

Apogee (or PrG for Perigee)

Lunar Quarter Phase

Eclipse Information

Full Moon in ♋ Cancer 8:40 pm PST
Total Lunar Eclipse 8:45 pm PST

Sample calendar page for reference only

Lunar Nodes: The most Northern and Southern points in the Moon's monthly cycle when it crosses the Sun's ecliptic or annual path, offering to integrate the past (South) and future (North) directions in life.

Aphelion (ApH): The point in a planet's orbit that is **farthest** from the Sun. At this time, the effects of transits (when planets pass across the path of another planet) may be less noticeable immediately, but may appear later.

Perihelion (PrH): The point in a planet's orbit that is **nearest** to the Sun. Transits with planets, when they are at perihelion, will be more intense.

Direct or Retrograde (D or R): These are times when a planet moves forward (D) or backward (R) through the signs of the zodiac (an optical illusion, as when a moving train passes a slower train that appears to be going backward). When a planet is in direct motion, planetary energies are more straightforward; in retrograde, planetary energies turn back in on themselves and are more involuted. See "Mercury Retrograde" (p. 22).

CONSTELLATIONS OF THE ZODIAC

These stations of the zodiac were named thousands of years ago for the constellations that were behind them at the time. The signs of the zodiac act like a light filter, coloring the qualities of life force. As the Sun, Moon and other planets move through the zodiac, the following influences are energized:

♒ **Aquarius** (Air): Community, ingenuity, collaboration, idealism. It's time to honor the philosophy of love and the power of community.

♓ **Pisces** (Water): Introspection, imagination, sensitivity and intuition. We process and gestate our dreams

♈ **Aries** (Fire): Brave, direct, rebellious, energized. Our inner teenager comes alive; our adult self needs to direct the energy wisely.

♉ **Taurus** (Earth): Sensual, rooted, nurturing, material manifestation. We slow down, get earthy, awaken our senses, begin to build form, roots, and stubborn strength.

♊ **Gemini** (Air): Communication, networking, curiosity, quick witted. We connect with like minds and build a network of understanding.

♋ **Cancer** (Water): Family, home, emotional awareness, nourishment. We need time in our shell and with our familiars.

♌ **Leo** (Fire): Creativity, charisma, warmth, and enthusiasm. Gather with others to celebrate and share bounty.

♍ **Virgo** (Earth): Mercurial, curious, critical, and engaged. The mood sharpens our minds and nerves, and sends us back to work.

♎ **Libra** (Air): Beauty, equality, egalitarianism, cooperation. We grow more friendly, relationship oriented, and incensed by injustice.

♏ **Scorpio** (Water): Sharp focus, perceptive, empowered, mysterious. The mood is smoky, primal, occult, and curious; still waters run deep.

♐ **Sagittarius** (Fire): Curiosity, honesty, exploration, playfulness. We grow more curious about what's unfamiliar.

♑ **Capricorn** (Earth): Family, history, dreams, traditions. We need mountains to climb and problems to solve.

adapted from Heather Roan Robbins' Sun Signs and Sun Transits
© Mother Tongue Ink 2016

SIGNS AND SYMBOLS AT A GLANCE

PLANETS

<u>Personal Planets</u> are closest to Earth.

⊙ **Sun**: self radiating outward, character, ego

☽ **Moon**: inward sense of self, emotions, psyche

☿ **Mercury**: communication, travel, thought

♀ **Venus**: relationship, love, sense of beauty, empathy

♂ **Mars**: will to act, initiative, ambition

<u>Asteroids</u> are between Mars and Jupiter and reflect the awakening of feminine-defined energy centers in human consciousness.

<u>Social Planets</u> are between personal and outer planets.

♃ **Jupiter**: expansion, opportunities, leadership

♄ **Saturn**: limits, structure, discipline

Note: The days of the week are named in various languages after the above seven heavenly bodies.

⚷ **Chiron**: is a small planetary body between Saturn and Uranus representing the wounded healer.

<u>Transpersonal Planets</u> are the outer planets.

♅ **Uranus**: cosmic consciousness, revolutionary change

♆ **Neptune**: spiritual awakening, cosmic love, all one

♇ **Pluto**: death and rebirth, deep, total change

ZODIAC SIGNS

♈ **Aries**

♉ **Taurus**

♊ **Gemini**

♋ **Cancer**

♌ **Leo**

♍ **Virgo**

♎ **Libra**

♏ **Scorpio**

♐ **Sagittarius**

♑ **Capricorn**

♒ **Aquarius**

♓ **Pisces**

ASPECTS

Aspects show the angle between planets; this informs how the planets influence each other and us. We'Moon lists only significant aspects:

☌ CONJUNCTION (planets are 0–5° apart)
linked together, energy of aspected planets is mutually enhancing

☍ OPPOSITION (planets are 180° apart)
polarizing or complementing, energies are diametrically opposite

△ TRINE (planets are 120° apart)
harmonizing, energies of this aspect are in the same element

□ SQUARE (planets are 90° apart)
challenging, energies of this aspect are different from each other

✶ SEXTILE (planets are 60° apart)
cooperative, energies of this aspect blend well

⚻ QUINCUNX (planets are 150° apart)
variable, energies of this aspect combine contrary elements

OTHER SYMBOLS

☽ v/c–Moon is "void of course" from last lunar aspect until it enters new sign.

ApG–Apogee: Point in the orbit of the Moon that's farthest from Earth.

PrG–Perigee: Point in the orbit of the Moon that's nearest to Earth.

ApH–Aphelion: Point in the orbit of a planet that's farthest from the Sun.

PrH–Perihelion: Point in the orbit of a planet that's nearest to the Sun.

D or R–Direct or Retrograde: Describes when a planet moves forward (D) through the zodiac or appears to move backward (R).

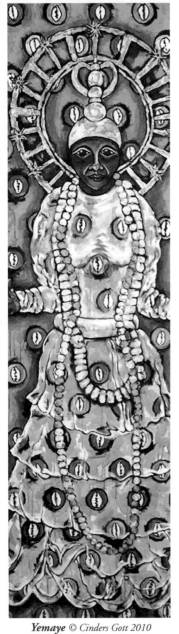
Yemaye © *Cinders Gott 2010*

ASTROLOGICAL OVERVIEW: 2020

The personal is political. In 2020 the stars ask us to pay attention to our spiritual life and relationships, but always remember they are embedded in the body politic, and the body politic needs our help. Our spirituality must feed into community and community organizing to help us build a healthier world. Jupiter and Saturn both conjunct Pluto in structural Capricorn, one after the other, and then finish up the year conjunct with one another in collaborative Aquarius on the Winter Solstice. We have a chance to turn things around, but we need to stay awake, aware and involved.

As Jupiter, Saturn and Pluto run together, they bring an opportunity for death and rebirth of power systems and political structures throughout the world; but it may get messy before it gets better. Pluto brings revolution to the nature of the sign it occupies by exposing its shadow side; 2008–2024 Pluto in Capricorn asks us to look at the abuse and use of political power, nuclear and fossil fuel power, gender-based authority, tradition, honor and responsibility. Pluto now approaches its first return to its position during the American Revolution, perfecting in 2022.

Jupiter—connected to liberal politics— is expansive and speaks of generosity, abundance and codependence. Saturn—connected to conservative politics—contracts and speaks of structure, tradition, discipline, restriction, control. A balanced tension between the two influences holds us upright. Every 20 years we have a great conjunction

between these two; since the American Revolution, every great conjunction brought to the USA a presidential term where the presidency underwent attack or stress—often precipitated a healthy bipartisan response. This year, in Aquarius, that conjunction calls for a philosophical rebirth.

Mercury usually retrogrades for three weeks, three times a year; this year's dates are 2/16–3/9, 6/17–7/12, and 10/13–11/3. On voting day in the USA, it appears stationary direct, which can precipitate problematic confusion, close votes and recounts. During this year, in which we need to overhaul systems that serve the community, let's advocate for transparent, efficient voting systems around the globe, and vote early in the USA.

On January 10, Uranus turns direct under a full moon and lunar eclipse in Cancer, which can pivot change both at home and in work. Saturn conjuncts Pluto on 1/12, and begins a breakdown of old structures. It also asks us to investigate what makes us secure, the health of our bones and teeth, the foundations of our house and our work. Watch out for power trips on every level.

Jupiter sextiles Neptune repeatedly this year—2/20, 7/27 and 10/12—renewing our sense of hope, helping us imagine a better future. This soft, intuitive, potentially escapist aspect can make us lazy or can make is visionary; it's up to us to use it well. Seek visions.

Saturn encourages us to step into a more collaborative, less authoritarian approach, as it steps out of Capricorn and into Aquarius 3/21, retrogrades back into Capricorn 7/1, and reenters Aquarius 12/16. We need to keep our philosophies alive and compassionate, not just impose a new system that still doesn't listen to the people.

Jupiter calls for introspection on the political left as well as the right, as it conjuncts Pluto at 24° Capricorn 4/4, 6/29 and 11/12. Jupiter maximizes whatever it touches; and here it increases the Hecate-Kali work of revolution, transformation, death and rebirth. We can use this to create a liberating time, or experience control issues. Some incident could call us to face our fears of mortality and move past them into a bigger acceptance.

Truth will out; the search for honesty becomes a spiritual practice. We may be surprised and transformed by a new perspective which

precipitates change, triggered by a full Sagittarius lunar eclipse. The moon squares Mars in Pisces on 6/5. All of this is echoed and magnified by a total solar eclipse 12/14, with Sun and Moon at 23° Sagittarius, and Mercury 20° Sagittarius. These eclipses ask us to examine our personal illusions, check our truths, and speak them aloud; we can demand truth, but can't rush to a new conclusion or simplify reality. World events or personal issues call us to move out of victimhood and into a deeper understanding, deeper compassion, and compassionate action.

As the year closes, the stars bring it home to us that our personal lives are intricately woven into our community, our community into our country, our country into the global present. As we face the realities of environmental troubles and seek collaboration to solve them, as we face health and economic issues which stem from our interwoven connection around the globe, we become acutely aware of this interconnected global community and our place in it. Saturn enters collective, cooperative Aquarius 12/16; Jupiter enters Aquarius 12/19; and at winter solstice on December 21, they join for the great conjunction for the first time since 2000. Aquarius turns our vision outwards and asks us to hold hands, to look at how we structure our families, circles, teams, society and global community. We are encouraged to form and expand spiritual and political circles, and find collaborative answers in cohousing and community investment.

This Capricorn/Aquarius nexus works in systems. Like the roots of trees within a forest, our psyches and our daily living conditions touch one another throughout the globe. We become deeply aware of our human role in the ecosystem, and can begin a great effort to transform that role. This conjunction encourages us to work together to investigate, address and heal systemic racism and gender assumption, systemic inequality, systematic abuse of our mother Earth.

As our eyes turn outward, we may neglect our more intimate relationships unless we remember to truly hold hands and feel one another's hearts. As the stars call us outwards, it's up to us to choose and treasure interpersonal sensitivity and emotional connection.

Heather Roan Robbins © Mother Tongue Ink 2019

2020 ASTROLOGICAL ASSIGNMENTS

2020 eclipses in Sagittarius trigger new honesty, and this honesty encourages us to restructure the systems of power while Saturn and Jupiter conjunct Pluto in Capricorn. By the end of 2020, Jupiter and Saturn enter Aquarius and empower us to integrate an authentically

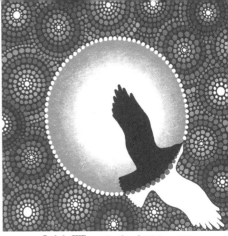

Spirit Wings © *Elspeth McLean 2011*

collaborative philosophy. We can hear a clue to our assignment in this great work through the signs of our Sun and ascendant. Each month, as the Sun changes signs, we all may feel the call of that sign.

Aries: Your assignment is to embrace responsibility and model healthy and positive authority. Speak from a place of strength and confidence, rather than defiance, when wrestling with other powers. Look for a new understanding about how you learn and communicate, as you may need to publish and network to get the word out. Build the infrastructure and networks needed so you can relax into the new organization by 2021.

Taurus: You may get a unique perspective about how shared resources are being utilized, how money is handled behind-the-scenes, or how sexual politics affects fair distribution. Speak up. Don't be discouraged, but steadily push to evolve the system, whether it's your circle, community, or international organization. Find connections in the larger global community with common interests. Your integrity and effort can help your work grow more meaningful in the future.

Gemini: You're multifaceted, and can use your versatile communications to weave together unusual allies into a healthy network. But be honestly who you are rather than bend to fit others' desires, whether in work, love, or community partnerships. If this honesty exposes unconscious power struggles around money and resources, keep the conversation flowing—just dig deeper to make sure you have the whole truth. Do the homework and your world will expand in the years ahead.

Cancer: Take inventory of your helpfulness; notice where you enable. Bring fresh air to any dysfunctional places which drain you and test your health. Encourage beloveds, believe in them, but let them do their own work, and then bring this energy out to a larger scope. When your boundaries feel clean and strong, you can let people closer in. By year's end you won't have to hold the line so intensely; new relationships grow more collaborative and supportive.

Leo: Inspire! You may have hidden your creative flow recently, feeling upstaged by hard work or potentially learning new skills or because of responsibilities to health. Be honest about your talents, let go of what does not grow corn, and pursue those hidden sparks within. Look at your natural creativity and charisma, and offer that in service. Your life force improves when you feel needed and effective. In return, your community expands and steadies.

Virgo: You have a rich and thoughtful philosophy; reassess it, and bring it home. Critique, but stay focused on the healing goals, both in your personal life and the world at large. Walk your talk in daily life, and find your relationships to animals and beloveds become more clear, clean, and energizing. Your creativity is strong, but needs you to choose discipline; give it time to manifest, and do it for the sake of all.

Libra: Take the pressure off family tensions this year. You have a natural inner gauge around social justice, so bring your eyes and tactful approach to the problem. Help educate. You know that inspiring information delivered without a strong personal torque, facts rather than opinion, open more minds. Lovingly help those around you become more aware of the vestiges of racism, internalized gender issues, and encourage sisterhood. Your creativity flows in response.

Scorpio: Ask what community resources need to be mobilized and what needs to be conserved. You aren't ruthless, but may see more clearly what surgery is necessary to create sustainability. Others may engage in personality struggles to control the situation, but you don't have to take the bait. Keep the focus on effectiveness, not ego, and hold clean boundaries for those less able. You feel more at home on the other side of this reorganization.

Sagittarius: Sometimes it can be hard for you to forgive yourself, so you don't look under all the rocks. Go for it! Let go of some preconceptions about yourself and about what you do or don't have to offer the world—find a new, empowering authenticity. Deal squarely with tough practicalities. From this integral place, heed the call to help your community get honest about, and improve on, their relationships to financial and ecological resources.

Capricorn: Be honest about how much you have actually healed and about what still needs work in your psyche; you've been in deep evolution and may need to reassess how far you've come. Be who you are now. Adjust to a more congruent sense of personal responsibility. This frees you up to offer healthy leadership while empowering others. Put your special gifts to service cultural responsibility, and find fresh reliable camaraderie.

Aquarius: If you've been holding on to an old image of community or sense of belonging, new realizations help you let go of what *was* so you're more open to *what is*. You learn much vicariously this year, walking friends and community through their challenges, and working through some personal inner demons in the process. Out of this work arises the potential for a stronger sense of self, woven into a refreshed and dynamic community.

Pisces: You see that the emperor has no clothes on, where people in authority, both close to home and nationally, are not in their integrity. Your assignment is to say what you see in an effective way, and to grow that integrity within people and systems. Sometimes your fellow collaborators may disagree on the goal; their job may be to fight, yours is to hold the vision for a positive future and to guide those steps forward. Inner peace grows in response.

New Moon—Venus □ Pamela Read 2010

Heather Roan Robbins
© Mother Tongue Ink 2019

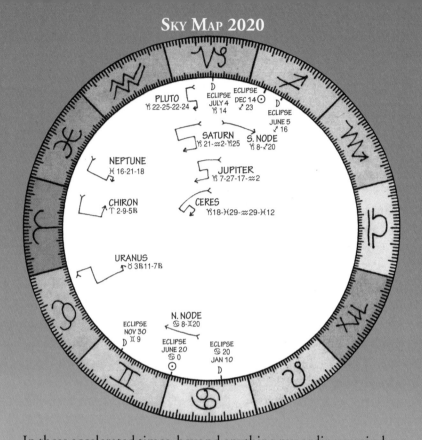

In these accelerated times, beyond anything my ordinary mind can comprehend, I look to the skies for navigational advice. Hoping to engage every sense, every source of understanding, with my finger I trace the path of each planet in this 2020 Sky Map. I am comforted—perhaps this simple ritual, repeated every so often this year, will connect me with the grander, wiser perspectives of these starry overseers.

My fingertip encounters hope and opportunity as I trace the path of **Jupiter**. **Saturn's** steady pressure holds me to ethical responsibility even if others aren't/can't/won't. **Pluto** pushes me to empower rather than overpower, as our worlds reorganize. My finger buzzes with brilliant resourcefulness as I follow **Uranus** in early Taurus. **Neptune** leads my finger to a quiet corner, whispering compassion and dreams of better times ahead

You hold in your hands *We'Moon 2020*, offering day by day, a steady stream of inspirational guidance from wise women all over the world. Take it in, through all of your senses. And in those wobbly moments, return to this map and let your finger remember the way forward.

Gretchen Lawlor © Mother Tongue Ink 2019

Astrological Year at a Glance Introduction

smash yourself open. search for the seeds of liberation within you. do not give up, search. there! pluck these tiny warriors from the tender fat of yourself and plant them in the earth for safekeeping.

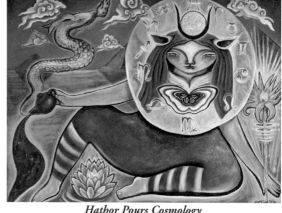

Hathor Pours Cosmology
© *Lindy Kehoe 2017*

go find the other smashed ones.

pluto and jupiter meet in capricorn three times in 2020; three times you may experience the miracle of remembering. get your presence practices on point—you need them now. you must learn to listen to what has come before you, so you can weave a coherent present and co-create a radiant future. capricorn is about putting in the work, your own brilliant, unique work. expect resistance from within yourself; learn to swallow it whole and continue on.

2020 offers us wisdom to see that we are crucial co-creators of past/present/future. in this year of recall and recognition, we must transmute oppression as it lives within us, within our lineage, and within our homes. move with integrity!

within and within and within. and again.

the pressure is high, the dials are turned up. stay present as best you can and remember: this will not last forever. by year's end saturn and jupiter will move from capricorn into aquarius like a sigh. the intense, visceral work of pluto, saturn, and jupiter in capricorn will lead us into a time of revolution, expansion, and reformation in aquarius. rebuild yourself from the inside out so you have the strength needed to nourish the future you desire.

blessings!

naimonu james © mother tongue ink 2019

i use all lowercase because i prefer it.

to learn more about astrological influences for your sign, find your sun and rising signs in the pages noted to the right.

19

Alchemy in 2020: The Saturn / Pluto Conjunction

The Planetary Elements
♄ **Saturn's** archetype wields the sickle of time,
a binding force for setting limits.
With a commitment to purpose, and the cultivation of wisdom,
Saturn maintains the precedents for abiding in the finite world.
It tests our moral compass, and reforms our social responsibilities.

♇ **Pluto**, known in myth as the overlord of the underworld,
symbolizes the dilemmas of dualism and life's reversals.
As a catalyst for turning points of change, Pluto evolves us,
into the soul of the collective and the infinite.

The Alchemical Brew

2020 begins with a jolt from pressures of the times when Saturn and Pluto conjoin at 22° Capricorn on January 12th. It will be a wake up call that echoes throughout the year and beyond. Listen up. Three times each century these planets align with symbolic synergy as we reset our collective agenda. The previous 1982–83 Saturn/Pluto cycle in Libra brought some sobering realities: a retreat into nostalgia and narcissism; catalyzing global terrorism; the unencumbered rise of the uber rich; economic instability; the Internet of Things; and a resurgence of nationalism in a post-truth world. These are some of the nested dilemmas setting the stage for this next transformative cycle, lasting until 2045.

In Capricorn, Saturn and Pluto represent the karmic forces that will expose ethical abuses by authoritarians in power, precipitating economic insecurities and moral outrage. The entrenched interests of the moneyed class, the plutocrats, hold many hostage in a predatory capitalism resulting in mass indebtedness. The industrial age has run aground, breeching the limits of our climate's capacities and our own conscience. We have altered the nature of Nature by the indiscriminate overconsumption of Earth's resources, and with the wastelands of our leavings. Time throws no lifelines to generations now emerging in peril of traumatic ill health. Undermined by the effects of electromagnetic radiation, chemical toxicants, living in cyber-centric cultures and alienated from nature, how many are sabotaged at birth?

March into April, Mars activates our survival drive when it joins with Jupiter, Saturn and Pluto, and our voices grow louder with urgency for government accountability and human rights. On April 4th, June 29th and November 12th, Jupiter, planet of social justice, conjoins Pluto while dire climate changes and global weaponization displace millions of people into migration, and we face the snares of scapegoating. Rulings from the high courts tip the scales of our tolerances. The US presidential election may fuel paranoia and polarization with the fervor of an un-civil political war. On Winter Solstice, December 21st, Jupiter and Saturn conjoin at 0° Aquarius. This 20 year cycle offers shifts in dynamics for social participation and group identity. Realign reactivity.

The Cauldron of Our Better Angels
During transit periods
adapt this ceremonial offering
for personal or community use.
Call forth the image of a wondrous bowl
that transmutes the alchemical brew
of our dysfunctions with grace.

Bring love. Invite callings from all the directions. Visualize a Cauldron of Our Better Angels, and circle round with the courage to confront our despair. Evoke our release from the trances and shadows keeping us in fear and separation. Allow space for grief to flow. Tap into gratitude. Imagine that our interconnected intent can support healthy social cohesion with goodwill as the glue and integrity as a strategy. May we realign our collective energies and let the gritty bits of patriarchal overload that threaten to diminish our species, loosen their grip. Through this redemptive power we may liberate ourselves from otherness to oneness. Lying in wait within our human hearts, fresh seeds of possibility emerge, as we come to inhabit a new mind, a new body, a new story. Let us become the critical mass of caring awareness that lives on to re-symbolize our dance of survival and renew the face of the Earth.

Be the momentum.

Sandra Pastorius © Mother Tongue Ink 2019

ECLIPSES: 2020

Solar and Lunar Eclipses occur when the Earth, Sun and Moon align at the Moon's nodal axis, usually four times a year, during New and Full Moons, respectively. The South (past) and North (future) Nodes symbolize our evolutionary path. Eclipses catalyze destiny's calling. Use eclipse degrees in your birth chart to identify potential release points.

January 10: Penumbral Lunar Eclipse at 19° Cancer opens us to watery, dreamy realms where healing can happen. Expose your heart to the wonders of wholeness. Be well.

June 5: Penumbral Lunar Eclipse at 15° Sagittarius fires up our questioning mind, asks us to aim for moral high ground. As the light returns find mutual learning opportunities to spread shared wisdom.

June 20: Annular Solar Eclipse at 0° Cancer releases memories of who we used to be. Let the returning light feed the emergence of your wings. Let fresh parts of yourself flutter into being.

July 4: Penumbral Lunar Eclipse at 13° Capricorn commits us to retracing our steps. As the light returns make your path holy ground.

November 30: Penumbral Lunar Eclipse at 8° Gemini reminds us: by our example, we will be known—honesty speaks volumes.

December 14: Total Solar Eclipse at 23° Sagittarius highlights our desire for influence and meaning. Let the returning light spread your cultivated wisdom. Exchange views and enlighten hearts.

MERCURY RETROGRADE: 2020

Mercury, planetary muse and mentor of our mental and communicative lives, appears to reverse its course three or four times a year. We may experience less stress during these periods by taking the time to pause and go back over familiar territory and give second thoughts to dropped projects or miscommunications. Breakdowns can help us attend to the safety of mechanics and mobility. It's time to "recall the now" of the past and deal with underlying issues. Leave matters that lock in future commitments until Mercury goes direct.

Mercury has three retrograde periods this year in water signs:

February 16–March 9: Mercury's retrograde in Pisces reminds us to revisit dreams and release our tears, regrets and best laid plans. When it goes direct again, renew with what feeds your soul.

June 17–July 12: When Mercury retraces steps in Cancer, look for cracks in the hard shell of protective attachments that keep you stuck. When direct again, emerge in greater awareness into your circle of kinship.

October 13–November 3: Take time when Mercury retrogrades in Scorpio to investigate your underlying motivations. When Mercury goes direct again, allow space to have the real conversations.

Sandra Pastorius © Mother Tongue Ink 2019

THE YEAR OF THE RAT 2020

The Year of the Rat begins on the new Moon of January 24th. (Chinese New Year begins the second new Moon after Winter Solstice.) Rat year is a time of abundance, plenty and good fortune, because Rat is considered a very lucky astrology sign. Rat year is also the time for a new beginning in life, because Rat is the first sign of the Chinese zodiac.

Scruffy © *Becky Bee 2019*

Now is an ideal time to start planning to achieve your goals. Ventures begun in a Rat year are fortunate, but only if well planned. This is not the year for spontaneous adventure or high risk.

Social Rat loves the pack, making Rat year the best time to work collectively. Rat is a doer who cares about performance, progress and reward. Anticipate scientific discoveries, medical breakthroughs and technological inventions. Creativity flourishes, with advancement in everything from artificial intelligence to soil analysis on Mars.

Rat year is always about money, like the last Rat year, 2008—the Great Recession. This year has an even stronger focus on financial markets, wealth and real estate, because it's a Metal year. There are five Taoist elements: Fire, Earth, Metal, Water and Wood; 2020 is the year of the Metal Rat. Metal represents money, so anticipate fluctuations in world economies. There can be a financial reset of rich and poor, with more people raised out of poverty. Metal also represents weaponry, and Rat year can bring collective militarization.

Wemoon born in Rat years (1912, 1924, 1936, 1948, 1960, 1972, 1984, 1996, 2008, 2020) are smart, sharp, funny gals who are highly perceptive. They are excellent at analyzing data to arrive at the correct conclusion, and can quickly figure out how to solve problems. Their quick wit and style makes them popular, and they can be very delightful when they turn on the charm. But a Rat wemoon won't reveal her true feelings if they block her success. Even the shyest Rat can be competitive, ambitious and calculating because Rat wants to win.

Rat correlates to the Western, sign Sagittarius. Rat is most compatible with another Rat, Ox, Dragon and Monkey. The element Metal is associated with the lungs in Chinese medicine, so take care of your lungs this year, especially in autumn.

Susan Levitt © Mother Tongue Ink 2019 23

WAKE UP HERBS

In these turbulent times, my instinct was to focus on herbs that stimulate and enliven us for this Wake Up Call edition of We'Moon. These herbs (like caffeine) say, "Do better faster! Adjust your body to an ever changing and often stressful environment." Even better: Let's go for deep nourishment, gentle restoration, and sustainable energy, while building the capacity to nourish others. We can use plants to bolster us as we combat the toxic forces of Patriarchy, Late Stage Capitalism, and White Supremacy. My hope is that you not only use herbal powers to support your activism, but that each of us, using whatever privilege and accessibility we have, will share these herbs and insights with others within and outside of our own communities. Equity in herbal medicine!

"Found" Lost Lake
© Genevieve Schall 2015

For sustainable support and grounded stability, let's nourish ourselves gently and deeply. Nutrition and movement are always first, right? Then, supplement with an adaptogen that sustains your life energy. Ashwagandha is a traditional plant native to India and common in Ayurveda medicine. Taken tonically, it can improve memory and regulate blood sugar; it is anti-inflammatory and lowers cortisol—a hormone of chronic stress that is not your friend. Or look below your feet, get grounded, and relish the effects of medicinal mushrooms. Chaga, Cordyceps, and Reishi powerfully boost your immune system, keeping you strong and healthy in the fight against racism and sexism gone viral. Nourish with nettle, have dinner with dandelion, attend to yourself with alfalfa, cleanse with clover, chill out with oat straw. Grow your own and share with your neighbor.

If you do need just a quick pick-me-up, pinch an orange or lemon peel under your nose. The scent boosts your serotonin (the happy hormone) and lowers norepinephrine (another stress hormone).

Our responsibility to redistribute resources includes herbs and health, both personally and communally—for our children, for the planet—and is paramount in the fight for justice: I am only truly well when all women are well.

Sue Burns © Mother Tongue Ink 2019

Tarot Card #20: Judgment

Look down at your feet, flat on the earth. We each have come so far in our journeys, and Judgment calls on us to truly "meet ourselves," to confront our decisions, our imperfections, and decide where to walk next. This is a card of both inaction and decisive intentional forward movement.

Judgment is a door half ajar—opening into darkness. Judgment is a fork in the road, a crossroads where we are faced with a choice. Do we walk the path we've walked before, circling back to the Fool's beginning, carving our footsteps into the Earth? Or do we take a path we cannot yet see? This dark and beautifully mysterious path leads us to the last archetype in the major Arcana—The World—there is no exit here; to enter through this door we must be ready. The Judgment card invites us to step back and truly ask ourselves the hard questions. These are the breaths you take before you jump off the high dive, or quickly scamper back down the ladder to solid ground.

What have we learned? What do we need to improve on? Has our perception of reality clouded the truth, or are we clearly seeing through static? When Judgment steps out before us, She challenges us to think deeply about our situation. Is there any other answer or viewpoint we missed? Reach out into the world; step into the footsteps of your neighbor, lover or enemy—see through their eyes. Do they think differently than we do, and is it wrong if so? Can we accept and honor the choices of others while still honoring our roots and our truth? Plant your feet firmly to dig into these answers.

We stand and stare at the door we can only see through if we open it. This is our choice—to walk the familiar old path of patterns and history or step though into a beautiful unknown. We can only walk forward if we are ready and open to difficulty, to doing what is right and not always what is easy. It is time to look at ourselves objectively and peel away the veils of false perception—discern what is real. We are calling our Truth to step forward. Are you ready to open the door and walk through?

Leah Markman ©
Mother Tongue Ink 2019

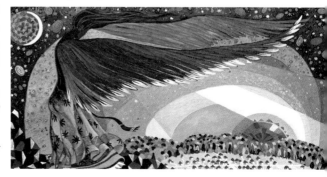

Cannabis Goddess Blessing
© Katalin Pazmandi 2017

STAR COUNCIL

What if you had a council of personal advisors available 24/7 to guide you through these intense, uncertain times? You do! Your astrological chart is a geometric portrait of the living forces of your own Star Council—the Sun, Moon and planets.

Who are these planetary advisors, and what wisdom do they offer? Sun lights up your path and fuels you with purpose. Moon helps you feel, brings comfort when stressed. Venus opens you to love and to be loved. Mercury assists you in giving and receiving information. Mars is your courageous warrior who pursues what you desire. Jupiter points to greater horizons and gifts you with hope. Saturn advises how accomplishment and authority are best cultivated. Chiron shape-shifts your challenges into healing tools. Uranus is your wild genius. Neptune is your portal to spirit and your imagination. Pluto's x-ray eyes reveal what is essential, and what must change or die.

How do you contact your Star Council? It can be as simple as standing in a circle of post-its representing the 12 signs of the zodiac, surrounded by cards/objects/stones representing the planetary characters, in the positions where they are found in your birth chart.

Place your Rising sign card on the floor to the East, your left, then lay out the rest of the 12 zodiac signs to complete a counterclockwise circle. East will be on your left, West on your right, South in front of you, North behind you. Now place the planets you see above the horizon in your chart to the South—in front of you—and those below the horizon to your North—at your back.

The energetic field created by this circle is a very potent space—treat it with respect by entering and leaving the circle with intention (best via your Rising sign). Ask permission and offer gratitude. Stay alert, use all your senses to connect with your council. Bring in meditation or movement, journaling, art or drumming. Note clusters of planets and patterns they create with each other—everything has meaning, all offer some pieces of wisdom.

Native peoples and spiritual seekers around the world have used circles forever as portals to go beyond the limits of what our everyday minds can understand or perceive. Astrologers use astrodrama,

astroshamanism, experiential and embodied astrology to understand the human experience via its synchronicity with celestial patterns and cycles.

When I'm working with people new to astrology, I organize the signs into the four basic elements: Fire, Earth, Air and Water. I use red paper, pen or paint for the three Fire signs, Aries/Leo/Sagittarius; green to designate Earth signs, Taurus/Virgo/Capricorn; yellow for Air signs, Gemini/Libra/Aquarius, and blue for Water signs, Cancer/Scorpio/Pisces. Beginners will connect with their Venus in Leo more readily when they experience her as Fire: hotheaded and active, attracted to passion and daring.

When I taught high school astrology, we had fabulous times playing with ordinary objects as planetary representatives. A potato peeler became Pluto, a spark plug was Uranus, Venus a mirror, Mercury a phone. Saturn had a ruler, Jupiter binoculars

I've created cards with symbols, colors and keywords for each planet, and collected stones, marbles and crystals to represent the planets. I've collaged cards with gathered images. Several classes created masks or headdresses for each of the planets and then embodied each other's council.

Over time, and with playful reverence, I've witnessed magic, even miracles, in Star Council encounters. I've lost the sense of being alone, in sole charge of my fate and destiny. I've come to understand that I am a necessary and valuable member of some grander, wiser universe. I wish the same for you.

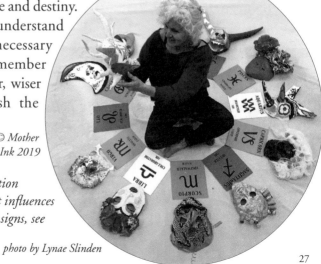

Gretchen Lawlor © Mother Tongue Ink 2019

For more information about the different influences of the planets and signs, see pages 10, 11 & 204

photo by Lynae Slinden

Who Will Inherit the Earth? A Wake Up Call!

We'Moon 2020: Wake Up Call The ancient question rings now with radical new alarm! Can the earth be passed on intact to any human beings beyond ourselves?! At the time of this writing, the latest UN report by climate scientists has concluded that we have until 2030, at the current rate, before the cataclysmic consequences of climate change are irreversible, and our life support systems collapse. All of us currently alive on the planet today are collectively responsible for the answer to this question—in our lifetime! How we respond to this Wake Up Call, individually and collectively—here and now—will determine the outcome in the next decade.

The sustainability of life on Earth is hanging in the balance. The good news is that the cycles of nature regenerate, and have maintained eco-logical balance in the web of life for 3.8 billion years. What comes around, goes around. Life is continually transforming. The most difficult passages are in the dark moon phase at the end of one cycle, when things fall apart, and the new cycle of growth is just beginning. The pain and suffering of dying and letting go, like the labor pains of birthing new life, are part of the dark moon phase between life cycles. Women have long been the priestesses and midwives of this mysterious realm: the womb/tomb cauldron of deep transformation. What is the Goddess teaching us now?

2020: 20/20 Vision. Can you read the writing on the wall? We may not be able to see clearly what's right in front of us, but if we stay present, we can begin to sense the unknowns in the dark. Far-sightedness and intuitive experience broaden our perspective. Knowing where we are in the larger cycles of transformation, and understanding the influences bearing upon us (personally, politically, planetarily, spiritually), we can get through this dark moon phase. Is this roiling cauldron of transformation a sign of a flailing system about to go down? . . . and/or of labor pains birthing another more life-affirming way of being?

We'Moon 2020 / **Tarot Card XX, Judgment:** Judgment is a double-edged sword of truth. Discernment tries to slice through illusion; judgmentalism may obscure reality. In this

dissociated Age of (dis) Information, perception of truth is not necessarily anchored in anything besides individual identity, opinion and beliefs. Who has the power to define reality for whom? Inventing truth has become a new weapon of mass destruction for those in power. The system of male dominance and control over woman, nature, and all "others" feeds on conflict; it has metastasized from sexism to racism to classism to all intersecting oppressions that

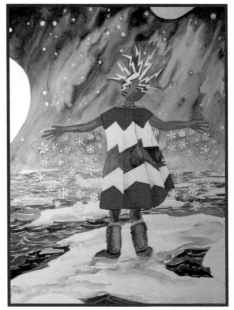

Thunder Woman in the Far North
□ *Sandy Eastoak 2010*

pit one against another. Naming the source of this societal dis-ease gives us power to fight the toxic system instead of each other. The systemic cause is finally being acknowledged and called out in public discourse by name: Patriarchy.

(XX) Judgment Call (XX+XX) 2020: the Future is Female!

Reverence for the Great Mother prevailed for eons of matriarchal time, interrupted by a few centuries of patriarchy whose time is up. What will it take for us to reclaim our female heritage—and be able to continue passing on the gifts of life? Conditioned "feminine" qualities that were devalued are needed now to be cultivated in everyone to heal the disconnects that we have inherited from the ruins of patriarchy. The impulse to reach out and "connect" with others, demonstrated predominantly by women, is an alternative to the endemic "fight or flight" response. Women are beginning to moonifest visions of a more just, fulfilling and life-loving paradigm—to rebalance human relations and restore the natural harmony among all beings. What roles do you want to play in creating more harmonious life on earth? What kind of earthly future do you want to pass on? It's your call!

Musawa © Mother Tongue Ink 2019

INTRODUCTION TO THE HOLY DAYS

We are meaning-making animals, embedded with all of creation in circles of mutuality. In the modern world, it's easy to forget our connection to nature and to story. Ritual provides a gateway to the ageless cycles of planting, growth, harvest and winter sleep. As Earth passes through Her changes of weather, light and cosmic sky-drama, we re-member our kinship with the world, as humans have always done. The Goddess we pray to is Mother Earth, that interdependent-brilliant-evolving Creation we're all a part of. Our rituals re-mind us of our harmony with Others, as we raise energy from the ancient, patient elementals and send conscious prayers spiraling forth, for life.

Rising Above it All © Rosella 2015

Ceremony, alone or with others, gives structure and order to our year. Holy Days are markers on the journey. Women's circles are the core of our feminist spiritual tradition. Gathered together we celebrate, finding deeper courage to feel our pain for the world's. We learn to witness this suffering so we can work to repair it. We're survivors of Post-Patriarchal-Capitalist-Stress Syndrome, where entire corrupt systems exist to compensate people with material bribes in exchange for giving up our ecstasy, our connection.

With every institution at the cliff-edge of ruin, creation and extinction are in a dead heat race. Will Earth's life support systems or the empires of capitalism crash first? How can we stay calm with so much beauty at stake? Earth-loving ceremony creates a way to elevate our imaginations, and live in the mythic terms of a larger story.

The most remarkable thing about this time in history, this wake up call, is not that we are destroying the world, but that we're beginning to awaken to a whole new relationship to the world, to ourselves and to each other. We gather together to turn the wheel. To sing songs of holiness. We shove, with all our collective strength, against this giant stone door of domination. From this space of communion with all, we can work to catalyze a mass psychic break and change the story.

Oak Chezar © Mother Tongue Ink 2019

THE WHEEL OF THE YEAR: HOLY DAYS

The seasonal cycle of the year is created by the Earth's annual orbit around the Sun. Solstices are the extreme points as Earth's axis tilts toward or away from the sun—when days and nights are longest or shortest. On equinoxes, days and nights are equal in all parts of the world. Four cross-quarter days roughly mark the midpoints in between solstices and equinoxes. We commemorate these natural turning points in the Earth's cycle. Seasonal celebrations of most cultures cluster around these same natural turning points:

February 2 Imbolc/Mid-Winter: celebration, prophecy, purification, initiation—Candlemas (Christian), New Year (Tibetan, Chinese, Iroquois), Tu Bi-Shevat (Jewish). Goddess Festivals: Brigit, Brighid, Brigid (Celtic).

March 19 Equinox/Spring: rebirth, fertility, eggs—Passover (Jewish), Easter (Christian). Goddess Festivals: Eostare, Ostara, Oestre (German), Astarte (Semite), Persephone (Greek), Flora (Roman).

May 1 Beltane/Mid-Spring: planting, fertility, sexuality—May Day (Euro-American), Walpurgisnacht/Valborg (German and Scandinavian), Root Festival (Yakima), Ching Ming (Chinese), Whitsuntide (Dutch). Goddess Festivals: Aphrodite (Greek), Venus (Roman), Lada (Slavic).

June 20 Solstice/Summer: sun, fire festivals—Niman Kachina (Hopi). Goddess Festivals: Isis (Egyptian), Litha (N. African), Yellow Corn Mother (Taino), Ishtar (Babylonian), Hestia (Greek), Sunna (Norse).

August 2 Lammas/Mid-Summer: first harvest, breaking bread, abundance—Green Corn Ceremony (Creek), Sundance (Lakota). Goddess Festivals: Corn Mother (Hopi), Amaterasu (Japanese), Hatshepsut's Day (Egyptian), Ziva (Ukraine), Habondia (Celtic).

September 22 Equinox/Fall: gather and store, ripeness—Mabon (Euro-American), Goddess Festivals: Tari Pennu (Bengali), Old Woman Who Never Dies (Mandan), Chicomecoatl (Aztec), Black Bean Mother (Taino), Epona (Roman), Demeter (Greek).

October 31 Samhain/Mid-Fall: underworld journey, ancestor spirits—Hallowmas/Halloween (Euro-American), All Souls Day (Christian), Sukkoth (Jewish harvest). Goddess Festivals: Baba Yaga (Russia), Inanna (Sumer), Hecate (Greek).

December 21 Solstice/Winter: returning of the light—Kwanzaa (African-American), Soyal (Hopi), Jul (Scandinavian), Cassave/Dreaming (Taino), Chanukah (Jewish), Christmas (Christian), Festival of Hummingbirds (Quecha). Goddess Festivals: Freya (Norse), Lucia (Italy, Sweden), Sarasvati (India).

* Note: Traditional pagan Celtic / Northern European holy days start earlier than the customary Native / North American ones—they are seen to begin in the embryonic dark phase: e.g., at sunset, the night before the holy day—and the seasons are seen to start on the Cross Quarter days before the Solstices and Equinoxes. In North America, these cardinal points on the wheel of the year are seen to initiate the beginning of each season.

© *Mother Tongue Ink 2003 Sources:* The Grandmother of Time *by Z. Budapest, 1989;* Celestially Auspicious Occasions *by Donna Henes, 1996 &* Songs of Bleeding *by Spider, 1992*

Introduction to We'Moon 2020

"Karma! Karma!" cries the Judgment Card—card #20 in Tarot's Major Arcana, and the symbolic underpinning for *We'Moon 2020: Wake Up Call*. Chickens come home to roost. We reap what we sow. The planet reels with catastrophe and crisis, heralding a plateful of just desserts for those who are hellbent on power and greed, refusing the humane imperatives for peace, justice and a sustainable earth-home. But it is not yet clear how and when the imperial bullies will be getting their due. Meantime, in this mean time, we the people, and all our relations, and the natural systems that support life, are suffering. As the prophet, Cassandra, insists on page 147, "Something's wrong. Something's very wrong." (Lucy H. Pearce).

We'Moon 2020 sets out to wake us, sometimes gently, sometimes with alarm, to our peril and our opportunities. This call summons and inspires us for the deepest, most loving and urgent rescue work we can imagine. From this year's Call for Contributions of Art and Writing: "We see with new eyes what we bring to the table of Transformation—as women from different cultures of origin, as women who live in and despite misogyny … We urgently seek new possibilities for healing Earth and mending human community. Goddess-sight is here. 2020—Clear Vision."

2020 Vision sees far and beyond the visible. This collection is not, then, a book of gloom and doom, but an ingathering of devotional work grounded in earth-beauty and heart-hope. "Mokosh, Goddess of the Working Woman" (p. 70, Joanne Clarkson) can be counted on to bless seeds and dirt and effort. Girl energy takes brand new responsibility for a better world: "We are the ancestors of the future" (p. 65, Sophia Faria). There is fantasy that imagines society reborn; the passion of protest has verve and reverence: "Join a silent march for more snow and new glaciers" (p. 77, Lorraine Schein). Rage does not flinch from speaking its truth, but it dares to partner with the long view's focus on healing and renewal. On page after page, women are reframing the possible, honoring the unusual, rediscovering Love.

And on page after page, color and image lift us into extraordinary dimensions. Like our *Lioness* on the front cover, filled with discovery, we catch our breath, marvel that words and art so blend into new sensibility, surprising revelation. There is nothing quite like We'Moon, is there? This datebook is food for the spirit. Eat hearty. Enjoy a Wakeful feast.

Bethroot Gwynn © Mother Tongue Ink 2019

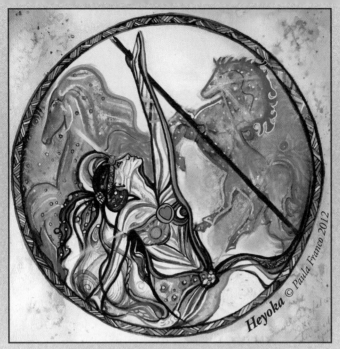

Heyoka © Paula Franco 2012

Sophia! Oshun! Goddesses of Wisdom!
Steady us in your Temples of Discernment, even as this Earth quakes.
Maat, clear the murky air with your Plume of Truth
Hokmah, Spirit of Understanding, shine your Insight through fog of war
Wake us to the moment of spirit-vision into
the mystery of ally, enemy, beloved, stranger, self.
Diké, Akonadi—Mothers of Justice. Themis, Lady of Good Counsel
Give us your epiphanies of redress, balance, completion.
The Harvest of Deeds is ripe. Reckoning has matured.
We peer into our own verdict-mirror—Come clean
Start fresh together to remake our precious, damaged world.
Durga, Kali, Nemesis—Divine Avengers, Arbiters of Karma
You dethrone the tyrant. You settle the accounts.
Keep us fiercely creative as we stop oppression, defend earth-life.
We call Tara, vast radical Sacred One
Quintessence of Compassion, Liberation, Illumination
You who dwell beyond Right and Wrong
as passionate to forgive as to halt the brutal.
Tara, Come to us. Keep our Actions Wise, our Hearts Open.
Dare us, even in Emergency, to Trust Risk Heal Love

Call It In

Calling all forces for good, calling in the elemental energies, the spirits of the land and of the creatures that walk it, the spirits of the waters, and those that dwell within, the spirits of the air, and those who float and take wing on the wind. Calling to the ancient guardians of this planet, and of its peoples. Calling on the long-sleeping force of the "mythological" beings of old. Calling on the directions: North, South, East, West. Calling on the Above and the Below. Calling on Center. See us through this time in a powerful and protective way. Give us courage and inner calm, foresight and preparedness for the battles we are fighting, and wins for the ones that are ahead. Give us clarity to see the moments of peace, and to draw strength for our love and fortitude. Offer us answers in our dreams, and support in our waking. Calling on the Great Mystery, the benevolent powers of creation. Help us tap our higher calling, our magic and our bravery for the days to come, and for today.

I. WAKE-UP

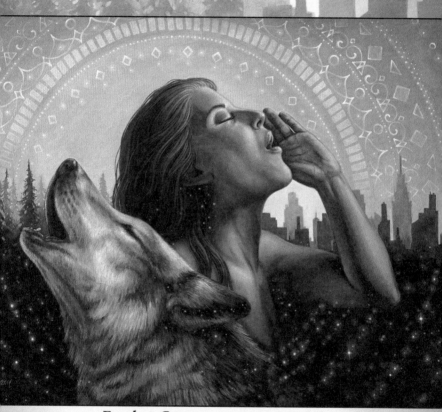

Freedom Cry © *Autumn Skye Morrison 2017*

There is no mediator
between goddess call
and inspiration,
so answer the call—
in moonlight
or sun.

excerpt ¤ Kersten Christianson 2012

December 2019

shí èr yuè

Saturday
21

♀⚹☋ 3:14 am	☽⚼♅ 9:46 am
☉⚹☽ 3:45 am	☽⚹♃ 12:20 pm
☽→♏ 4:57 am	☉→♑ 8:19 pm
☽□♀ 7:51 am	

Winter Solstice

Sun in ♑ Capricorn 8:19 pm PST

Sunday
22

♀□♅ 5:30 am	☽⚹♄ 3:51 pm
♂⚹♇ 6:32 am	☽⚹♇ 6:51 pm
☽△♆ 8:32 am	☽♂♂ 7:27 pm

Monday
23

☉□☋ 7:17 am	
☽→♐ 8:34 am	
☽⚹♀ 4:37 pm	

Tuesday
24

☽□♆ 12:56 pm	
☉△♅ 1:44 pm	

Wednesday
25

☽♂♅ 3:18 am	☽△♅ 6:45 pm
☽→♑ 1:45 pm	☉♂☽ 9:13 pm
♃ApH 1:54 pm	☽♂♃ 11:29 pm

New Moon in ♑ Capricorn 9:13 pm PST

Thursday
26

☽⚹♆ 7:23 pm	

Friday
27

☽♂♄ 4:08 am	☽⚹♂ 1:03 pm
☽♂♇ 6:42 am	☽→♒ 9:20 pm
☉♂♃ 10:25 am	

Gaia, Save Us

Earth's heart speaks
in the wind, the moon,
the stars, the flowers, the trees
& the rivers, the fires,
the lakes, the clouds
and the ocean.
"Wake up!" Earth says.
"Loosen your ears, your arms,
your words, your singing.

Relax your heart
& wake to
beauty & true freedom.
Wake up!
Look into my
blue, green, brown eyes.
Pay attention! Tell the truth!
Wake up!
You can fix this if you try."
excerpt © Joyce McCallister 2018

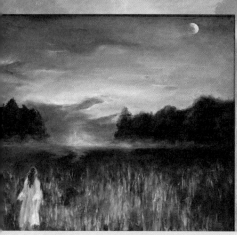

Into the Mists
© Melissa Harris 2013

ᚾᚾᚾ xīng qī liù

 ♒

Saturday
28

☽□♅ 2:32 am
☽♂♀ 6:07 pm
☿→♑ 8:55 pm

⊙⊙⊙ lǐ bài rì

 ♒

Sunday
29

☿□♃ 8:57 pm

Dec. '19–Jan. '20

Ogrohaeon / Poush

□ *Natasha Stanton 2016*

Raven's Breath

♒︎
♓︎

Monday
30

☽□♂	2:24 am
☽→♓	7:41 am
☽✳︎♅	12:52 pm
☽✳︎♅	1:04 pm
☿△♅	2:22 pm
☽✳︎♃	8:37 pm

─── ♂♂♂ mongolbar ───

♓︎

Tuesday
31

☉✳︎☽	2:32 am
☽♂♆	4:15 pm

─── ☿☿☿ budhbar ───

♓︎
♈︎

Wednesday
1

January

☽✳︎♄	2:43 am
☽✳︎♇	4:38 am
☽ApG	5:21 pm
☽△♂	6:13 pm
☽→♈︎	8:00 pm

─── ♃♃♃ brihospotibar ───

♈︎

Thursday
2

☿♂♃	8:41 am
☽□♃	10:19 am
☽□☿	10:32 am
☉□☽	8:45 pm

Waxing Half Moon in ♈︎Aries 8:45 pm PST

─── ♀♀♀ sukrobar ───

♈︎

Friday
3

♂→♐	1:37 am
☽✳︎♀	7:38 am
☽□♄	3:49 pm
☽□♇	5:18 pm

───

ALL ASPECTS IN PACIFIC STANDARD TIME; ADD 3 HOURS FOR EST; ADD 8 HOURS FOR GMT

Her Voice

For some She comes in a dream. For others in words as clear as a bell: *It is time, I am here.*

She may come in a whisper so loud She can deafen you, or a shout so quiet you strain to hear. She may appear in the waves or the face of the moon, in a red goddess or a crow.

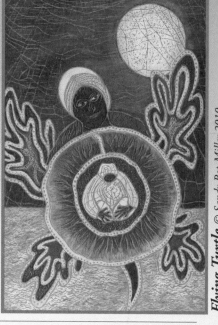

The voice of She we were told did not exist, of She we were told not to trust. The voice of She we did not expect—ringing in the darkness, calling you home.

Who is She? She is your power, your Feminine source. Big Mama. Goddess. The Great Mystery. Web-weaver. The first time, the twentieth time, you may not recognize Her. You may pretend not to hear, as She fills your body with ripples of terror and delight.

But when She calls, you will know it. Then it is up to you to decide if you will answer.

© Lucy H. Pearce 2016

Flying Turtle © Sandy Bot-Miller 2010

ኌኌኌ sonibar

♈ ♉ Saturday
4

☽→♉ 8:15 am
☽☌♅ 1:31 pm
♉ApH 8:08 pm
☽△♃ 11:20 pm

☉☉☉ robibar

♉ Sunday
5

☽△♉ 7:18 am
☉△☽ 1:37 pm
♂△♄ 1:53 pm
☽✶♆ 4:15 pm

January

Mí Eanair

Sun

The Sun and I have an agreement: No matter what, it appears every day, on time. And it gives me the gift of the day.

excerpt © Maria Strom 2017

───── ☽☽☽ Dé Luain ─────

♉
♊

Monday
6

☽□♀ 1:07 am
☽△♄ 3:07 am
☽△♇ 4:08 am
☽→♊ 6:11 pm
☉⚹♆ 10:21 pm
☽☌♂ 11:05 pm

───── ♂♂♂ Dé Máirt ─────

♊

Tuesday
7

♂⚼♅ 12:13 am

───── ☿☿☿ Dé Céadaoin ─────

♊

Wednesday
8

☽□♆ 12:27 am
☿⚹♆ 5:03 am
☽△♀ 2:16 pm

───── ♃♃♃ Dé Ardaoin ─────

♊
♋

Thursday
9

☽→♋ 12:43 am
☽⚹♅ 5:23 am
☽☍♃ 4:00 pm

───── ♀♀♀ Dé Haoine ─────

♋

Friday
10

☽△♆ 5:19 am
☉☌♅ 7:19 am
☉☍☽ 11:21 am
☽☍♅ 11:33 am
☽☍♄ 3:43 pm
☽☍♇ 3:58 pm
♅D 5:48 pm

Penumbral Lunar Eclipse 11:11 am PST*
Full Moon in ♋ Cancer 11:21 am PST

*Eclipse visible from Europe, Africa, Asia, Australia

Blooms

Our little child Time will not wait for us
She is here, she is NOW
Patience is not her forte.

Truth is
I'll never be ready
I'll never be
as prepared
As I am right Now.

When that call
comes in
When that wind
starts blowing
When the voice
of destiny says
rise to your feet
—Shoes or not—
It's Time to
get up
and walk.

excerpt ¤ Nicole Nelson 2016

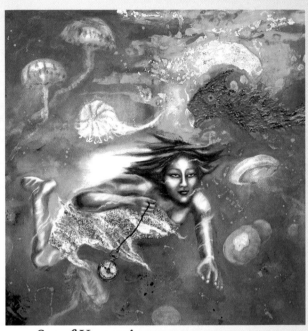

Sea of Uncertainty © *Catherine Molland 2015*

─────── ᚺᚺᚺ Dé Sathairn ───────

♋
♌
Saturday
11

☽→♌ 4:16 am
☽□♅ 8:43 am
☽△♂ 1:53 pm

─────── ☉☉☉ Dé Domhnaigh ───────

♌
Sunday
12

☿☌♄ 1:51 am
☿☌♇ 2:14 am
♄☌♇ 8:58 am

January
enero

♌
♍

Monday
13

♄ApH	2:35 am	☽△♅	10:29 am
☉☌♇	5:20 am	♀→♓	10:39 am
☽⚹♀	5:41 am	☽PrG	12:30 pm
☽→♍	6:06 am	☽□♂	6:00 pm
☉☌♄	7:15 am	☽△♃	10:07 pm

♍

Tuesday
14

☽⚹♆	9:27 am
☽△♇	7:51 pm
☽△♄	8:12 pm
☉△☽	10:41 pm

♍
♎

Wednesday
15

☽△☿	4:12 am
☽→♎	7:43 am
♇ApH	3:17 pm
♀⚹♅	3:18 pm
☽⚹♂	10:14 pm

♎

Thursday
16

☽□♃	12:45 am
☿→♒	10:31 am
☽□♇	10:16 pm
☽□♄	10:56 pm

♎
♏

Friday
17

☉□☽	4:58 am
☽→♏	10:20 am
☽□☿	1:36 pm
☽⚹♅	2:55 pm
☿⚹♆	3:08 pm
☽△♀	7:26 pm

Wake Up!
How do we fall asleep
right inside our lives?
For brief spells, we see
beyond sleep's scrim.
Some parts of us are dreams
it's time to wake from.
excerpt © Dawn Sperber 2013

Waning Half Moon in ♎ Libra 4:58 am PST

ALL ASPECTS IN PACIFIC STANDARD TIME; ADD 3 HOURS FOR EST; ADD 8 HOURS FOR GMT

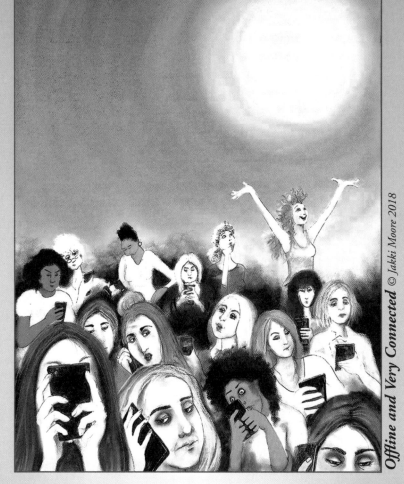

Offline and Very Connected © Jakki Moore 2018

♏

Saturday
18

♉☐♅ 12:32 am
☽✶♃ 4:45 am
☽△♆ 3:13 pm

♏
♐

Sunday
19

☽✶♇ 2:18 am
☽✶♄ 3:19 am
☉✶☽ 1:21 pm
☽→♐ 2:41 pm

January

yī yuè ━━━━━ ⅅⅅⅅ xīng qī yī ━━━━━

 ## Monday
20

D⚹♉ 1:39 am
D□♀ 5:20 am
☉→♒ 6:55 am
D☌♂ 11:46 am
D□♅ 8:46 pm

Sun in ♒ Aquarius 6:55 am PST

━━━━━ ♂♂♂ xīng qī èr ━━━━━

 ## Tuesday
21

D→♑ 9:00 pm

━━━━━ ♀♀♀ xīng qī sān ━━━━━

 ## Wednesday
22

D△♅ 2:00 am
☉⚹♇ 10:03 am
D⚹♀ 5:52 pm
D☌♃ 6:45 pm
☉□♅ 10:54 pm

━━━━━ ♃♃♃ xīng qī sì ━━━━━

 ## Thursday
23

D⚹♆ 4:20 am
♀⚹♃ 5:07 am
D☌♇ 4:18 pm
D☌♄ 6:08 pm

━━━━━ ♀♀♀ xīng qī wǔ ━━━━━

 ## Friday
24

Lunar Imbolc

D→♒ 5:20 am
D□♅ 10:34 am
☉☌D 1:42 pm

New Moon in ♒ Aquarius 1:42 pm PST

ALL ASPECTS IN PACIFIC STANDARD TIME; ADD 3 HOURS FOR EST; ADD 8 HOURS FOR GMT

2020 Year at a Glance for ♒ Aquarius (Jan. 20–Feb. 18)

dear aquarius, how are you settling into your madness? how are you learning to honor the voices in your head and keep them in check? saturn and pluto have been inviting you to shed ego/selves/ideas/beings far too stagnant for the wild work you are here to do. when pluto and saturn join on january 12, what startles into clarity may stretch you to your limits. be so, so tender with yourself and others right now. work with the new moon in your sign on january 24 to cultivate the important practice of honoring your own version of reality.

jupiter will join with pluto three times in 2020 (april 4, june 30, and november 12), opportunities for deep truths to rise to your surface. reflect on whatever lightning insights come to you so you enact them with awareness, understanding, and compassion. on august 3, ask the moon to support you in cultivating unconditional kindness; you will need this gift for your work.

in december, saturn and jupiter move into aquarius, ruler of your first house of self and identity. with your intuition as a solid foundation, deepen into your wildness and rest in your youness. no one can be or has ever been you. tremble.

naimonu james © mother tongue ink 2019

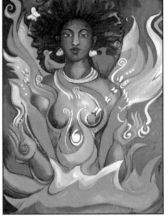

Eve © Toni Truesdale 2017

----------------- ♄♄♄ xīng qī liù -----------------

♒

Saturday
25

☿✶♂ 5:09 am
☽✶♂ 10:34 am
☽♂☿ 11:06 am

----------------- ☉☉☉ lǐ bài rì -----------------

♒
♓

Sunday
26

☽→♓ 3:44 pm
♀□♂ 5:37 pm
☽✶♅ 9:12 pm

The Standing People Are Moving

Bashing themselves about,
stag horns clashing as cymbals of wood and wind.

The watchful mothers are stirring,
shifting their burdens as they wait for their moment.

IT. IS. NOW.

Restless roots cleave the ground,
leaving behind their ancestral songlines
to form an unending procession.
Their breath opposite ours,
these Earth sentinels carry our earliest memories
as monkeys, untamed creatures.

They are cut down and so are we.
They are sick and so are we.
They are threatened and so are we.

Standing people are walking, now running,
there is no more silent waiting.
Moving to a thunderous beat, primal, persistent.

The sky is open and marked by their absence.
The axis of the world tilted, the four directions shifted.
The trees are AWAKE and shaking the Earth!

Join flesh and branch, breath and dance,
The Tree Tribe is rising,
The Black Mother is calling us from drowsiness:
Awaken from your false security, your wild maturity,
Awaken to your all encompassing connectivity!

The trees thump and the Earth rocks,
and the drums pulse in time,
To a vow of aliveness, pounding, pounding,
Pounding in our feet up to our hearts,
So that, my child,
we will never fall asleep again.

II. SPIRIT SIGHT

Moon II: January 24–February 23

New Moon in ♒ Aquarius Jan. 24; Full Moon in ♌ Leo Feb. 8; Sun in ♓ Pisces Feb. 18

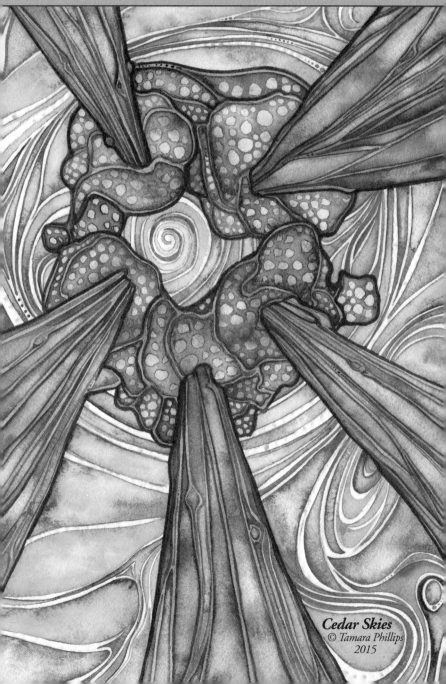

Cedar Skies
© Tamara Phillips
2015

January / February
Poush / Magh

--- ☽☽☽ sombar ---

♓

Monday
27

♀☌♆ 12:00 pm
☽✶♃ 5:13 pm

--- ♂♂♂ mongolbar ---

♓

Tuesday
28

☽□♂ 1:30 am
☽☌♆ 1:34 am
♂□♆ 2:34 am
☽☌♀ 3:02 am
☽✶♇ 2:21 pm
☽✶♄ 5:08 pm

--- ☿☿☿ budhbar ---

♓
♈

Wednesday
29

☽→♈ 3:50 am
☽ApG 1:32 pm
☉✶☽ 11:50 pm

--- ♃♃♃ brihospotibar ---

♈

Thursday
30

☽□♃ 6:54 am
☽△♂ 5:49 pm

--- ♀♀♀ sukrobar ---

♈
♉

Friday
31

☽□♇ 3:11 am
☽□♄ 6:24 am
☽✶☿ 7:09 am
☽→♉ 4:28 pm
☽☌♅ 10:10 pm

ALL ASPECTS IN PACIFIC STANDARD TIME; ADD 3 HOURS FOR EST; ADD 8 HOURS FOR GMT

Imbolc

Celebration of the hearth fire, and time to plant the future we want to see. Spirit wants your attention. A restlessness is growing to break the constraints of winter, and with it comes the fire of inspiration. The light is waxing, and what was born in darkness begins to manifest. Cabin fever. We gather our strength and vision, begin to wake up with nature to the creative work of fundamental change. For all its power, the patriarchy never dreamt of us. Imagine kicking in the rotten door of its powerhouse, igniting the fuse of revolution together! All we have to lose are our illusions! Being disillusioned is a great start; naked in the light of reality, we can visualize a personal/global politics of Satisfaction, of enough-ness. This system can cope with most anything: protests, violence, voting, terrorism. But it can't cope with the radical act of peoples' refusal to participate in an economy of excess. As we become conscientious objectors in the battle for more, we find that experimentation is a great way to live. Join evolution in its holy work of making guesses.

Oak Chezar © Mother Tongue Ink 2019

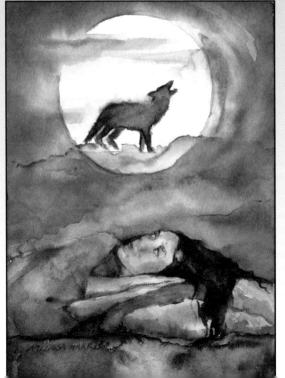

*Answering
the Call
of the Wild*
© *Melissa Harris
2013*

In the Glorious Later

In the glorious later a great freedom was born. People went dancing in the streets, and honey was running down their legs through their toes and into the earth. The sky was falling and laughter ensued—Chicken Little at last validated and looked upon with great admiration. The woods became a meeting place where stockbrokers and landlords tore up their contracts. Chickens and cows, turkeys and pigs were set free from every factory farm. The dancing continued all night.

And all the birds . . . How they knew what a special day this was! In unison each color and type flew together, creating arches the colors of the rainbow, until a kaleidoscope of color filled the sky! Arches of rainbows flooded over oceans and mountains setting off waves of pulsing electrical energies. These waves penetrated the spines of all the humans and creatures who truly believed that love would find them.

Tomorrow came and they remembered. They slowed down and planted more food. They tended their gardens and spent time telling stories and brushing each other's hair. The grooming once known to other species became a way of life for a more affectionate existence. Hugging proliferated, and small yurts were filled with softness for rolling in. Yummy food was served twice a day, and everyone was just fat enough and happy. Dogs and cats danced under the moonlight to the chirp of coqui frogs. The only things that were forgotten were judgment and hate, isolation and fear.

Time passed and soon enough, all this too became a dream—a dream dreaming the dream, hoping for a better life where love wins and life is peaceful and abundant. The rocks know this, the stars know this, streams and rivers know this. Lakes and oceans and mountains never forget.

□ *Kauakea Winston 2017*

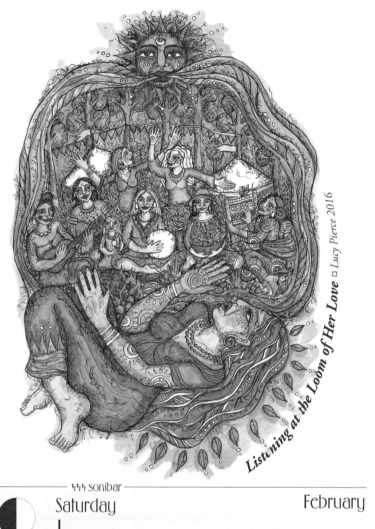

Listening at the Loom of Her Love □ Lucy Pierce 2016

♉ ## Saturday
1

February

⊙□☽ 5:42 pm
☽△♃ 8:11 pm
♀✶♇ 11:07 pm

Waxing Half Moon in ♉ Taurus 5:42 pm PST

⊙⊙⊙ robibar

♉ ## Sunday
2

Imbolc / Candlemas

☽✶♆ 2:29 am
☽△♇ 2:54 pm
☽✶♀ 4:32 pm
☽△♄ 6:24 pm

February
Mí Feabhra

Monday
3

☽□☿	3:28 am
☽→♊	3:29 am
☿→♓	3:37 am
♀⚹♄	2:01 pm

♂♂♂ Dé Máirt

Tuesday
4

☉△☽	8:20 am
☽□♆	11:50 am
☽☍♂	9:07 pm

☿☿☿ Dé Céadaoin

Wednesday
5

☿⚹♅	1:43 am
☽□♀	6:19 am
☽→♋	11:03 am
☽⚹♅	4:17 pm
☽△☿	6:00 pm

♃♃♃ Dé Ardaoin

Thursday
6

☽☍♃	1:14 pm
☽△♆	5:15 pm

♀♀♀ Dé Haoine

Friday
7

☽☍♇	4:02 am
☽☍♄	7:43 am
♀→♈	12:02 pm
☽→♌	2:45 pm
☽△♀	2:59 pm
☽□♅	7:43 pm

ALL ASPECTS IN PACIFIC STANDARD TIME; ADD 3 HOURS FOR EST; ADD 8 HOURS FOR GMT

I've Heard if You Wanna Change Your Life, Start Waking Up at 4 a.m.

In the still ginger of morning, I sip pearl tea and watch flames from my stove and candles, flutter and lick, this way and that. Sensual relish of my skin, dim fiery tones, all those tender surroundings of not-yet-daybreak envelop me like a warm cocoon. I always thought it was writing in the quiet which made me new, but now I know better. It's the lingering play of delicate wee hours that inspire what is deep in me, to stir in the magic of discovery of this fresh awakening to life, today.

© Anna Rose Renick 2010

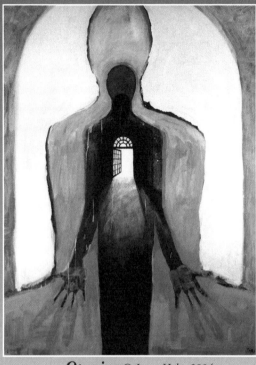

Opening *© Jenny Hahn 2004*

ᚻᚻᚻ Dé Sathairn

♌

Saturday

♉

☉☍☽ 11:33 pm

ᚩᚩᚩ Dé Domhnaigh

Full Moon in ♌ Leo 11:33 pm PST

♌
♍

Sunday

9

☽△♂ 8:08 am
☽→♍ 3:39 pm
☽△♅ 8:31 pm

February
febrero

Mindfully, we care for the Dreamers,
for it is the Dreamers who resolutely
hold the world together by
imagining and creating a future
sustained by Love.
© Denise Kester 2014

♍

Monday
10

♀☌♅ 12:05 am
☽☍♉ 6:51 am
☽PrG 12:39 pm
☽△♃ 4:55 pm
☽☍♆ 7:29 pm

♍
♎

Tuesday
11

☽△♇ 5:36 am
☽△♄ 9:37 am
☽□♂ 10:26 am
☽→♎ 3:37 pm

♎
♏

Wednesday
12

☽☍♀ 12:06 am
☽□♃ 5:53 pm

♏

Thursday
13

☽□♇ 6:20 am
☉△☽ 7:17 am
☽□♄ 10:46 am
☽✶♂ 1:40 pm
☽→♏ 4:37 pm
☽☍♅ 9:54 pm

♏

Friday
14

☽△♉ 1:43 pm
☽✶♃ 8:52 pm
☽△♆ 10:25 pm

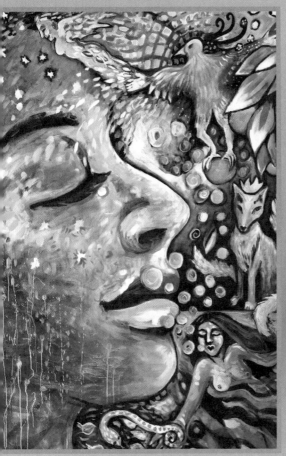

Just Begun: A Call to Creative Action

Come songwriters
And priestesses
of a new era
Come now actors
and activists,
Creators, risk takers
and mischief makers,
Find your wings
Your voice that sings
And speak up!
Sing out!
Rise up
and dance about!

excerpt
¤ *Casey Sayre Boukus*
2018

Dreamer © *Sophia Rosenberg 2017*

ㅐㅐㅐ sábado

♏
♐

Saturday
15

☽✶♇ 9:21 am
☉□☽ 2:17 pm
☽✶♄ 2:20 pm
☽→♐ 8:07 pm

Waning Half Moon in ♏ Scorpio 2:17 pm PST

⊙⊙⊙ domingo

♐

Sunday
16

♂→♑ 3:33 am
☽△♀ 3:06 pm
☿R 4:54 pm
☽□♅ 7:10 pm

MOON II

55

February

 èr yuè

───── ♌♌♌ xīng qī yī ─────

Monday
17

☽□♆ 3:49 am

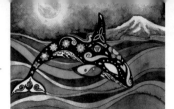

Blackfish ¤ *Melissa Winter 2016*

───── ♂♂♂ xīng qī èr ─────

Tuesday
18

☉⚹☽ 1:03 am
☽→♑ 2:37 am
☽♂♂ 5:16 am
☽△♅ 8:45 am
☉→♓ 8:57 pm

Sun in ♓ Pisces 8:57 pm PST

───── ☿☿☿ xīng qī sān ─────

Wednesday
19

☽⚹♅ 1:56 am
☽□♀ 4:08 am
☽♂♃ 11:50 am
☽⚹♆ 12:05 pm

───── ♃♃♃ xīng qī sì ─────

Thursday
20

☽♂♇ 12:07 am
☽♂♄ 6:18 am
♃⚹♆ 7:56 am
☽→♒ 11:42 am
☽□♅ 6:13 pm

───── ♀♀♀ xīng qī wǔ ─────

Friday
21

♂△♅ 1:10 am
♂□♇ 5:16 am
☽⚹♀ 8:08 pm

───────────────────────

2020 Year at a Glance for ♓ Pisces (Feb. 18–March 19)

when you choose to care for your selves at the cellular level, you choose radiance. from this place, simply showing up as yourself is a sacred offering.

saturn and pluto will meet in your house of ideals and collective liberation january 12. hold yourself through any shifts in communities and friend groups you find home in. prepare to stand shoulder to shoulder with your people and sweat and shake toward freedom. wise jupiter meets pluto three times in 2020 (april 4, june 30, and november 12), an opportunity to integrate (and manifest!) any wild insights you may gather at the start of the year.

use the new and full moons in your sign on february 23 and september 1 to release disempowering relationships that no longer serve you. folks in your life need to be on team you!

by year's end, saturn and jupiter move into aquarius, ruler of your twelfth house of spirit. call in the rest and contemplation you need to stretch your selves in the directions you yearn to stretch. honor your intuition and center your own version of reality. if you are to guide us, you must speak your truths, no matter how wild they sound to unknowing ears.

naimonu james © mother tongue ink 2019

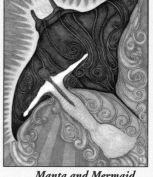

Manta and Mermaid
© Francene Hart 2017

ㅎㅎㅎ xīng qī liù

≈
♓

Saturday
22

☉⚹♅ 6:13 am
☽→♓ 10:37 pm

○○○ lǐ bài rì

♓

Sunday
23

☽⚹♅ 5:29 am
☉☌☽ 7:32 am
☽⚹♂ 8:30 am
♀□♃ 8:59 am
☽☌♉ 4:39 pm

New Moon in ♓ Pisces 7:32 am PST

Return, Girl

Return, girl of autumn golds
frozen-blue lakes and velvet-moss summers
girl of rising bread dough and luscious steam beckoning
sun-warmed summer girl
finding secret woodland truffles and
girl of city-park hopscotch

return to us, girl of something wonderful is just about to happen
girl of another brand-new life
girl passionate with causes
girl sashaying to today's best beat in her own head

girl of the most exciting thing I did that you
 absolutely will not believe but it is true!
girl of new-attitude hair design
girl skimming life-fed lakes carrying
 sun and moon simultaneously

girl of this older woman
set the boring tinder of this world on fire
flood our stale lives with the magnitude of your imagination
swell and drench us with your conjurings and unshakable beliefs
soak us to the bone with the possibilities of who we could become
like you taught us so long ago, singing over the hot steam
 of everyday
 soap and dishes
return to us,
Girl of a Greater World
and show us the way.
 ¤ *Stephanie A. Sellers 2018*

2 Girls
© *Elizabeth Diamond Gabriel*
2007

III. SPROUTING

Moon III: February 23–March 24

New Moon in ♓ Pisces Feb. 23; Full Moon in ♍ Virgo March 9; Sun in ♈ Aries March 19

Joy © KT InfiniteArt 2018

T InfiniteArt

February / March

Magh / Falgun

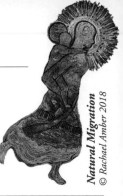

H

Monday
24

D♂Ψ 10:26 am
D⚹♃ 11:45 am
☉⚹♂ 6:06 pm
D⚹♇ 10:57 pm

Natural Migration
© Rachael Amber 2018

—— ♂♂♂ mongolbar ——

H
♈

Tuesday
25

D⚹♄ 6:12 am
D→♈ 10:47 am
☉♂♉ 5:45 pm
☿⚹♂ 9:58 pm

—— ☿☿☿ budhbar ——

♈

Wednesday
26

D□♂ 12:32 am
DApG 3:34 am

—— ♃♃♃ brihospotibar ——

♈
♉

Thursday
27

D□♃ 1:22 am
D♂♀ 9:05 am
D□♇ 11:46 am
D□♄ 7:25 pm
D→♉ 11:30 pm

—— ♀♀♀ sukrobar ——

♉

Friday
28

D♂♅ 6:50 am
D⚹♉ 7:51 am
♅PrH 9:51 am
♀□♇ 2:08 pm
D△♂ 4:56 pm
☿⚹♅ 7:13 pm
☉⚹D 7:40 pm

ALL ASPECTS IN PACIFIC STANDARD TIME; ADD 3 HOURS FOR EST; ADD 8 HOURS FOR GMT

St. Anne, Patron of Mothers of Daughters

Whether or not I believe in scriptures, you resonate, Anne, mother of a head-strong girl-child. The older woman whose young daughter gets pregnant out of wedlock, won't say who the father is, scorns your hope of a wedding, marries the first guy who asks her, some carpenter who has a woodshop of his own.

Right when she should be nesting, they head out for the big city. She has the baby without you. With strangers in an old shed, singing and smoking god-knows-what in the cold. Then they move to Egypt for twelve years and never write or call, chasing a dream.

You stick it out at home with your husband who gets more forgetful by the day. When you complain about his little-girl-Mary-who-can-do-no-wrong, he smiles in his vague way, not comprehending your heartbreak.

Yes, she becomes famous. Even political. Yes, she is the heroine of hardbacks and stars in a feature-length film. You had tried to teach her open-hearth cooking and the weaving of soft cloth. Garden work. How to stay near home, the quiet place you wombed her. She becomes all about the sky.

I take you as my mentor, dear Anne, patron of how to let go through centuries of worry. There is no greater risk than a daughter.

© *Joanne Clarkson 2018*

ꑕꑕꑕ sonibar

♉ ☿ **Saturday**
29

☽⚹♆ 11:50 am
☽△♃ 2:41 pm

☉☉☉ robibar

♉ ♊ **Sunday**
1

March

☽△♇ 12:04 am
☽△♄ 7:52 am
☽→♊ 11:21 am
☽□♉ 3:05 pm

March
Mí Márta

When Mother Nature shows her teeth the time has passed for false belief.

> When Mother Nature
> shows her teeth
> the time has passed
> for false belief.
> ◻ *The Obsidian Kat 2007*

———— ⊃⊃⊃ Dé Luain ————

♊

Monday
2

☉□☽ 11:57 am
☽□♆ 10:24 pm

———— ♂♂♂ Dé Máirt ————

Waxing Half Moon in ♊ Gemini 11:57 am PST

♊
♋

Tuesday
3

♀□♄ 8:44 am
☽✶♀ 6:20 pm
☽→♋ 8:25 pm
☽△☿ 8:44 pm

———— ☿☿☿ Dé Céadaoin ————

♋

Wednesday
4

☿→♒ 3:08 am
☽✶♅ 3:25 am
☿✶♀ 1:24 pm
☽☍♂ 6:24 pm
♀→♉ 7:07 pm
☉△☽ 11:49 pm

———— ♃♃♃ Dé Ardaoin ————

♋

Thursday
5

☽△♆ 5:14 am
☽☍♃ 8:56 am
☽☍♇ 3:50 pm
☽☍♄ 11:11 pm

———— ♀♀♀ Dé Haoine ————

♋
♌

Friday
6

☽→♌ 1:27 am
☽□♀ 4:00 am
☽□♅ 8:06 am

ALL ASPECTS IN PACIFIC STANDARD TIME; ADD 3 HOURS FOR EST; ADD 8 HOURS FOR GMT

21st Century Girl Activism

they're breaking and entering, flexing their muscles
letting in the delights of feet hitting pavement
like a million clackers inside the Liberty Bell
ringing across this country, until the systems of What Was
crumble, and the reality of What Is
is brought into being like two girls
casting song-spells with a jump rope
the politicians inside their hoop
trying to keep up, jumping as quick as they can
now, *Pepper!*

> *I asked my mother for 50 cents*
> *to see a senator jump the fence*
> *he jumped so far*
> *he jumped so fast*
> *when he came down*
> *he was a thing of the past*
> *no war, no guns, no hate remained*
> *the senator said "betta change my name"*
> *mamma's gonna fuss*
> *mamma's gonna sing*
> *mamma's election comes this spring.*

<div align="right">

¤ *Stephanie A. Sellers 2018*

</div>

--- ᚻᚻᚻ Dé Sathairn ---

♌ ## Saturday
7

No Exact Aspects

--- ☉☉☉ Dé Domhnaigh ---

♌
♍ ## Sunday
8

☽☌☿ 12:12 am ☽△♀ 10:00 am
☽→♍ 3:47 am ☽△♅ 10:11 am
☉☌♆ 5:23 am ♀☌♅ 12:38 pm

Daylight Saving Time Begins 2:00 am PST

March

marzo

♍

Monday
9

ΨApH	1:48 am	ⅅ△♃	1:08 pm
ⅅ△♂	3:48 am	ⅅ△♇	6:24 pm
ⅅ☍Ψ	8:56 am	☿D	8:49 pm
☉☍ⅅ	10:48 am	ⅅPrG	11:22 pm

Full Moon in ♍ Virgo 10:48 am PDT

♍
♎

Tuesday
10

ⅅ△♄	1:32 am
ⅅ→♎	3:03 am

♎

Wednesday
11

ⅅ□♂	5:06 am
☉⚹♃	5:27 am
ⅅ□♃	12:48 pm
ⅅ□♇	5:41 pm
ⅅ△☿	11:58 pm

♎
♏

Thursday
12

ⅅ□♄	1:12 am
ⅅ→♏	2:28 am
ⅅ☍♅	9:14 am
ⅅ☍♀	4:10 pm

♏

Friday
13

ⅅ⚹♂	7:59 am
ⅅ△Ψ	8:53 am
ⅅ⚹♃	2:14 pm
☉△ⅅ	5:47 pm
ⅅ⚹♇	6:53 pm

ALL ASPECTS IN PACIFIC DAYLIGHT TIME; ADD 3 HOURS FOR EDT; ADD 7 HOURS FOR GMT

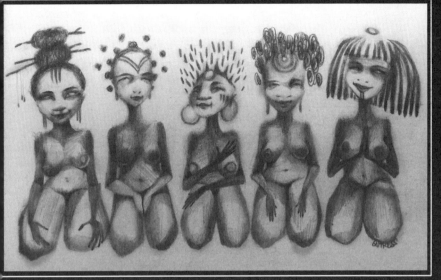

Expanding the Sisterhood Grid © Qutress 2017

Stay

A knowing emerges
around the actions I must take
Recognizing my roots
and responsibility
We are the ancestors of the future

excerpt ¤ Sophia Faria 2018

─────── ♄♄♄ sábado ───────

♏
♐

Saturday
14

☽□♅ 2:36 am
☽⚹♄ 3:06 am
♂⚹♆ 3:32 am
☽→♐ 4:09 am
☉⚹♇ 9:47 am

─────── ⊙⊙⊙ domingo ───────

♐

Sunday
15

☽□♆ 12:51 pm

Spring Equinox

The return of spring, time of holy equality. The landscape is still winter-rough and wind-blown. Walk outside and feel the raw possibility. The world is made of stories, and we need to change the narrative. Poised in the season's symmetry, ask: what does another world look like? The anxieties hover—climate change, nuclear holocaust, environmental devastation—but let us not stress only existential apocalyptic tales. How do we stop devouring the planet and instead energize stories of plenty and repair?

From the ballast of balance, begin to notice The Commons, that entire life support system that we hold in trust for future beings. Envision a healing, parallel economy producing air, diversity, wilderness, asking only respect in return. Collect bits of wind-blown trash for a day. Gather in community, sharing the common wealth. Remember that the root word for "religion" is "re-linking"; when we speak in the language of longing, we re-enter the mystery.

Walking in the woods, see that trees aren't isolated individuals. Each one is Forest, Forest, Forest. I walk in the world, and I'm not even *me*; I am World. Gaze through the mirror. World. World. World.

Oak Chezar © Mother Tongue Ink 2019

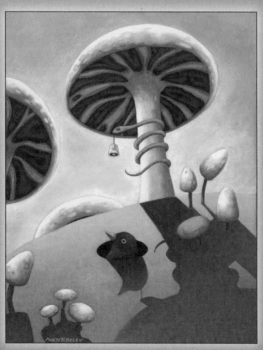

The Awakening © Susan Bolen 2014

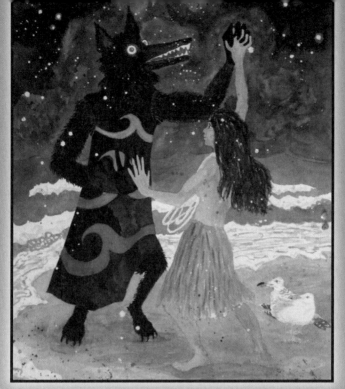

Out of the Nursery and Into the Streets!

Grandma and Little Red
are tree-sitting in the Tongass
defending the wolves against the woodsmen

Snow White has joined
the ladies' auxiliary
of the seven dwarves' union
so she's out fighting for mine safety
when the witch comes around
with her two-faced apples

Goldilocks is camped on the National Mall,
explaining to the president
that Venus is tooooo hot
Saturn is tooooo cold
and the Earth is juuust right

March

sān yuè

Monday
16

☿→♓ 12:42 am
☉□☽ 2:34 am
☽→♑ 9:25 am
☽⚹♉ 9:49 am
☽△♅ 5:33 pm

I come up for air
whipping my hair
in an arch of splintered light
and I am humming
raw and incandescent
excerpt © Meredith Heller 2018

Waning Half Moon in ♐ Sagittarius 2:34 am PDT

Tuesday
17

☽△♀ 10:31 am
☽⚹♆ 8:36 pm

Wednesday
18

☽☌♂ 1:32 am
☽☌♃ 3:47 am
☽☌♇ 7:53 am
☉⚹☽ 3:57 pm
☽☌♄ 5:48 pm
☽→♒ 6:16 pm

Thursday
19

☽□♅ 3:04 am
☉⚹♄ 4:50 pm
☉→♈ 8:49 pm

Spring Equinox

Sun in ♈ Aries 8:49 pm PDT

Friday
20

☽□♀ 2:00 am
♂☌♃ 4:35 am

2020 Year at a Glance for ♈ Aries (March 19–April 19)

after years of shedding work out of alignment with you, 2020 demands you continue searching out your work in the world. use the radical energy of jupiter and pluto, conjunct on january 12 in your tenth house of persona and career, to clear the paths toward the gifts only you can bring through in this life. have courage, for wise jupiter meets pluto three times in 2020 (april 4, june 30, and november 12), three pillars of support to integrate (and manifest!) any new insights.

use the new and full moons in your sign on march 24 and october 1 to build momentum to leap toward work that nourishes you. deliberate and determined, gather the knowledge you need to set

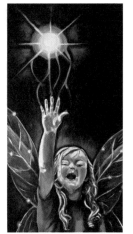

yourself up for success. the north node of the moon will move into youthful gemini on may 5, a reminder to follow your curiosity, no matter how "childish" your journey may seem to others.

in december, saturn and jupiter move into aquarius, your eleventh house of collective liberation. offer your skills and talents to the freedom plight of the whole—not for glory, but because your liberation is wrapped up in the liberation of all beings.

naimonu james © mother tongue ink 2019

───────── ♄♄♄ xīng qī liù ─────────

Saturday
21

♒
♓

☽→♓	5:33 am
☽♂♉	1:39 pm
☽✶♅	2:51 pm
♄→♒	8:58 pm

Playing with Light (Hannah)
◻ *Catherine McGagh 2012*

───────── ⊙⊙⊙ lǐ bài rì ─────────

Sunday
22

♓

☿✶♅	6:19 am
☽✶♀	7:36 pm
☽♂♆	7:38 pm
♀✶♆	8:08 pm
♂♂♇	10:20 pm

Mokosh, Goddess of the Working Woman

Goddess of stamina, old world crone whose only altar was story, she is rough-hewn, statueless. Unearthed on Slavic steppes she was worshipped in breast-shaped stones, both the great rounded mounds stubborn in the fields and small nippled pebbles carried in pockets of farm women, the dust-rakers, the dry-eyed.

If they found one ringed with white, a child was on the way. A hopeful need for labor. Smooth agate was a teardrop of this quasi-goddess whose name means moisture, what field folk most prize. In dreams she was often green. Raindrop sister of seed.

Her sacred song was a hushed harsh lullaby: M K SH. M K SH. M K SH. Her animal, the plow horse, determined and earth-useful. Her favorite plant, flax, for she was a spinner, cousin of the Fates.

Some place her feast in October. Most say any Friday, even before there were week-ends. The one to pray to in times of drought and overwhelm. Saint of oh-yes-I-can.

© Joanne Clarkson 2018

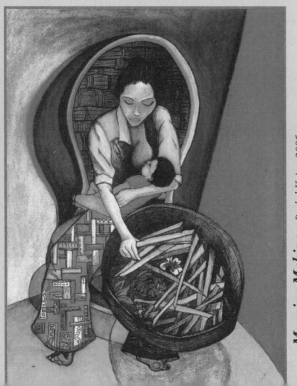

Morning Making □ *Rachel Kaiser 2005*

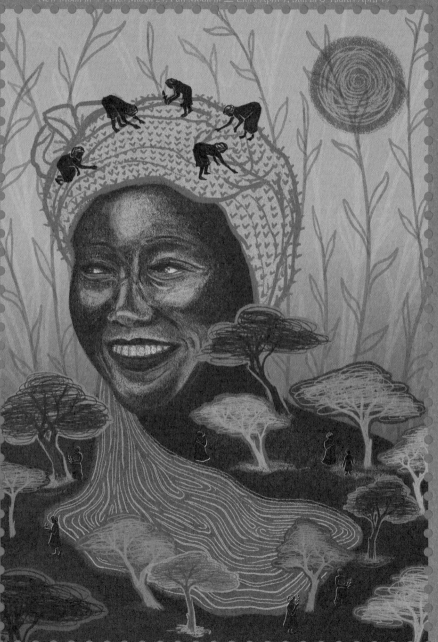

Wangari Maathai © Rachael Amber 2018

March
Falgun

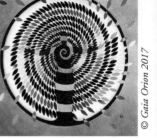

From the Heart

))) sombar

♓
♈

Monday
23

☽✶♃	4:20 am
☽✶♇	7:18 am
☽✶♂	7:51 am
☽→♈	5:58 pm
☽✶♄	6:15 pm

♂♂♂ mongolbar

♈

Tuesday
24

☉♂☽	2:28 am
☽ApG	8:21 am

New Moon in ♈ Aries 2:28 am PDT

☿☿☿ budhbar

♈

Wednesday
25

☉♂☿	6:27 am
☽□♃	5:43 pm
☽□♇	8:02 pm

♃♃♃ brihospotibar

♈
♉

Thursday
26

☽□♂	12:16 am
☽→♉	6:37 am
☽□♄	7:15 am
☽♂♅	4:29 pm
☿ApH	6:50 pm

♀♀♀ sukrobar

♉

Friday
27

☽✶♅	2:03 am
☽✶♆	9:02 pm
♀△♃	9:24 pm

ALL ASPECTS IN PACIFIC DAYLIGHT TIME; ADD 3 HOURS FOR EDT; ADD 7 HOURS FOR GMT

She Who Flies Helicopters

Estimate: in 2017, there were 15,355 licensed USA helicopter pilots. Women represented less than 3% of that total number. That's roughly one woman for every 33 men. This is our story—riddled with refusal, repression, oppression, denial, and blatant prejudice. Ripe with victories of unlikely pioneers, visionaries, conquerors, and luminaries. Women of courage, selflessly doing battle with the status quo. Living their truth and creating a path for the next round of warriors.

I am down in the trenches now. Wrapped in my suit of armor, I am giving thanks to those ladies who came before me. I am going through my initiation, being called "Sweetheart." I am turning heads as I walk into the room, full of men, who are wide-eyed and wondering. I am that one for every 33 incarnate, splashing out ripples in the water and stretching beyond my wildest imagination. I am unconventional. I am inspirational. I am a statistic whose number cannot be padded. I am working smarter and harder.

We are life's leading edge, blazing trails, and being heard. Divine consciousness is expanding. We are being seen around the world. We are creating a future for girls who are too young to know, cultivating the soil where rich feminine roots thrive, watering this garden with love and perseverance. We are nurturing an experience of appreciation, acceptance, and praise, basking in the admiration for scientific geniuses calling themselves "SHE." We are told we can be anything we want to be. I am being one for every 33.

© Amy Alana Ehn 2018

�88 sonibar

ꙩ
Ⅱ

Saturday
28

☽△♃	6:39 am	☽→Ⅱ	6:38 pm
☽☌♀	7:20 am	☽△♄	7:36 pm
☽△♇	8:19 am	♀△♇	7:57 pm
☽△♂	4:05 pm		

☉☉ robibar

Ⅱ

Sunday
29

☉✶☽	1:32 pm
☽□♅	7:58 pm

March / April

Mí Marta / Mí Aibreán ▷▷▷ Dé Luain ───────

Spirit+Matter 1

♊ ## Monday
30

☽□♆ 8:10 am
♂→♒ 12:43 pm

────── ♂♂♂ Dé Máirt ──────

♊
♋ ## Tuesday
31

☽→♋ 4:43 am
♂☌♄ 11:31 am
☽⚹♅ 2:24 pm

────── ☿☿☿ Dé Céadaoin ──────

♋ ## Wednesday
1 April

☉□☽ 3:21 am
☽△☿ 10:51 am
☽△♆ 4:22 pm

────── ♃♃♃ Dé Ardaoin ────── Waxing Half Moon in ♋ Cancer 3:21 am PDT

♋
♌ ## Thursday
2

☽☍♃ 1:49 am
☽☍♇ 2:20 am
☽⚹♀ 9:49 am
☽→♌ 11:26 am
☽☍♄ 12:49 pm
☽☍♂ 3:13 pm
☽□♅ 8:39 pm

────── ♀♀♀ Dé Haoine ──────

♌ ## Friday
3

♀→♊ 10:10 am
☉△☽ 12:29 pm
☿☌♆ 6:14 pm

───────────────────────────────

All aspects in Pacific Daylight Time; add 3 hours for EDT; add 7 hours for GMT

Litany for Survival
after Audre Lorde

for those of us steeped in privilege
wrapped in the invisible blanket of entitlement
 if we believe in justice
 if our hearts hold compassion
we must own the inequities that favor us
we must not let this go unchallenged
our world balances on a sharp blade
we may be sliced in two
we are not meant to survive like this

those of us who have not been
followed by security at Macys,
who have not been stopped for driving while black,
who walk down main street with ease
must awaken

when one more bullet
claims a life, we despair and yet
it is not our child left fatherless,
not our family, our community whose sorrow
echoes up and down the generations

as the stink of slavery and genocide festers
we must stand up, embrace resistance
because none of us are meant to survive like this.

excerpt © Judith Prest 2017

ħħħ Dé Sathairn ──────────────

♌ Saturday
♍ 4

♀△♄ 10:09 am
☽→♍ 2:18 pm
☽□♀ 4:08 pm
♃☌♇ 7:45 pm
☽△♅ 11:06 pm

──────── ☉☉☉ Dé Domhnaigh ────────

♍ Sunday
5

☽☍♆ 9:37 pm

April
abril

from Billie Potts' New Amazon Tarot
© Carol Newhouse 1973

XX Muse

Muse

───── ☽☽☽ lunes ─────

♍
♎

Monday
6

☽☌♉	2:48 am
☽△♇	6:15 am
☽△♃	6:29 am
☽→♎	2:16 pm
☽△♄	3:52 pm
☽△♀	6:56 pm
☽△♂	10:20 pm

───── ♂♂♂ martes ─────

♎

Tuesday
7

☽PrG	11:17 am
♂□♅	11:50 am
☿⚹♇	2:28 pm
☿⚹♃	7:20 pm
☉☍☽	7:35 pm

Full Moon in ♎ Libra 7:35 pm PDT

───── ☿☿☿ miércoles ─────

♎
♏

Wednesday
8

☽□♇	5:17 am
☽□♃	5:50 am
♂⚹♅	10:23 am
☽→♏	1:17 pm
☽□♄	3:03 pm
☽☍♅	10:09 pm
☽□♂	11:41 pm

───── ♃♃♃ jueves ─────

♏

Thursday
9

☽△♆	8:32 pm

───── ♀♀♀ viernes ─────

♏
♐

Friday
10

☽⚹♇	5:15 am
☽⚹♃	6:08 am
☽△♅	12:35 pm
☽→♐	1:35 pm
☽⚹♄	3:37 pm
♀⚹♅	6:39 pm
☿→♈	9:48 pm

ALL ASPECTS IN PACIFIC DAYLIGHT TIME; ADD 3 HOURS FOR EDT; ADD 7 HOURS FOR GMT

Rabble-Rousing

Call a strike against this world for a bluer, purpler one;
one where arms will always embrace us against darkness.
Protest science without magic.
Picket for an Earth with imaginary colors and more moons.
Picket for life in an alternate dimension,
where all can fly and birds can speak.

This world force-feeds us logic and offices,
locks us out of childhood and nights prone to stars.
Protest light pollution.
Demand equal pay for thoughts.
Demand cats' and flowers' rights for dandelions.
Boycott splinters and paper cuts. Boycott Mondays.

Be a troublemaker, be demonstrative.
Hug a cloud! Organize lightning strikes!
Incite a slowdown against time flying.
Join a silent march for more snow and new glaciers.
Provoke a riot against tight underwear.
Stage a walkout from nightmares.
This is a direct call to indirect action,
an indirect call to direct action.
Resist gravity—uprise skyward!

© Lorraine Schein 2017

Hina © *Sudie Rakusin 1998*

ħħħ sábado

♐

Saturday
11

☽☌♀ 12:27 am
☽⚹♂ 3:03 am
☿⚹♄ 4:58 pm
☽□♆ 10:53 pm

☉☉☉ domingo

♐
♑

Sunday
12

☉△☽ 4:46 am
☽→♑ 5:05 pm
☽□☿ 11:00 pm

April
sì yuè

♑

Monday
13

☽△♅ 3:36 am

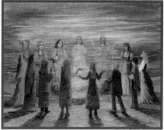

Woman Power

♑

Tuesday
14

⊙□♇ 4:07 am
☽⚹♆ 5:10 am
☽♂♇ 3:01 pm
⊙□☽ 3:56 pm
☽♂♃ 4:47 pm
☿♂♄ 10:02 pm

Waning Half Moon in ♑ Capricorn 3:56 PM PDT

♑
♒

Wednesday
15

☽→♒ 12:37 am
☽♂♄ 3:21 am
⊙□♃ 3:59 am
☽□♅ 12:09 pm
☽⚹♅ 3:40 pm
☽△♀ 8:29 pm
☽♂♂ 10:42 pm

♒

Thursday
16

No Exact Aspects

♒
♓

Friday
17

⊙⚹☽ 7:34 am
☽→♓ 11:29 am
☿⚹♀ 10:36 pm
☽⚹♅ 11:46 pm

ALL ASPECTS IN PACIFIC DAYLIGHT TIME; ADD 3 HOURS FOR EDT; ADD 7 HOURS FOR GMT

2020 Year at a Glance for ♉ Taurus (April 19–May 20)

on january 12, jupiter and pluto will join in your ninth house of belief, ideology, and higher knowledge. use the potent energy of this conjunction to release rigid, stagnant teachings that no longer serve you. seek out faiths, adventures, and lands that (re)ignite your passions and align with your deepest held values. be wary of false prophets and stale mentorships!

pluto conjoins jupiter three times in 2020 (april 4, june 30, and november 12), offering wisdom (jupiter) and x-ray vision (pluto) to see through the bullshit. return to integrity again and again—what faiths and value systems model the ways you want to move?

work with the new moon in your sign on april 22 to become the enchantress of your own life. there is much newness for you to discover within your selves. allow your flirtations to carry you to new destinations, conversations, and values. on the full moon in your sign on october 31, bring your committed relationships into alignment with any newness that has arisen over the year.

in december, saturn and jupiter move into aquarius, your tenth house of work and career. the skills and talents you have been gathering to yourself are ready to create good in the world. be bold, the collective needs your wisdom, dear taurus.

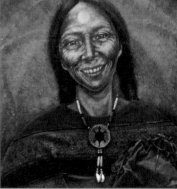

naimonu james © mother tongue ink 2019

ħħħ xīng qī liù

Saturday
18

☽□♀ 11:57 am
☿⚹♂ 8:55 pm

Hina © Dorrie Joy 2014

⊙⊙⊙ lǐ bài rì

Sunday
19

☽♂♆ 3:32 am
⊙→♉ 7:45 am
☽⚹♇ 1:51 pm
☽⚹♃ 4:31 pm

Sun in ♉ Taurus 7:45 am PDT

I Wish You

I wish you mouthfuls of laughter and warm hands and bowls of nourishing soup and starry light glittering at the periphery of your eyes as if someone is tapping you gently on the shoulder, whispering a song from your childhood that makes you smile and weep at the same time, in a good way, like when you know who you are.

I wish you the scent of lime blossoms and the taste of salt on your lips, and the inviting rhythm of rain on your roof that wakes you up at night and draws you from your bed to dance a little in the darkness with a prayer in your body.

I wish you a loving letter from an old friend when you least expect it, with words that warm you like small sticks of kindling that catch and smoke and smell of ancient sandalwood forests and the tiny blue birds that sing at night, and a low slung moon, lying on her back, points up, like a bowl of light.

I wish you pan-fried plantains drizzled with honey, and the lonely sound of a fog horn at dusk after it's rained all day, and the sweet, rich, gentleness you feel in every cell of your body when you're kind to another human being.

I wish you the stillness of the great blue heron as she fishes from her perch at the edge of the world, and the feel of your back, leaning against these rocks here, that have soaked up the sun all day.

I wish you the cool clean whiteness of shells, the sacredness of bones, the memory of flight that leaves its signature in the feather. I wish you the wide wingspan of a low swooping owl as it turns 90 degrees on its side, to fly between trees in the forest, as you walk home alone one night, listening for your song.

© Meredith Heller 2017

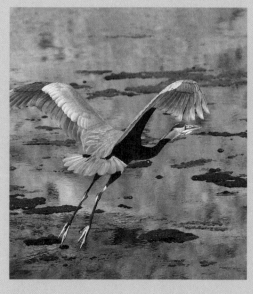

Blue Heron Takeoff
© Barbara Landis 2013

V. LOVE CALLS
Moon V: April 22–May 22
New Moon in ♉ Taurus April 22; Full Moon in ♏ Scorpio May 7; Sun in ♊ Gemini May 20

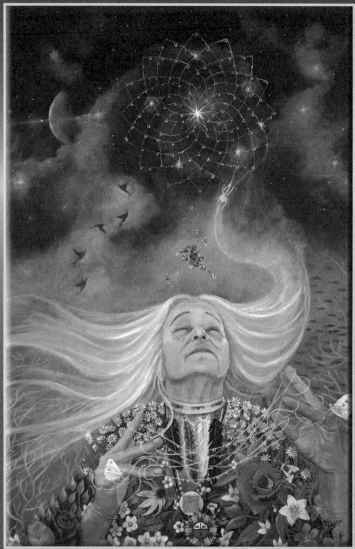

Grandmother Spider—The Weaver
© Jo Jayson 2016

An Ode to Love
love is the tapestry of life,
the string that weaves
the fabric of creation
and ties it all together
excerpt ▫ Elsie Ula Luna Sula 2018

April

Choitro

 ♓
♈

Monday
20

☽→♈ 12:00 am
☽✶♄ 3:16 am
☽ApG 12:00 pm

 ♈

Tuesday
21

☉□♄ 12:00 am
☽✶♀ 4:17 am
☽✶♂ 6:35 am
☽☌♅ 1:06 pm

♈
♉

Wednesday
22

☽□♇ 2:31 am
☽□♃ 5:32 am
☽→♉ 12:36 pm
☽□♄ 3:59 pm
☉☌☽ 7:26 pm

New Moon in ♉ Taurus 7:26 pm PDT

♉

Thursday
23

☽☌♅ 1:28 am
☽□♂ 10:30 pm

♉

Friday
24

☽✶♆ 4:38 am
☽△♇ 2:27 pm
☽△♃ 5:43 pm

ALL ASPECTS IN PACIFIC DAYLIGHT TIME; ADD 3 HOURS FOR EDT; ADD 7 HOURS FOR GMT

say yes

let go of the millstone of worry
the dullness of holding back
the fear of not knowing

just listen to
the morning's music
birds darting through
the plum thicket
or perched
on the branches
cracking seeds
this is it
say yes

let love melt your heart
enter your dreams
wake you up

© *Cathy Casper 2006*

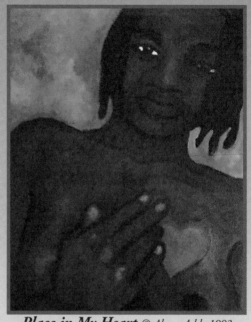

Place in My Heart © *Abena Addo 1993*

––––––– �professor sonibar –––––––

♉
♊

Saturday
25

☽→♊ 12:20 am
☿□♇ 12:36 am
☽△♄ 3:47 am
♇R 11:54 am
☿□♃ 9:31 pm

––––––– ☉☉☉ robibar –––––––

♊

Sunday
26

☉☌♅ 2:01 am
☽☌♀ 9:38 am
☽△♂ 12:55 pm
♅ApH 1:47 pm
☽□♆ 3:31 pm

April / May
Mí Aibreán / Mí Bealtaine

Reach © Sophia Rosenberg 2014

—— ☽☽☽ Dé Luain ——

♊
♋

Monday
27

☽⚹☿ 10:00 am
☽→♋ 10:28 am
☿→♉ 12:53 pm
☽⚹♅ 11:08 pm

—— ♂♂♂ Dé Máirt ——

♋

Tuesday
28

☉⚹☽ 2:38 am
☿□♄ 10:28 am

—— ☿☿☿ Dé Céadaoin ——

♋
♌

Wednesday
29

☽△♆ 12:12 am
☽☍♇ 9:01 am
☽☍♃ 12:29 pm
☽→♌ 6:06 pm
☽☍♄ 9:27 pm

—— ♃♃♃ Dé Ardaoin ——

♌

Thursday
30

☽□♉ 3:46 am
☽□♅ 6:20 am
☉□☽ 1:38 pm
☿♂♅ 8:41 pm

Waxing Half Moon in ♌ Leo 1:38 pm PDT

—— ♀♀♀ Dé Haoine ——

♌
♍

Friday
1

☽⚹♀ 4:15 am
☽☍♂ 9:04 am
☽→♍ 10:35 pm

May
Beltane

Beltane

Joyful time of flowers, softening the world; the chains of winter are broken. Break your symbolic bindings by planting seeds. As these seeds unclench in the darkness, ask what choices can you make in response to the needs of this sacred moment? What is it that you value and how can you align your life with that? In simpler times, communities gathered to jump over fires in the fields and participate in the great round of fertility. Listen to the voices of the universe saying YES—the sun shines, the birds sing, the flowers bloom. The purpose of the universe is to celebrate the delight of its existence. May that inspiration hot-wire us into the living voltage of the Mother. Renew your life with others.

What we all long for is relationship with other beings; it's the only thing that cures this massive alienation. Lying on your back in the woods, see how the trees lift themselves in a circle. Reach out and extend your circle. Community, the geography of Somewhere, is the We that balances the Me. Women know this, in the compass of our bones.

Oak Chezar © Mother Tongue Ink 2019

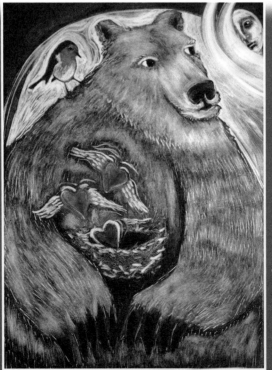

Love Awakens © Denise Kester 2017

To Sing a Different Song

Dry strikes char and scar the West, firebrand fear.
Plumes of smoke soak October air with haze and soot
and prayers for rain. Lightning Creek is hushed, uncharged,
just rock tumbling dry bed. Fishes exiled.
Grasses and trees, birds and beasts, thirsting.
The river's evaporated dreams, wistful remains.
Autumn tiptoes across smoldering embers,
and we talk of climate change and human impact,
envisioning a collective do-over.

At the same time, you've returned home after a long while away.
We fan old flames, reignite. We are firewalking,
stepping gently from the heat of one another,
our climate changing while we shift and adapt.
In other ways, we trickle like Lightning Creek
as mists shroud smoke, and rains once again fall.
We flow around each other again, trade words and breath,
merge after drought to flash stronger.

All around us beings gulp and crave—for clean air and water,
love and connection, give and take,
looking for a do-over of our own faults and those of humanity.
You say love is bigger than words,
and maybe so are natural rhythms we humans
must measure and name. We are meant to dwell
between abundance and lack,
between flashes of rain and love,
between smoke and the mirrors
we all are to each other.

© Heather McElwain 2015

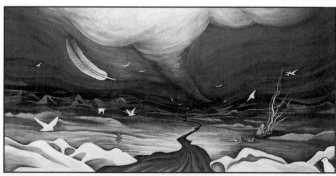

Passing Through
□ Janis Dyck 2012

Precious Moments © Melissa Harris 2001

♍ 🌓 **Saturday**
2

☿ApH 8:52 am
☽△♅ 10:19 am
☽△♉ 4:38 pm
☉△☽ 8:40 pm

♍ 🌒 **Sunday**
3

☽□♀ 8:06 am
☽☍♆ 8:22 am
☽△♇ 4:01 pm
☽△♃ 7:24 pm
♀□♆ 8:52 pm

May
Mayo

© Margaret Karmazin 2018

♍
♎

Monday
4

☽→♎ 12:09 am
☽△♄ 3:15 am
☉☌♉ 2:41 pm

♎

Tuesday
5

☽△♀ 9:23 am
☽□♇ 4:05 pm
☽△♂ 4:13 pm
☽□♃ 7:30 pm
☽PrG 7:51 pm

♎
♏

Wednesday
6

☽→♏ 12:05 am
☽□♄ 3:10 am
☽☍♅ 11:31 am

♏

Thursday
7

☿⚹♆ 3:42 am
☉☍☽ 3:45 am
☽△♆ 8:40 am
☽☍♉ 9:30 am
☽⚹♇ 4:03 pm
☽□♂ 6:33 pm
☽⚹♃ 7:39 pm

Full Moon in ♏ Scorpio 3:45 am PDT

♏
♐

Friday
8

☽→♐ 12:15 am
☽⚹♄ 3:27 am

All aspects in Pacific Daylight Time; add 3 hours for EDT; add 7 hours for GMT

A Wild Thing Full of Magnets

I've been a mind and ability; I've been plans and focus and fiery, hopeful belief. But when you speak, keys fall through your voice, and go unlocking me, freeing a body that erupts beneath my eyes and lips. My long-lost body, beautiful and imperfect, silken-haired and scarred—a wild thing full of magnets, now pulled toward you and all the keys falling though your voice.

It's magic, to grow legs and feet and breasts and hands, and yet, my body confuses time and disrupts my eagle-eye and dream strategies, by leaning forward, by wanting and ringing, ringing like that tinkling pile of keys left on the floor after your oblivious magic tricks. I don't fit on the chair anymore; my legs kick, my ass bumps the cushion off, and I'm a wild animal in the house.

My missing half of me returned, now I don't fit. Shoved from my logic dreams, in a body, I'm lonely. Yet how can I not be grateful for the trick, and replay how all you did was talk, and here I unlocked and went unfurling like I've been a jack-in-the-box all along.

So now I'm a tangle of hips and arms and belly, wrapped 'round with one-eyed plans, but for those minutes when you told a story, I remembered how to be complete. Thanks for the unlocking and zap and the beautiful electricity powering you, even if now all my hands get in their own way. Still, the trick was glorious, and terrible and more real than I'd remembered. Bless your voice's keys. And now here I go into this weird, blazing day.

© *Dawn Sperber 2014*

--- �되되되 sábado ---

♐ | Saturday
| 9

☿△♇ 6:17 am
☽□♆ 10:14 am
☽☍♀ 12:13 pm
☽⚹♂ 11:11 pm

--- ☉☉☉ domingo ---

♐ | Sunday
♑ | 10

☽→♑ 2:38 am
☿△♃ 7:36 am
☉⚹♆ 9:16 am
☽△♅ 3:38 pm
♄R 9:09 pm

May

wǔ yuè

───── ☽☽☽ xīng qī yī ─────

♑

Monday
11

☿□♂ 12:33 am
☿→♊ 2:58 pm
☽⚹♆ 3:05 pm
☉△☽ 5:24 pm
☽☌♇ 11:14 pm

Receive

───── ♂♂♂ xīng qī èr ─────

♑
♒

Tuesday
12

☽☌♃ 3:30 am
☽→♒ 8:39 am
☽△☿ 12:07 pm
☽☌♄ 12:18 pm

☿△♄ 1:14 pm
♂→♓ 9:17 pm
☽□♅ 10:52 pm
♀R 11:45 pm

───── ☿☿☿ xīng qī sān ─────

♒

Wednesday
13

No Exact Aspects

───── ♃♃♃ xīng qī sì ─────

♒
♓

Thursday
14

☽△♀ 2:20 am
☉□☽ 7:03 am
♃R 7:32 am
☽→♓ 6:24 pm
☽☌♂ 9:06 pm
☉△♇ 11:49 pm

Waning Half Moon in ♒ Aquarius 7:03 am PDT

───── ♀♀♀ xīng qī wǔ ─────

♓

Friday
15

☽⚹♅ 9:41 am
☽□♅ 9:57 am
☿⚹♇ 1:22 pm

ALL ASPECTS IN PACIFIC DAYLIGHT TIME; ADD 3 HOURS FOR EDT; ADD 7 HOURS FOR GMT

© Mojgan Abolhassani 2006

Life Savings

An elderly man was walking across four lanes of traffic
when his bag broke, vegetables rolling all over the intersection.
He tried to grab a few things but gave up and hobbled to the curb—
his food left laying in the street.
It was rush hour and the light had turned green. On a Friday.
I made the cars wait as I ran over to pick up
purple cabbage, lemons, tomatoes—
living colors splashed across the baking concrete.
The man waved me off, looking at the impatient drivers,
"It's no use! There's too much." But I managed to collect every
errant vegetable into the broken bag and set it down
next to him at the curb. Running back to my car
another driver gave me the "thumbs up" sign.
We all know what it's like to have a bag break.
And probably many bags will unceremoniously break
in the future for all of us.
Bags will break, cabbage heads will roll and no one
is going to care about your credit score.
Everyone is going to care about you helping
the elderly man with his vegetables.
That's our worth. Our currency. Our wealth.
Our life savings.
We can invest it locally or use it as we see fit.
It's real. It's priceless.

¤ Amy Nicole Purpura 2017

───── ♁♁♁ xīng qī liù ─────

♓

Saturday
16

☽☌♆ 11:34 am
☽□♀ 1:35 pm
☽⚹♇ 8:15 pm

───── ☉☉☉ lǐ bài rì ─────

♓
♈

Sunday
17

☉⚹☽ 12:13 am
☽⚹♃ 12:59 am
☽→♈ 6:36 am
☉△♃ 9:40 am
☽⚹♄ 10:29 am

May
Boishakh

——— ☽☽☽ sombar ———

♈

Monday
18

☽ApG 12:42 am
☽✶☿ 10:17 am

——— ♂♂♂ mongolbar ———

♈
♉

Tuesday
19

☽✶♀ 1:17 am
☽□♇ 8:50 am
☽□♃ 1:33 pm
☽→♉ 7:10 pm
☽□♄ 10:58 pm

——— ☿☿☿ budhbar ———

♉

Wednesday
20

☽✶♂ 5:10 am
☉→♊ 6:49 am
☽♂♅ 11:07 am
♀□♆ 4:03 pm

Sun in ♊ Gemini 6:49 am PDT

——— ♃♃♃ brihospotibar ———

♉

Thursday
21

☽✶♆ 12:19 pm
☽△♇ 8:29 pm

——— ♀♀♀ sukrobar ———

♉
♊

Friday
22

☽△♃ 1:01 am ☿□♆ 8:43 am
♉♂♀ 1:41 am ☽△♄ 10:12 am
☉△♄ 5:02 am ☉♂☽ 10:39 am
☽→♊ 6:36 am ☽□♂ 7:43 pm

New Moon in ♊ Gemini 10:39 am PDT

ALL ASPECTS IN PACIFIC DAYLIGHT TIME; ADD 3 HOURS FOR EDT; ADD 7 HOURS FOR GMT

2020 Year at a Glance for ♊ Gemini (May 20–June 20)

on january 12 jupiter and pluto join in your eighth house of deep truth and alchemy to aid you in shedding people, habits, and thought patterns that lock you away from your messy/sexy/powerful selves. these two guides will work with you to conquer fears that keep you from stepping into the deep knowing that comes from lifetimes of living.

jupiter and pluto will join together three times in 2020, (april 4, june 30, and november 12)—opportunities to integrate what cracks open at the start of the year with wisdom and clarity.

when the north node of the moon moves into gemini may 5, your soul work comes to center, and we must all cultivate gemini qualities of sharing, communication and learning. learn yourself and be curious about your needs/wants/and desires. use the new moon in your sign on may 22 to call in exactly the kind of relationship you want with yourself. bravely restructure your relationships as needed on the full moon lunar eclipse in your sign on november 30.

by year's end, saturn and jupiter move into aquarius, your ninth house of belief and ideology. what wisdom are you called to sink into? what wisdom are you ready to share? what faiths allow you to move through your life with honesty and integrity?

naimonu james © mother tongue ink 2019

Invocation
© Kimberly Webber 2017

─────── ꝑꝑꝑ sonibar ───────

♊ Saturday
23

☽☌♀ 8:14 pm
☽□♆ 10:34 pm

─────── ☉☉☉ robibar ───────

♊
♋ Sunday
24

☽☌♉ 4:09 am
☽→♋ 4:09 pm
☿☓♇ 9:26 pm
♂☓♅ 11:48 pm

Seeds of Promise

The Earth knows
all the seeds
that ever were
so peace is already planted
justice, too, is there
beside empathy and reverence
the seeds of awareness
lie next to willingness
and in a neighbor field
are wisdom, trust and care
the sprouts of every variety
summoning our attention
the season urges us
to sow the seeds long planted
to nurture and watch them grow

© Cindy Ruda 2018

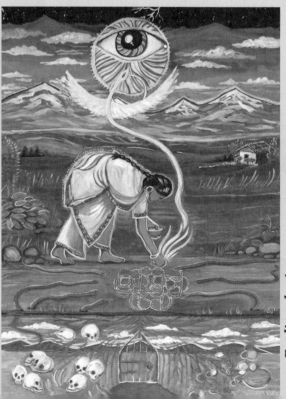

Feeding the Ancestors © *Rachel Houseman 2011*

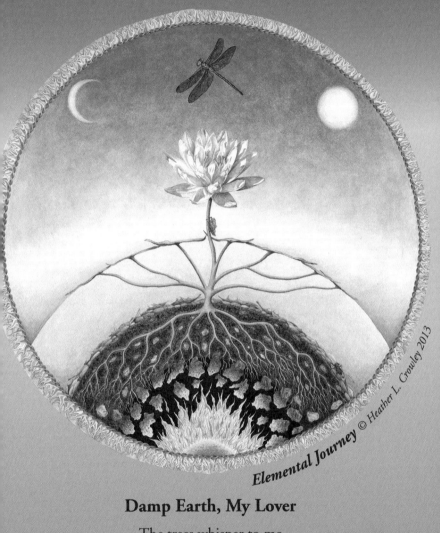

Elemental Journey © Heather L. Crowley 2013

Damp Earth, My Lover

The trees whisper to me
in a language of lost words
rooted so far down
with arms that touch the universe
they hold me to their core
and gently heal me

excerpt © Zoë Rayne 2016

May
Mí Bealtaine

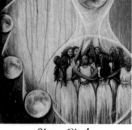

Sister Circle

─────))) Dé Luain ─────

Monday
25

☽✶♅ 7:34 am
☽△♂ 7:58 am

───── ♂♂♂ Dé Máirt ─────

Tuesday
26

☽△♆ 6:43 am
☿⚹♃ 8:35 am
☽☍♇ 2:03 pm
☽☍♃ 6:06 pm
☽→♌ 11:33 pm

───── ☿☿☿ Dé Céadaoin ─────

Wednesday
27

☽☍♄ 2:42 am
☉✶☽ 12:02 pm
☽□♅ 2:34 pm

───── ♃♃♃ Dé Ardaoin ─────

Thursday
28

☽✶♀ 6:30 am
☿→♋ 11:09 am

───── ♀♀♀ Dé Haoine ─────

Friday
29

☽→♍ 4:40 am
☽✶☿ 6:32 am
☉✶♄ 6:57 am
☿⚹♄ 5:25 pm
☽△♅ 7:15 pm
☉□☽ 8:30 pm

Waxing Half Moon in ♍ Virgo 8:30 pm PDT

ALL ASPECTS IN PACIFIC DAYLIGHT TIME; ADD 3 HOURS FOR EDT; ADD 7 HOURS FOR GMT

Grandmothers' University

Vandana Shiva, the nuclear physicist,
went back to her land in the Himalayas
to save seed for the farmers.
Organic farms, five times more productive than monoculture,
lead the way at Navdanya, "Nine Seeds," her farm and home.
Saving fifteen hundred seeds, a biodiversity of seeds,
for local farmers to plant.
Farmers in the Cotton Belt of India committed suicide
by the quarter million after Monsanto colonized the region.
Monsanto limited to five
the thousands of cotton types known,
and from these five, genetically modified,
extracting royalties for the farmer's use.
"We learn from the seed.
We learn from the seed generosity.
We learn from the seed diversity."
says Vandana, her smile huge and warm, her eyes alight.
Grandmothers, the elders, are the best link,
the true source of biodiversity.
"the link of the past and to the future,
The Grandmothers' University."
Vandana's way, at Navdanya, her ecological farm.
"I have deep trust in the Earth."

© Annelinde Metzner 2013

───── ꙗꙗꙗ Dé Sathairn ─────

♍ Saturday
30

☽☌♂ 12:34 am
☽□♀ 8:18 am
☽☍♆ 4:14 pm
☽△♇ 10:46 pm

───── ☉☉☉ Dé Domhnaigh ─────

♍ Sunday
♎
31

☽△♃ 2:16 am
☽→♎ 7:38 am
☽△♄ 10:20 am
☽□♅ 2:16 pm

June
junio

♎ ## Monday
1

⊙△☽ 2:28 am
☽△♀ 8:20 am

♎
♏ ## Tuesday
2

☽□♇ 12:22 am ♀□♂ 5:41 pm
☽□♃ 3:40 am ☽△☿ 7:41 pm
☽→♏ 9:05 am ☽PrG 8:29 pm
☽□♄ 11:38 am ☽☍♅ 11:16 pm

♏ ## Wednesday
3

☽△♂ 8:44 am
♀PrH 10:10 am
⊙♂♀ 10:44 am
☽△♆ 7:14 pm

♏
♐ ## Thursday
4

☽⚹♇ 1:26 am
☽⚹♃ 4:36 am
☽→♐ 10:17 am
☽⚹♄ 12:43 pm

♐ ## Friday
5

☿⚹♅ 4:04 am
☿□♇ 6:40 am
☽☍♀ 6:57 am
⊙☍☽ 12:12 pm
☽□♂ 12:44 pm
☽□♆ 9:10 pm

Full Moon in ♐ Sagittarius 12:12 pm PDT
Penumbral Lunar Eclipse 12:25 pm PDT*

*Eclipse visible from Europe, Africa, Asia, Australia

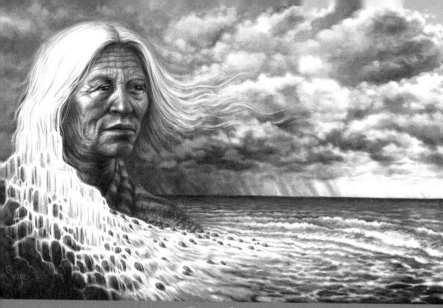

Eternal Waters © *Autumn Skye Morrison 2018*

Living Waters

Sister, how deep
 is the ocean inside you?
 swelling in this second,
 currents stirring
 brewing dreams
 you have yet to fathom

excerpt © Xelena González 2014

ꜧꜧꜧ sábado

♐
♑

Saturday
6

☉□♂ 12:11 pm
☽→♑ 12:44 pm

☉☉☉ domingo

♑

Sunday
7

☽△♅ 4:08 am
☽☌☿ 7:06 am
☽⚹♂ 7:06 pm

MOON VI

June
liù yuè

Vocabulary for Joy
Women hold a vocabulary
for joy in their mouths like
a field of lavender and bee bellies
buzzing a hum back into the earth.
◻ *Liza Wolff-Francis 2018*

—— ☽☽☽ xīng qī yī ——

♑
♒

Monday
8

☽✶♆　1:25 am
☽♂♇　8:01 am
☽♂♃　11:05 am
☽→♒　5:54 pm
☽♂♄　8:17 pm

—— ♂♂♂ xīng qī èr ——

♒

Tuesday
9

☽□♅　10:30 am
☽△♀　12:15 pm

—— ☿☿☿ xīng qī sān ——

♒

Wednesday
10

☉△☽　7:35 am

—— ♃♃♃ xīng qī sì ——

♒
♓

Thursday
11

☽→♓　2:31 am
☉□♆　2:37 am
♀✶♅　3:50 am
☽□♀　7:34 pm
☽✶♅　8:20 pm

—— ♀♀♀ xīng qī wǔ ——

♓

Friday
12

☽△☿　5:06 am
☽♂♂　7:12 pm
☽♂♆　7:51 pm
☉□☽　11:24 pm

Waning Half Moon in ♓ Pisces 11:24 pm PDT

ALL ASPECTS IN PACIFIC DAYLIGHT TIME; ADD 3 HOURS FOR EDT; ADD 7 HOURS FOR GMT

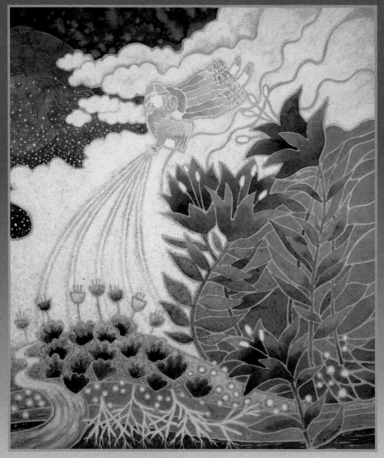

Spring Symphony © *Barbara Levine 1997*

♓
♈

Saturday
13

☽⚹♇ 2:56 am
☽⚹♃ 5:45 am
♂☌♆ 7:13 am
☽→♈ 2:03 pm
☽⚹♄ 4:12 pm

♈

Sunday
14

☽⚹♀ 5:24 am
☽ApG 5:49 pm
☉⚻♇ 6:57 pm
☽☐♅ 7:07 pm

MOON VI 101

Summer Solstice

Summit of full summer. Feel the sun within you shining with abundance, as we blink in the light of that glowing promise, resurrection from death. The triumph of light peaks, slides slowly to dissolve. This is the tipping point for everything: democracy, misogyny, racism, climate, freedom. All are on the cliff edge. We've reached the neon-bright entrance to The Great Turning. Change is the only thing that doesn't change. Are we ready? Trapped between a failed story and a future at risk, it's time to live in mythic terms, to change our language from techno-data to poetry. Gather together in circles; trade material bribes for the ecstasy of interconnection. Every conventional symbol system of our culture is bankrupt, and that's good, because now,

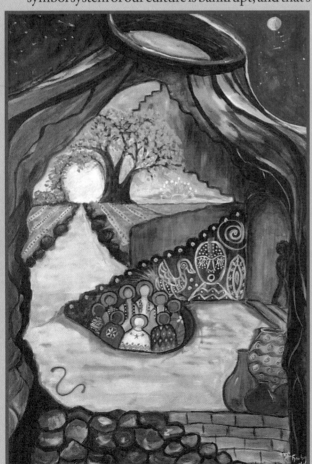

at last, we have the potential to open, to sway and to fall. Call in the sacred rescue workers: the cultural shamans, the clowns, the shape shifters, the change agents, and let's re-write the rules, now! What will save us? Not profit-driven technology and not imperial force. Only the imagination. What can you imagine?

Oak Chezar
© Mother Tongue Ink
2019

Into the Deep I Go . . . © Maryruth Chorbajian 2011

The Bees

A crystal grid beneath the earth's skin
mapped their escape route
only to be used in case of emergencies
like ice caps falling too quickly.

The bees felt the quiver on their furry bodies
and knew it was time,
sorrowfully carrying out their divine instructions.

Some people who we never saw on the news
were dancing their prayers for the
ice caps and the bees to hold on,
give humanity a little more time
to awaken.

▫ Jennifer Lothrigel 2016

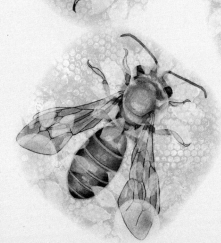

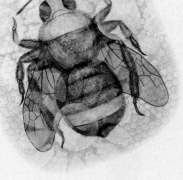

Local Heroes
© *Nancy Watterson 2016*

June
Joishtho

♈

Monday
15

☽□♇ 3:22 pm
☉✶☽ 5:11 pm
☽□♃ 5:49 pm

♈
♉

Tuesday
16

☉⊼♃ 12:33 am
☽→♉ 2:35 am
☽□♄ 4:29 am
☽♂♅ 9:15 pm

♉

Wednesday
17

☽✶☿ 8:03 am
☽✶♆ 8:18 pm
☿R 9:59 pm

♉
♊

Thursday
18

☽✶♂ 2:16 am
☽△♇ 3:01 am
☽△♃ 5:02 am
☽→♊ 2:00 pm
☽△♄ 3:34 pm
♂✶♇ 4:08 pm

♊

Friday
19

☽♂♀ 1:40 am

2020 Year at a Glance for ♋ Cancer (June 20–July 22)

the beginning of 2020 is electric for you, dear cancer. two days after a full moon in your sign on january 10, saturn and pluto join across the sky in capricorn. prepare for radical (re)structuring within your relationships, including your relationship to yourself.

wise jupiter will join up with pluto three times this year (april 4, june 30, and november 12) to help you transform your relationships to better suit you. remember: endings make way for beginnings. above all else, be honest with yourself and others, even when sharing your truth feels difficult. your honesty is your magic. have courage.

on july 20 the new moon solar eclipse in your sign (the last for a while) is a potent invitation to call in what you yearn for. no fear, no drama—just your truth. by year end, saturn and jupiter move into aquarius, your eighth house of deep truth and alchemy. after years of work in your relational realms, now it is time to deepen your contracts. explore your sex and sexuality, your desire for exchange, and allow your wildness to breathe. trust that there will be hard truths that rise to the surface for you to grapple with. worry not, you are ready.

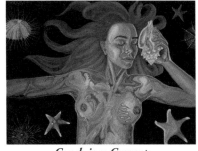

naimonu james © mother tongue ink 2019

Conch-ious Currents
◻ *Monika Andrekovic 2018*

--- ᚼᚼᚼ sonibar ---

♊
♋

Saturday
20

♂✶♃ 12:56 am
☽□♅ 6:07 am
☉→♋ 2:44 pm

☽□♂ 2:47 pm
☽→♋ 11:02 pm
☉♂☽ 11:41 pm

Summer Solstice

Sun in ♋ Cancer 2:44 pm PDT
New Moon in ♋ Cancer 11:41 pm PDT
Annular Solar Eclipse 11:41 pm PDT*

--- ☉☉☉ robibar ---

♋

Sunday
21

☉☌♄ 7:14 am
☽✶♅ 4:35 pm

The Frozen Ark

where the DNA of endangered species is being stored

Nested vials in cloudy cold, row on row of species
sleeping curled into the single speckle
of their DNA. Our Keeper ranks them tier on tier:
over here, the big cats caught before they faded
to a rumor stalking dreams. I could place them
on one hand: Sumatran Tiger reeking
of the swampland, Saudi Lioness with her eyes
of pale lemon moon. Here, beside the top joint
of my little finger sits the emaciated cheetah
and look, on my thumb a single mark
of rosette-printed snow leopard, whose long
ancestral memory seems complicit with this ice.

And will they come back, ever? Will the centuries
roll towards a time when we'll afford the grace
of empty tracts of land: no wheatfields, war-zones,
cities, no mines for rare earth elements or fuel?
Will the cats come stepping slowly
from their clouds of freezing mist, staring
at the way we've engineered another Eden—
a brand new wilderness to which we make no claim?

© Rose Flint 2017

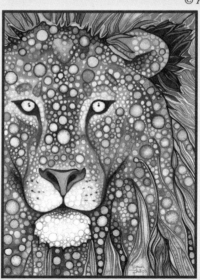

Lion
© Tamara Phillips
2016

VII. FACING THE MUSIC

Moon VII: June 20–July 20

New Moon in ♋ Cancer June 20; Full Moon in ♑ Capricorn July 4

The Three Graces and Their Cats © Denise Kester 2004

June
Mí Meitheamh

♋

Monday
22

☽☌♉ 1:01 am
☽△♆ 1:22 pm
☽☍♇ 7:19 pm
☽☍♃ 8:29 pm
♆R 9:31 pm

♋
♌

Tuesday
23

☽△♂ 12:20 am
☽→♌ 5:33 am
☽☍♄ 6:31 am
☽⚹♀ 3:05 pm
☽□♅ 10:34 pm

♌

Wednesday
24

♀D 11:48 pm

♌
♍

Thursday
25

☽→♍ 10:05 am
☉⚹☽ 6:33 pm
☽□♀ 7:17 pm

♍

Friday
26

☽△♅ 2:44 am
☽⚹♉ 7:18 am
☽☍♆ 9:56 pm

ALL ASPECTS IN PACIFIC DAYLIGHT TIME; ADD 3 HOURS FOR EDT; ADD 7 HOURS FOR GMT

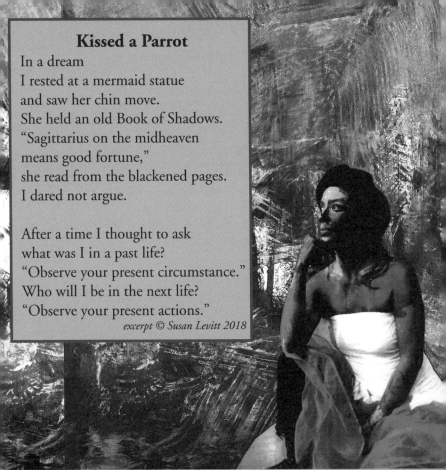

Kissed a Parrot

In a dream
I rested at a mermaid statue
and saw her chin move.
She held an old Book of Shadows.
"Sagittarius on the midheaven
means good fortune,"
she read from the blackened pages.
I dared not argue.

After a time I thought to ask
what was I in a past life?
"Observe your present circumstance."
Who will I be in the next life?
"Observe your present actions."

excerpt © Susan Levitt 2018

I Create ¤ *Rebecca Tidewalker 2013*

ℏℏℏ Dé Sathairn

♍
♎

Saturday
27

☽△♇	3:24 am	☽△♄	1:44 pm
☽△♃	3:51 am	♂→♈	6:45 pm
☽☌♂	1:02 pm	☽△♀	10:34 pm
☽→♎	1:16 pm		

☉☉☉ Dé Domhnaigh

♎

Sunday
28

☉□☽	1:16 am
♂✶♄	3:59 am
☽□♅	8:13 am
♅PrH	4:27 pm

Waxing Half Moon in ♎ Libra 1:16 am PDT

June / July
junio / julio

Call Yourself
Be willing to awaken while
the world dissolves before your eyes.
Call yourself forth, call yourself
by your true name.
excerpt ☐ Susa Silvermarie 2018

—————— ☽☽☽ lunes ——————

♎︎
♏︎

Monday
29

☽□♇	5:55 am
☽□♃	6:02 am
☽→♏︎	3:47 pm
☽□♄	4:01 pm
☽PrG	7:11 pm
♃♂♇	10:46 pm

—————— ♂♂♂ martes ——————

♏︎

Tuesday
30

☉△☽	7:20 am
☽☍♅	8:21 am
☽△♅	8:39 am
☉□♅	10:48 am
☿⚹♅	3:12 pm
☉♂♅	7:52 pm
☉⚹♅	11:07 pm

—————— ☿☿☿ miércoles ——————

♏︎
♐︎

Wednesday
1

July

☽△♆	3:02 am	♄→♑︎	4:37 pm
☽⚹♃	8:06 am	☽⚹♄	6:20 pm
☽⚹♇	8:19 am	☽→♐︎	6:21 pm
☿□♅	9:56 am	☽△♂	10:35 pm

—————— ♃♃♃ jueves ——————

♐︎

Thursday
2

☽☍♀	5:02 am

—————— ♀♀♀ viernes ——————

♐︎
♑︎

Friday
3

☽□♆	6:06 am
☽→♑︎	9:48 pm

ALL ASPECTS IN PACIFIC DAYLIGHT TIME; ADD 3 HOURS FOR EDT; ADD 7 HOURS FOR GMT

Burn

Please do not fight my fire
let it burn
devour
the putrid remains
of what is left
of yesterday

your fire hoses
and attack dogs
keep them away
from our bodies
mr. officer

please don't arrest tomorrow
or the day after

we need them for our planting

in times of war
we save seeds
from the species
extinct from your blow

hide them
under our tongues
deep below the ground

harvest peace long after
the fragrance of her fruit
has been forgotten

and we will feed you
when you come to us
on your knees
weighed down from weaponry
begging forgiveness
and water

we will share our medicine
until you weep
at the resemblance
of our faces

you will remember our names
and your numbers
will crumble to dust
bankrupt

your blood money
will be as worthless
as your guns

excerpt from ClimbingPoeTree, *Whit Press (2015).*
© Naima Penniman, ClimbingPoeTree.
Used by permission of Whit Press

ꛂꛂꛂ sábado

♑ Saturday
4

☽□♂ 4:28 am
☽☍☿ 11:13 am
☽△♅ 3:19 pm
☉☍☽ 9:44 pm

Penumbral Lunar Eclipse 9:32 pm PDT*
Full Moon in ♑ Capricorn 9:44 pm PDT

☉☉☉ domingo

♑ Sunday
5

☽✳♆ 10:44 am
☽♂♃ 3:13 pm
☽♂♇ 4:14 pm

July
qī yuè

Monday
6

☽ ☌ ♄ 2:35 am
☽ → ♒ 3:08 am
☽ ✶ ♂ 12:37 pm
☽ △ ♀ 5:22 pm
☽ □ ♅ 9:37 pm

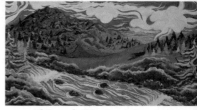

El Portal, CA ◻ *Laurie Bauers 2007*

♒

Tuesday
7

No Exact Aspects

♒
♓

Wednesday
8

☿ □ ♂ 3:41 am
☽ → ♓ 11:12 am
☽ △ ☿ 10:34 pm

♓

Thursday
9

☽ □ ♀ 4:15 am
☽ ✶ ♅ 6:50 am
☉ △ ☽ 11:08 pm

♓
♈

Friday
10

☽ ☌ ♆ 3:57 am
☽ ✶ ♃ 7:47 am
☽ ✶ ♇ 9:51 am
♀ ✶ ♄ 11:36 am
☽ ✶ ♄ 8:49 pm
☽ → ♈ 10:06 pm

ALL ASPECTS IN PACIFIC DAYLIGHT TIME; ADD 3 HOURS FOR EDT; ADD 7 HOURS FOR GMT

at this land known as "the breaks," above the Ogallala aquifer between the creek and the river, the buck stepped into our view just as sun set. we slowed to a crawl. he stood back, turning his heavily antlered head to watch the car pass.

a land, crossed by this road, yes, but never by plow. ragged, wild, rising and heaving in wave-echoes of sea that tossed here long ago, now covering the water you cannot see: ancient, pristine, fossil water, millions of years old.

we broke in a century ago. the water's not likely to last much longer—in places it's already gone. of course it builds up on its own, about an inch a year. the rain finds places to seep in, but not as fast as we can take it out.

the sun sets. our headlights pierce the night and we travel forward following the road. part of me contains the moment that we leave behind, a calm and silent witness of what we do to the earth: deplete, so little time to renew, always pushing on. what happens when the water's gone?

© Cathy Casper 2016

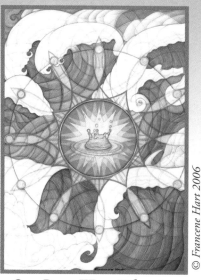

© Francene Hart 2006

One Drop Wave Vibration

———— ꜧꜧꜧ xīng qī liù ————

♈ **Saturday**
11

☽□☿ 9:09 am
♃R 12:16 pm
☽☌♂ 2:16 pm
☽⚹♀ 6:21 pm

———— ☉☉☉ lǐ bài rì ————

♈ **Sunday**
12

♉D 1:26 am
☉△♆ 11:43 am
☽ApG 12:33 pm

☉□☽ 4:29 pm
☽□♃ 7:25 pm
☽□♇ 10:03 pm

Waning Half Moon in ♈ Aries 4:29 pm PDT

July
Asharh

♈
♉

Monday
13

♇PrH	1:49 am
☽□♄	8:54 am
☽→♉	10:34 am
☽⚹☿	9:56 pm

♉

Tuesday
14

☉☍♃	12:58 am
♂☌♆	2:07 am
☽☌♅	7:14 am

♉
♊

Wednesday
15

♃PrH	2:53 am	☽△♇	10:01 am
☽⚹♆	4:16 am	☉☍♇	12:12 pm
☽△♃	6:56 am	☽△♄	8:21 pm
☉⚹☽	9:50 am	☽→♊	10:19 pm

♊

Thursday
16

☽⚹♂	7:26 pm
☽☌♀	11:40 pm

♊

Friday
17

☽□♆	2:14 pm

Preparation

We can act as if the world
of banks,
chemical companies
and multinationals
has already fallen;
As if the tide
of rising waters
has already washed out
the ports;
the roads
already reclaiming—
green grass rising
through the cracks,
the paths we make,
our own.

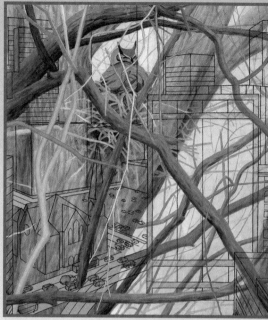

She Waits
© *Nancy Watterson 2014*

We can learn to harrow and hallow,
to barter, and join together
for our survival—
Skills known to Isis
singing songs of grief and awakening
over the decaying body of Osiris
Making it fit for rebirth.

— ꜜꜜꜜ sonibar —————— © *Gail Nyoka 2018*

♊
♋

Saturday
18

☽→♋ 7:24 am
☽♂♉ 9:19 pm

———————— ☉☉☉ robibar ————————

♋

Sunday
19

☽⚹♅ 2:24 am
☽□♂ 5:38 am
☽△♆ 9:00 pm
☽☍♃ 10:27 pm

on the forest floor

i lay my body
and ask
to be reborn
made of ferns
and branches
and bird calls
that this earth
she undresses me
of my thoughts
and connect me to her
in the language
my blood speaks
that she grows
tiny roots
at the end
of my limbs

so she be
my anchor
my only true home
so i can belong
to her anywhere
the way
animals do
so that our hearts
beat in harmony
so that i know
the only truth
the one she whispers
always
so that she lives
on my lips
in my skin

© Sarah Satya 2017

East Side of Volcan Mountain
© Sally Snipes 2004

VIII. TRUE HOME

Moon VIII: July 20–August 18

New Moon in ♋ Cancer July 20; Sun in ♌ Leo July 22; Full Moon in ♒ Aquarius August 3

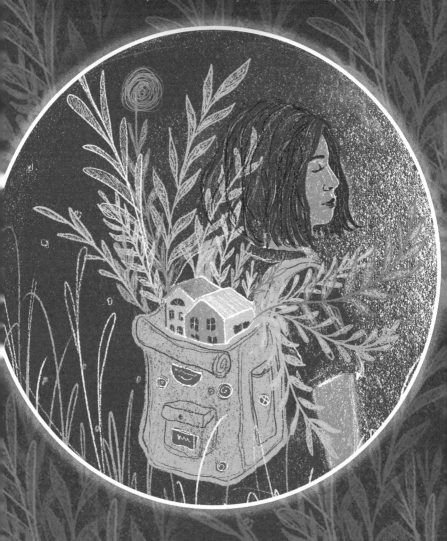

You are Home
© *Rachael Amber 2017*

July
Mí Iúil

Mystical Cat

© Jakki Moore 2010

ᗪᗪᗪ Dé Luain ───────

♋
♌

Monday
20

☽☍♇	2:04 am
☉☌☽	10:33 am
☽☍♄	10:55 am
☽→♌	1:16 pm
☉☍♄	3:28 pm
♄PrH	7:33 pm

New Moon in ♋ Cancer 10:33 am PDT

───────── ♂♂♂ Dé Máirt ─────────

♌

Tuesday
21

☽□♅	7:22 am
☿□♃	8:51 am
☽△♂	12:23 pm
☽⚹♀	5:27 pm

──────── ☿☿☿ Dé Céadaoin ────────

♌
♍

Wednesday
22

☉→♌	1:37 am
☿⚹♅	1:25 pm
☽→♍	4:40 pm

──────── ♃♃♃ Dé Ardaoin ────────

♍

Thursday
23

☽△♅	10:16 am
☽⚹☿	11:47 am
☽□♀	10:46 pm

Sun in ♌ Leo 1:37 am PDT

──────── ♀♀♀ Dé Haoine ────────

♍
♎

Friday
24

☽☍♆	3:22 am
☽△♃	3:57 am
☽△♇	8:05 am
☽△♄	4:08 pm
☽→♎	6:54 pm
☽PrG	10:01 pm
☉⚹☽	11:32 pm

ALL ASPECTS IN PACIFIC DAYLIGHT TIME; ADD 3 HOURS FOR EDT; ADD 7 HOURS FOR GMT

2020 Year at a Glance for ♌ Leo (July 22–Aug 22)

if you are to heal others you must be vigilant about the ways you need healing too, dear leo. pluto joins saturn in your sixth house of body-spirit reverence on january 12. beware ignoring any part of you; if you have been negligent, your silenced parts may rise up to meet you viscerally. notice the soles of your feet and the beat of your heart. find quiet often and (re)claim meditation practices that suit and support you. attune to your inner rhythms so you can step up into your divine work in this world.

jupiter joins pluto three times in 2020 (april 4, june 30, and november 12)—three opportunities to balance your body-spirit with your work in the world. the full moon in leo on february 8 offers deep insights into routines and rituals you need, to be well in your relationships. listen carefully. on august 18, a leo new moon reminds you to love all of your selves—continue practicing acceptance, patience, and forgiveness.

by year's end, saturn and jupiter move into aquarius, your seventh house of intimate relationships. your determination to be well will nourish all others in your life.

naimonu james © mother tongue ink 2019

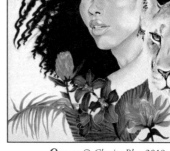

Queen © *Chasity Bleu 2018*

♎

Saturday
25

☽□♅ 6:11 pm
☽☌♂ 8:50 pm

♎
♏

Sunday
26

☽△♀ 3:44 am
☽□♃ 5:41 am
☽□♇ 10:12 am
☽□♄ 6:09 pm
☽→♏ 9:12 pm

July
julio

♏

Monday
27

☉□☽	5:32 am
♃✶♆	9:07 am
♀⚻♃	10:36 am
♀□♆	10:48 am
☿□♂	2:46 pm
☽⚼♅	3:04 pm

Lemons

□ *Peggy Sue McRae 2014*

Waxing Half Moon in ♏ Scorpio 5:32 am PDT

♂♂♂ martes

♏

Tuesday
28

☽△☿	2:04 am
☽✶♃	8:08 am
☽△♆	8:18 am
☽✶♇	1:05 pm
☽✶♄	9:01 pm

☿☿☿ miércoles

♏
♐

Wednesday
29

☽→♐	12:25 am
☉△☽	12:46 pm

♃♃♃ jueves

♐

Thursday
30

☽△♂	7:02 am
☿☌♃	7:17 am
☿△♆	11:45 am
☽□♆	12:20 pm
☽☌♀	5:08 pm
♀⚻♇	6:50 pm

♀♀♀ viernes

♐
♑

Friday
31

☽→♑	4:58 am
☉△♃	6:15 pm
☽△♅	11:56 pm

ALL ASPECTS IN PACIFIC DAYLIGHT TIME; ADD 3 HOURS FOR EDT; ADD 7 HOURS FOR GMT

Lammas

Feel the passing of summer; as light lessens, we deepen the rhythms of rebirth. This is the first harvest—a time of abundance, our opportunity to assume conscious collective responsibility for creating the future. In this time of grains ripening, as we can also feel the Great Loneliness that wraps our human world, keep asking: What is it we value? How can we align our lives with that vision?

How can we control our population, transition from fossil fuels, eliminate toxic waste, practice wisdom without the sacrifices of technology? How can we stop feeding the world to our machines?

For most of human time we've lived connected to Nature. Over five thousand years of patriarchal values have bent us in the direction of domination by the few and pillage of Earth, but that's just a blink in evolutionary time. *Wicca* means *To Bend*. How can we channel the trust of this season, re-shape our lifestyles and re-join the spiral dance of creation and equanimity? A dormant mode of consciousness is willing itself awake within us. Grasp the authority to be cultural shamans and bend our society back to serving life. Rebirth. Re-shape. Re-join.

Oak Chezar © Mother Tongue Ink 2019

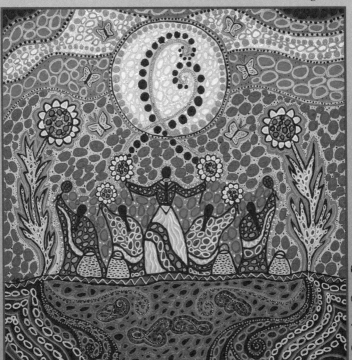

Setting Sun Prayers © Leah Marie Dorion 2017

She Who Dances in Dirt

SHE who dances in dirt knows the joy of being clean.
SHE who dances in dirt eats a slice of darkness
alongside her cup of sunlight.
SHE who dances in dirt can smell the stench and survive,
won't hesitate to cry when she feels pain.
She screams until her anguish breeds laughter
and her laughter breeds movement.
She proclaims her boundaries loud, proud, with conviction,
and believes fervently that her input is valuable
SHE who dances in dirt breathes fully, breathes freely.

SHE who dances in dirt has also flirted with fire, swam in sadness,
tasted tragedy, felt the forceful flames of fury rise within her soul
then bubble up, out, and over into a salty sea.
She has been there. She has gone deep.
She knows the meaning of suffering,
and has risen from her pain alive and clean—ruggedly scarred—
but shining clean.

SHE who dances in dirt does so because
she knows her dancing will cause her wounds to heal.
Her dancing will connect her with the pulse of the great mother.
Her joy atop a mass of confusion
will help others learn
to trust the dirt, befriend the pain, know its watery depths
and in them find power to rise from the black hole.
Her dancing will spread until
SHE who dances in dirt
does not dance alone.
SHE who dances in dirt is one of many
who move their bare feet
across and into the land
dancing, dancing, dancing . . .
joyfully, confusedly, wildly, in the dirt.
¤ *Anna Ruth Hall 2016*

© Liz Darling
2018

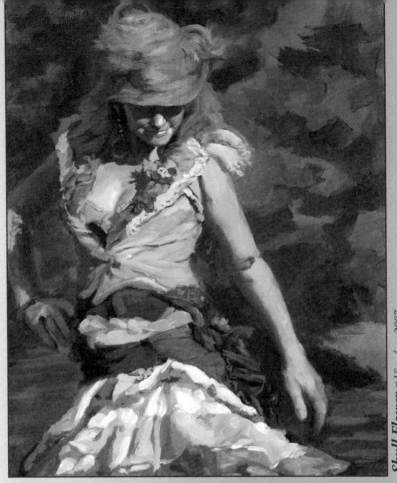

Skull Flower ▫ *Viandara 2007*

♑

Saturday
1

August

♉☌♇	3:52 am
☽□♂	2:22 pm
☽☌♃	4:57 pm
☽✶♆	5:55 pm
☽☌♇	10:57 pm

◉◉◉ domingo

♑
♒

Sunday
2

Lammas

☽☌♉	1:53 am
☉□♅	4:19 am
☽☌♄	6:59 am
☽→♒	11:11 am

MOON VIII

August
bā yuè

♒︎

Monday
3

Lunar Lammas

☽□♅ 6:52 am
☉☍☽ 8:59 am
☿☍♄ 2:00 pm
☽⚹♂ 11:45 pm

Full Moon in ♒︎ Aquarius 8:59 am PDT

♒︎
♓︎

Tuesday
4

♂□♃ 6:06 am
☽△♀ 2:45 pm
♀⚻♄ 3:07 pm
☽→♓︎ 7:27 pm
☿→♌︎ 8:32 pm

♓︎

Wednesday
5

☽⚹♅ 4:01 pm

♓︎

Thursday
6

☽⚹♃ 9:20 am
☽☌♆ 11:11 am
☽⚹♇ 4:38 pm

♓︎
♈︎

Friday
7

☽⚹♄ 12:53 am
☽□♀ 5:53 am
☽→♈︎ 6:05 am
♀→♋︎ 8:21 am
☽△☿ 5:12 pm

ALL ASPECTS IN PACIFIC DAYLIGHT TIME; ADD 3 HOURS FOR EDT; ADD 7 HOURS FOR GMT

Riverbed

Looking though Time's wide-open eye, I remember what it feels like
To be braided into the length of a body, to be poured into fleshed form
And to breathe the exact number of breaths I have been given
Without ever knowing what that number is.

Sometimes
We wake up
All at once
And every cell
Housed in our skin
Summons the way
Back home
To now,
That opens into forever
Without ever knowing
How long forever is.

Love caught me
Love without a face
Or even a song or word
It was love like water
That caught me as I fell
Easily into myself
The way a riverbed
Catches a stone.

¤ *Emily Kedar 2018*

The Ocean Brings Me Peace
¤ *Beth Lenco 2018*

ㅕㅕㅕ xīng qī liù

 ♈ ☽ Saturday
♉

☉△☽ 3:49 pm
☽□♃ 8:44 pm

◎◎◎ lǐ bài rì

♈
♉ ☽ Sunday
9

☽♂♂ 1:35 am ☽□♄ 12:50 pm
☽□♇ 4:38 am ☽→♉ 6:28 pm
☽ApG 6:51 am ☽✱♀ 11:23 pm
☿△♄ 11:02 am

August
Srabon

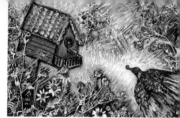

Bringing it Home © Louie Laskowski 20

──── ☽☽☽ sombar ────

♉

Monday
10

☿□♅ 5:52 am
☽♂♅ 4:05 pm
☽□♉ 6:11 pm
☉⊼♃ 11:34 pm

──── ♂♂♂ mongolbar ────

♉

Tuesday
11

☽△♃ 8:51 am
☉□☽ 9:45 am
☽✶♆ 11:32 am
☽△♇ 5:03 pm

──── ☿☿☿ budhbar ──── Waning Half Moon in ♉ Taurus 9:45 am PDT

♉
♊

Wednesday
12

☽△♄ 12:55 am
☽→♊ 6:46 am
☉⊼♆ 7:32 am

──── ♃♃♃ brihospotibar ────

♊

Thursday
13

♂□♇ 12:14 am
☽✶♉ 5:33 pm
☽□♆ 10:16 pm

──── ♀♀♀ sukrobar ────

♊
♋

Friday
14

☉✶☽ 1:32 am
☽✶♂ 4:19 am
☿⊼♃ 4:28 am
☽→♋ 4:35 pm
☿⊼♆ 10:13 pm

─────────────────────────────

ALL ASPECTS IN PACIFIC DAYLIGHT TIME; ADD 3 HOURS FOR EDT; ADD 7 HOURS FOR GMT

Awakening to the Direction Called Home

She began with 8 hatchlings, but only 7 ducklings remain. Her brood follows her in a straight line, then plops awkwardly into the pond to eat bugs and algae, paddle about in safe waters. Sipping coffee, I know spying on them is the best part of my day.

Mother duck stands tall in their midst, a protective giant next to her midget hatchlings, tilting her head, watching for osprey, owls and other dangers. She lets her brood scatter, then feeds hungrily herself, ever vigilant and famished. She works so hard.

When it's time to leave, the ducklings line up to follow her, except for the most independent one, off feeding under a bush, missing the communal exodus. Realizing she's suddenly alone, the duckling panics, then frantically darts about, stridently peeping. If Mama Duck had heard, she would have surely returned for her.

My heart clenches to witness this survival drama. I want to rescue her little fuzzy body, return her to mommy. But this would terrify her, and rob her of the critical lesson: how to find her own way home.

Finally, the little lost one stands still and collects herself. Listens. Then, in this stillness it dawns on her where they often feed and she speedily heads in that direction. I begin to breathe again.

Next time I am lost, in a panic, I want to remember this tiny duckling, awaken to her deeper instinctual wisdom: stop and listen for home, then head there, straightaway. It is simply and always, awaiting my return.

□ Caryl Ann Casbon 2018

— ꜛꜛꜛsonibar —

Saturday
15

⊙⊼♇ 3:13 am
☽♂♀ 6:26 am
♅R 7:26 am
☽✶♅ 12:18 pm

— ☉☉☉ robibar —

Sunday
16

☽☌♃ 2:32 am
☽△♆ 5:28 am
☿⊼♇ 6:38 am
⊙△♂ 7:02 am
☽☌♇ 10:23 am

☽□♂ 12:32 pm
♀□♄ 4:59 pm
☽♂♄ 4:59 pm
☿△♂ 10:29 pm
☽→♌ 10:38 pm

Inviolate

I see her in the violet darkness
through billowing swirls of steam
the shadow of her strong, muscular frame
Bold against the hardened lava river bed.

I see where she called
the loyal alchemists of rock and rubble
to rise up through the fissured scars
to prepare a soft cradle of soil.

I see her unwavering stance
Arms framing a gateway
between the Heavens
and the Earth.

With one hand, her long nimble fingers
encircle the charred clay vessel
fiercely guarding
the holy ancient seeds.

The other, raised to the sky
Palm open
Praying for rain.

◻ *Sheryl J. Shapiro 2017*

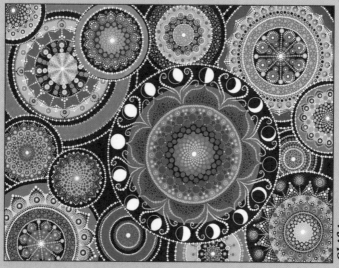

Shifting © *Mandalamy Arts 2018*

IX. 20/20 VISION
Moon IX: August 18–September 17
New Moon in ♌ Leo August 18; Sun in ♍ Virgo August 22; Full Moon in ♓ Pisces Sept. 1

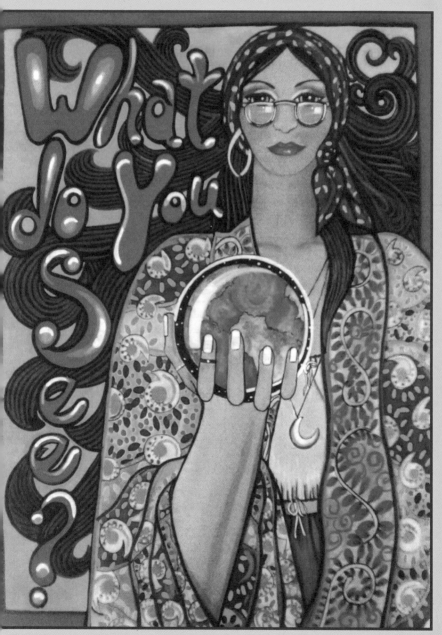

For My Mother ▢ *Penn King 2018*

August
Mí Lúnasa

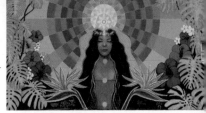

Lightworker ⌑ *Carrie Martinez 2017*

─────── ꗊꗊꗊ Dé Luain ───────

♌

Monday
17

☉♂♉ 8:07 am
☽□♅ 5:01 pm

─────── ♂♂♂ Dé Máirt ───────

♌

Tuesday
18

☿⊼♄ 2:17 am
♀✶♅ 12:28 pm
☽△♂ 4:51 pm
☉♂☽ 7:42 pm
☉⊼♄ 8:48 pm
☽♂♉ 10:38 pm

New Moon in ♌ Leo 7:42 pm PDT

─────── ☿☿☿ Dé Céadaoin ───────

♌
♍

Wednesday
19

☽→♍ 1:20 am
☿→♍ 6:30 pm
☽△♅ 6:52 pm
☽✶♀ 9:05 pm

─────── ♃♃♃ Dé Ardaoin ───────

♍

Thursday
20

☽△♃ 7:13 am
☽☍♆ 10:15 am
☽△♇ 2:48 pm
☽△♄ 8:37 pm

─────── ♀♀♀ Dé Haoine ───────

♍
♎

Friday
21

☽→♎ 2:16 am
☽PrG 3:56 am

ALL ASPECTS IN PACIFIC DAYLIGHT TIME; ADD 3 HOURS FOR EDT; ADD 7 HOURS FOR GMT

2020 Year at a Glance for ♍ Virgo (August 22–Sept. 22)

saturn and pluto have been working with you for years to create a foundation for your creative life, dear virgo—to build, day by day, a clear channel to share your radiance, gifts and talents in service of the collective. your foundations undergo a reality check january 12 when pluto and saturn meet in capricorn. any place where integrity and truth are lacking may crumble. praise! for the rebuilding can bring your soul-work and earth-work into greater alignment.

when jupiter and pluto join three times this year (april 4, june 30, and november 12), orient yourself to integrity, truth, and your greatness so these two planets can work with you. cultivate your gifts!

work with the full moon in virgo on march 9 to fine tune the routines and rituals you need, to be well in your relationships to yourself and others. allow yourself to experiment, get it wrong, and make a couple of mistakes. the less pressure you put on yourself and others, the better.

on september 17 a new moon in your sign offers an opportunity to begin again. speak what you want and find the most gentle, nourishing, and kind ways to manifest it.

by year's end, saturn and jupiter move into aquarius, your sixth house, where you offer your unique gifts to the collective from a place of service and compassion. with these two in aquarius, you will be pushed to evolve past your fears of belonging, connection, and groups so you can get to work healing your peoples.

naimonu james © mother tongue ink 2019

--- ♄♄♄ Dé Sathairn ---

♎

Saturday
22

☽□♀	1:25 am
☽□♃	7:45 am
⊙→♍	8:45 am
☽□♇	3:34 pm
☿ApH	4:56 pm
☽☌♂	8:35 pm
☽□♄	9:20 pm

Sun in ♍ Virgo 8:45 am PDT

--- ⊙⊙⊙ Dé Domhnaigh ---

♎
♏

Sunday
23

☽→♏	3:16 am
⊙⚹☽	4:35 am
☽⚹☿	3:42 pm
☽☍♅	9:00 pm

August
agosto

───── ☽☽☽ lunes ─────

 ♏︎ **Monday**
24

☿⊼♃	6:35 am
☽△♀	6:51 am
☽✶♃	9:21 am
♂□♄	11:19 am
☽△♆	12:47 pm
☽✶♇	5:35 pm
☽✶♄	11:27 pm

───── ♂♂♂ martes ─────

♏︎
♐︎ **Tuesday**
25

☽→♐︎	5:49 am
☿△♅	8:18 am
☉□☽	10:58 am
♀☍♃	3:26 pm

───── ☿☿☿ miércoles ───── Waxing Half Moon in ♐︎ Sagittarius 10:58 am PDT

 ♐︎ **Wednesday**
26

☽□☿	2:46 am
☽□♆	4:43 pm

───── ♃♃♃ jueves ─────

♐︎
♑︎ **Thursday**
27

☽△♂	5:00 am
☽→♑︎	10:37 am
♀△♆	2:12 pm
☉△☽	8:09 pm

───── ♀♀♀ viernes ─────

 ♑︎ **Friday**
28

☽△♅	5:51 am
☽△☿	5:04 pm
☽☌♃	6:56 pm
☽✶♆	10:54 pm

───────────────────────────

ALL ASPECTS IN PACIFIC DAYLIGHT TIME; ADD 3 HOURS FOR EDT; ADD 7 HOURS FOR GMT

Hear Our Vote!

Your time is up. We will weed you out—vote you out of every election large or small—from dog catcher down to president. We will show up at every election and bring others with us. We will run against your tired rhetoric with strong-woman-wisdom of hope and truth. We will tear down walls that separate us and look for that which unites humankind, and with compassion bring together a divided nation. We will work to inaugurate ethics, honesty, trust, accountability and true justice.

Bless and protect all who stand here seeking peace and justice as we continue the Great Work. Help us set our intentions for this new cycle calling to the Wisdom of the Earth and to the Wise One within to guide us. Straighten our backs and warm our hearts as we stand on this cold place.

We are women—hear our Vote!

excerpt ¤ Lyrion ApTower 2018

Editor's Note: August 26 marks the 100th Anniversary of the 19th Amendment to the US Constitution. The right of US citizens to vote "shall not be denied ... on account of sex." We honor those determined women who fought so hard to win the vote. We also recognize that women of color struggled in vain to participate in the white-dominated suffragist movement, and were denied the vote for decades in many states and communities. Still today we are fighting underhanded white supremacist tactics that suppress the votes of black and brown people. It is no wonder the dominant forces continue to resist an open democratic process fiercely: They know that the power of the people can, and will, topple racist systems and patriarchy's control of the social order.

© Mother Tongue Ink 2019

––––––––– ꜧꜧꜧ sábado –––––––––

Saturday
29

☽☍♀	1:50 am	☽☌♄	10:18 am
☽☌♇	4:12 am	☽☐♂	12:31 pm
♀△♃	6:28 am	☽→♒	5:37 pm

––––––––– ☉☉☉ domingo –––––––––

Sunday
30

♀☍♇	6:31 am	
♀☍♆	11:44 am	
☽☐♅	1:31 pm	

August / September

bā yuè / jiǔ yuè

—————))) xīng qī yī —————

≈

Monday
31

☉⽊♇ 1:54 am
☽⚹♂ 9:56 pm

————— ♂♂♂ xīng qī èr —————

≈
♓

Tuesday
1

September

☽→♓ 2:34 am
☿△♇ 3:42 am
☉☍☽ 10:22 pm
☽⚹♅ 11:04 pm

Full Moon in ♓ Pisces 10:22 pm PDT

————— ☿☿☿ xīng qī sān —————

♓

Wednesday
2

♀☍♄ 5:17 am
☉△♅ 7:09 am
☽⚹♃ 12:48 pm
☽☌♆ 5:09 pm
☽⚹♇ 10:55 pm

————— ♃♃♃ xīng qī sì —————

♓
♈

Thursday
3

☿△♄ 12:22 am
☽⚹♄ 5:10 am
☽☍♅ 5:56 am
☽△♀ 7:34 am
☽→♈ 1:22 pm

————— ♀♀♀ xīng qī wǔ —————

♈

Friday
4

♀□♂ 2:12 am
☿⽊♂ 6:15 am
☿⚹♀ 1:32 pm

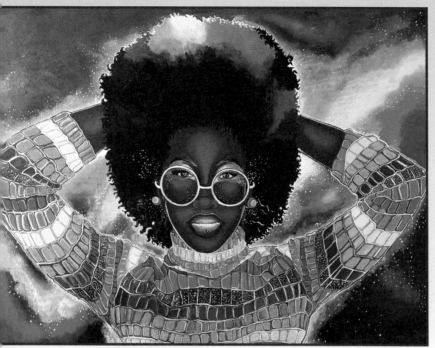

Colorful Queen © *Destiney Powell 2017*

♈ 🌘 Saturday
5

☽□♃ 12:26 am ☽□♄ 5:09 pm
☽□♇ 10:54 am ☽♂♂ 9:45 pm
♀→♎ 12:46 pm ☽ApG 11:26 pm

♈ 🌘 Sunday
♉ 6

♀→♌ 12:21 am
☽→♉ 1:43 am
☽□♀ 1:52 am
☽♂♅ 11:00 pm

September
Bhadro

The Unsolved Puzzle

——— ☽☽☽ sombar ———

♉

Monday
7

⊙△☽ 9:09 am
☽△♃ 1:08 pm
☽⚹♆ 5:35 pm
☽△♇ 11:39 pm

——— ♂♂♂ mongolbar ———

♉
♊

Tuesday
8

☽△♄ 5:46 am
☽→♊ 2:27 pm
☽⚹♀ 8:41 pm

——— ☿☿☿ budhbar ———

♊

Wednesday
9

☽△☿ 1:38 am
⊙△♃ 9:04 am
♂R 3:22 pm

——— ♃♃♃ brihospotibar ———

♊

Thursday
10

⊙□☽ 2:26 am
☽□♆ 5:16 am
☿☌♅ 3:24 pm
♆PrH 5:44 pm
☽⚹♂ 9:48 pm

Waning Half Moon in ♊ Gemini 2:26 am PDT

——— ♀♀♀ sukrobar ———

♊
♋

Friday
11

☽→♋ 1:22 am
⊙☌♆ 1:26 pm
☽□☿ 7:49 pm
☽⚹♅ 8:57 pm

———

ALL ASPECTS IN PACIFIC DAYLIGHT TIME; ADD 3 HOURS FOR EDT; ADD 7 HOURS FOR GMT

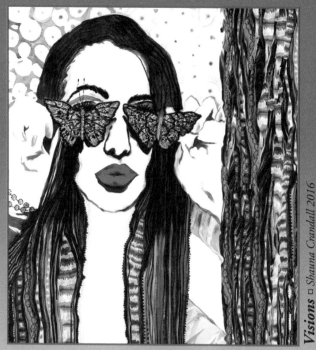

Visions ¤ Shauna Crandall 2016

Stand for the Divine

Know this deeply in your body: *The game is not over!*
You have seen the weeds breaking though concrete,
You have seen bravery in the darkest hour,
You have seen the walls fall down.
You know that there is power and magic in the Divine.

excerpt © Patricia Dines 2016

ካካካ sonibar

♋

Saturday
12

♉⊼♅	5:34 am	⊙⚹☽	3:44 pm
☽☍♃	9:54 am	♃D	5:41 pm
☽△♆	1:45 pm	☽☍♇	7:19 pm

⊙⊙⊙ robibar

♋
♌

Sunday
13

☽☍♄	12:37 am
♀△⚹	4:25 am
☽□♂	5:05 am
☽→♌	8:32 am
☽♂♀	11:53 pm

Reclaiming

We are the descendants of generations of women who were told that they were sinful or crazy. We are the descendants of generations of women who were not believed. We are the descendants of the women who had to hide their ability to heal, on pain of death.

This is the time of reclaiming.

We are reclaiming the lost Feminine and birthing it through our shame-less female bodies, into the modern world. We are reclaiming lost Feminine voices and self-expression, and listening to them at last. We are reclaiming our communities as places where these values are cherished. We are reclaiming our magic.

We are reclaiming healing ritual. We are reclaiming our intuition as a valid and necessary way of knowing. We are reclaiming our connections with each other, the natural world, and directly to soul and spirit. We are reclaiming a direct connection to our own life force. We are reclaiming the wholeness of ourselves—our lightness and our dark.

We are reclaiming the traditions of our people—forgotten, punished, ignored, supplanted—gratefully relearning the ways

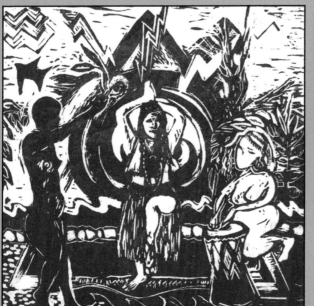

of other healers, from those who have kept their traditions alive against all odds, through times of peril.

In this, the time of the great unraveling, it is time to reclaim our birth-right.

© *Lucy H. Pearce*
2018

Wild Women
© *Sara Steffey McQueen*
2011

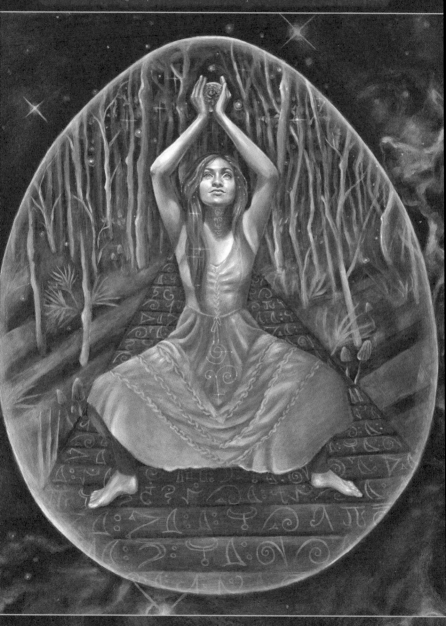

We Are The Ones We Have Been Waiting For

© Emily Kell 2016

September
Mí Meán Fomhair

───── ☽☽☽ Dé Luain ─────

♌

Monday
14

☽□♅ 2:33 am
☽⚹☿ 7:53 am
☉△♇ 4:09 pm

───── ♂♂♂ Dé Máirt ─────

♌
♍

Tuesday
15

☽△♂ 8:09 am
♀□♅ 8:29 am
☽→♍ 11:37 am

───── ☿☿☿ Dé Céadaoin ─────

♍

Wednesday
16

☽△♅ 4:24 am
☽△♃ 3:54 pm
☽☍♆ 7:03 pm

───── ♃♃♃ Dé Ardaoin ─────

♍
♎

Thursday
17

☽△♇ 12:06 am
☿□♃ 3:34 am
☉☌☽ 4:00 am
☽△♄ 4:42 am
☽→♎ 11:56 am
☉△♄ 2:36 pm

New Moon in ♍ Virgo 4:00 am PDT

───── ♀♀♀ Dé Haoine ─────

♎

Friday
18

☽PrG 6:51 am
☽⚹♀ 9:41 am
☿⚻♆ 1:05 pm
☽□♃ 3:35 pm
☽☌♅ 7:08 pm
☽□♇ 11:39 pm

───────────────────

ALL ASPECTS IN PACIFIC DAYLIGHT TIME; ADD 3 HOURS FOR EDT; ADD 7 HOURS FOR GMT

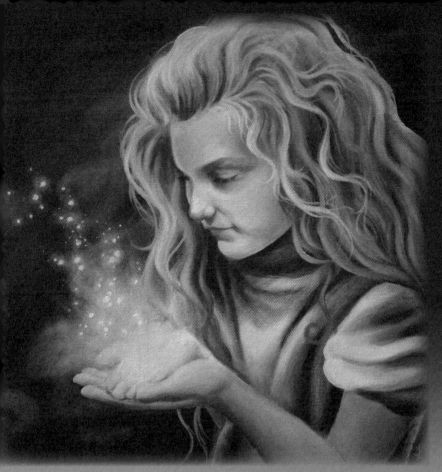

I Opened It © A. Levemark 2010

♎
♏

Saturday
19

☽□♄ 4:14 am
☽☍♂ 7:29 am
☽→♏ 11:33 am
☉⊼♂ 2:55 pm

♏

Sunday
20

☽☍♅ 3:56 am
☽□♀ 1:42 pm
☽⚹♃ 3:51 pm
☽△♆ 6:47 pm
♀□♇ 10:21 pm

MOON X 141

Fall Equinox

Perfect balance returns, light and dark in harmony again for the final harvest. As we wheel in the last-lit days of seasonal symmetry, face the coming darkness together with gratitude for what we've learned about light. Autumn's grain is spring's seed; paradox surrounds us with ripening wisdom. If we lose hope, remember that Hope has two daughters to support our balancing acts: Anger and Courage. Instead of passive hope, embrace radical willingness. The good news is that an organism under attack creates blooming antibodies, devoted to restoring original health to the world's immune system. Activists are that devotion.

The season of barrenness mists her breath on our windowpanes—a foreshadowing—yet we're full of our gathering visions. What holds you back? Every minus is a plus that just needs a stroke of vertical awareness. Awake, ask what do you want to harvest into your life? Find the courage to move forward into action. Science and love, the two most powerful poles of humanity have been so fiercely separated. The truth is, we're all connected; the greatest disability is, we don't believe this. Believe it. Practice powerful participation in the great circus of life. Find balance on the wild trapeze.

Oak Chezar © Mother Tongue Ink 2019

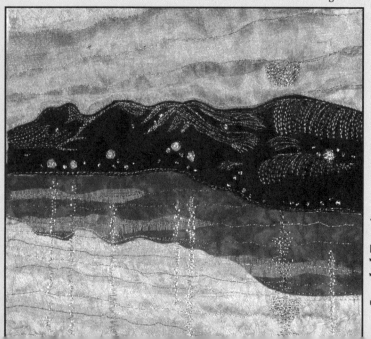

Jeweled Evening © Winter Ross 2002

The Gatherer © Chantel Camille 2018

A Hag's Guide to Spring Cleaning

Scrub your skin with the dirt from a hollow hill. Brush your body with raven feathers and the blessings of a million hags gone before who have never given a shit about what looks "nice" to others.

Take all the pots and pans out of your kitchen, clean them with black salt, and bring them outside with your spoons and knives. Make a racket to wake up the earth and let the neighbors know that their local hag has woken up from winter slumber.

Water your garden with the tears shed by those suffering from fragile masculinity to help them grow towards their heart instead of their fear.

Stitch up your worn out clothes with the red thread of intersectionality and luck. Scare the life back into your heart by grinning so loudly in the mirror that you can see every tooth, fang, and monster song gurgling forth from the back of your throat.

Go to a crossroads, turn to the east, and spit three times so that you never forget how to find your way back. Stain your lips and fingers with the blood of berries. Braid thorns into your hair and rub rose dust into your eyebrows.

Never say you're sorry for making it to another spring. Cackle instead and celebrate the ugly bits that have kept you alive.

Lace up your boots with the stories of your ancestors raging against powers they were told were unbreakable but have long turned to dust.

Greet your witchen kin with right hands grasped, left hand over the heart of the other, foreheads touching. Breath in, breath out. Say, "I fucking love you." Remember that hags like you grow like weeds and springtime will never be the same.

¤ *L. Sixfingers 2018*

Sending witchen kin greetings to our sister hags celebrating Spring in the southern hemisphere.

September
septiembre

───── ☽☽☽ lunes ─────

Monday
21

♏︎
♐︎

☽⚹♇ 12:07 am
☽⚹♄ 4:50 am
☉⚹☽ 11:13 am
☽→♐︎ 12:32 pm
♀⚻♃ 6:12 pm

───── ♂♂♂ martes ─────

Tuesday
22

♐︎

☉→♎︎ 6:31 am
☽△♀ 8:34 pm
☽□♆ 9:20 pm

Fall Equinox

Sun in ♎︎ Libra 6:31 am PDT

───── ☿☿☿ miércoles ─────

Wednesday
23

♐︎
♑︎

☿□♄ 3:38 am
♀⚻♆ 5:45 am
☽⚹☿ 8:31 am
☽△♂ 10:31 am
☽→♑︎ 4:16 pm
☉□☽ 6:55 pm

Waxing Half Moon in ♑︎ Capricorn 6:55 pm PDT

───── ♃♃♃ jueves ─────

Thursday
24

♑︎

☿☍♂ 3:53 am
☽△♅ 10:20 am

───── ♀♀♀ viernes ─────

Friday
25

♑︎
♒︎

☽☌♃ 12:11 am
☽⚹♆ 3:00 am
☽☌♇ 9:09 am
☽☌♄ 2:26 pm
☽□♂ 4:12 pm
☽□☿ 8:36 pm
☽→♒︎ 11:08 pm

ALL ASPECTS IN PACIFIC DAYLIGHT TIME; ADD 3 HOURS FOR EDT; ADD 7 HOURS FOR GMT

2020 Year at a Glance for ♎ Libra (Sept. 22–Oct. 22)

pluto joins saturn on january 12 in your fourth house of home, roots, and family. what is home to you? where is it? and how hard are you willing to work to (re)build it? there is deep, visceral work for you to do here, work that will support you in creating truly nourishing homes and familial environments. jupiter and capricorn join three times in 2020 (april 4, june 30, and november 12) to help shift the ways you relate to home, security, belonging and family.

the full moon in your sign falls on april 7. (re)strengthen your boundaries and deal with any relationship ish that rises up. are you able to find home in your beloveds, friends, and community? begin again on the new moon in your sign on october 16, remember this life is yours to co-create with the divine!

by year's end, saturn and jupiter move into aquarius, your fifth house where you learn to balance your obligation to the collective with your obligation to your joy. both are important. is there a way you can bring them into alignment? dissolve any fears of belonging so you can get out of your heart's way and live in alignment with its desires.

naimonu james © mother tongue ink 2019

Mwelu (Inner Light)
© Jenny Hahn 2011

ካካካ sábado

♒ ◑ Saturday
26

♀⚻♇ 2:22 am
☉△☽ 6:30 am
☽□♅ 6:01 pm

☉☉☉ domingo

♒ ◑ Sunday
27

☿→♏ 12:40 am
☽☍♀ 10:04 pm

September / October

jiǔ yuè/ shí yuè

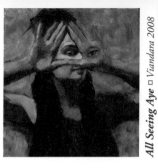

All Seeing Aye ▫ Viandara 2008

——— ☽☽☽ xīng qī yī ———

≈
ℋ

Monday
28

☽⚹♂ 12:17 am
☽→ℋ 8:34 am
⚷PrH 8:42 am
☽△♀ 11:44 am
♀♄♄ 1:23 pm
♀△♂ 6:01 pm
♄D 10:11 pm

——— ♂♂♂ xīng qī èr ———

ℋ

Tuesday
29

☽⚹♅ 3:58 am
☉☍⚷ 1:44 pm
♂□♄ 2:49 pm
☽⚹♃ 7:40 pm
☽☌♆ 10:00 pm

——— ☿☿☿ xīng qī sān ———

ℋ
♈

Wednesday
30

☽⚹♇ 4:50 am
☽⚹♄ 10:29 am
☽→♈ 7:47 pm

——— ♃♃♃ xīng qī sì ———

♈

Thursday
1

October

☉☍☽ 2:05 pm

Full Moon in ♈Aries 2:05 pm PDT

——— ♀♀♀ xīng qī wǔ ———

♈

Friday
2

☉♄♅ 6:31 am
☽□♃ 7:58 am
♀→♍ 1:48 pm
☽□♇ 5:00 pm
☽☌♂ 8:57 pm
☽□♄ 10:47 pm

ALL ASPECTS IN PACIFIC DAYLIGHT TIME; ADD 3 HOURS FOR EDT; ADD 7 HOURS FOR GMT

Remembering Cassandra

We have imbibed the story of Cassandra subconsciously. You may never have heard her legend before in your classroom or at your grandmother's knee, I certainly hadn't. But we know it in our bones.

Cassandra was a woman who was gifted by Apollo with the ability to prophesy. She spoke aloud what was going to happen. But no one believed her prophecies: they were too disturbing to the comfortable reality of those around her. And so she was confined to the care of a warden, driven mad from being disbelieved. Again and again she warned them . . . *Something's wrong. Something's very wrong.*

But they did not listen. The painful irony was that it was not really the truth that people could not heed. It was that it came through the body and voice of a woman. That was unbearable.

You see, Cassandra instructed her twin brother in the power of prophecy. Unlike his sister, people believed him. People listened to him when he said: *Something's wrong. Something's very wrong.*

We are the Cassandras of our world, gifted with highly sensitive bodies that feel what the System would have us ignore. We have been taught to distrust our own body systems, to distrust our inner knowing. We have internalized the message that there's something wrong with *us*, rather than that there is something wrong in the world.

Listen carefully. *Something is wrong. Something's very wrong.* It's time for us to believe ourselves and rewrite the story with this knowing.

© *Lucy H. Pearce 2018*

�324 xīng qī liù

♈
♉ Saturday
 3

☽→♉ 8:12 am
☽△♀ 10:13 am
☽ApG 10:21 am
☽☍♀ 10:17 am
♉⊼♂ 10:55 pm

☉☉☉ lǐ bài rì

♉ Sunday
 4

☽♂♅ 3:59 am
♇D 6:32 am
☽△♃ 9:07 pm
☽⚹♆ 10:37 pm

October

Ashshin

Remedies © *Darlene Cook 2018*

☾☾☾ sombar ────────────

♉
♊

Monday
5

☽△♇ 5:50 am
☽△♄ 11:41 am
☽→♊ 9:03 pm

♂♂♂ mongolbar ─────────────────

♊

Tuesday
6

☽□♀ 5:41 am
♂PrH 7:00 am

☿☿☿ budhbar ──────────────────

♊

Wednesday
7

☉△☽ 2:18 am
☽□♆ 10:51 am
☿☍♅ 1:56 pm
☽✶♂ 6:57 pm

♃♃♃ brihospotibar ────────────────

♊
♋

Thursday
8

♀⚻♀ 8:18 am
☽→♋ 8:45 am
☽✶♀ 11:16 pm

Time to order We'Moon 2021!
Free Shipping within the US October 8-13th!
Promo Code: Lucky13 www.wemoon.ws

♀♀♀ sukrobar ──────────────

♋

Friday
9

☽✶♅ 3:14 am
☽△♉ 5:03 am
♂□♇ 6:09 am
☉□☽ 5:39 pm
☽☍♃ 8:17 pm
☽△♆ 8:43 pm

Waning Half Moon in ♋ Cancer 5:39 pm PDT

ALL ASPECTS IN PACIFIC DAYLIGHT TIME; ADD 3 HOURS FOR EDT; ADD 7 HOURS FOR GMT

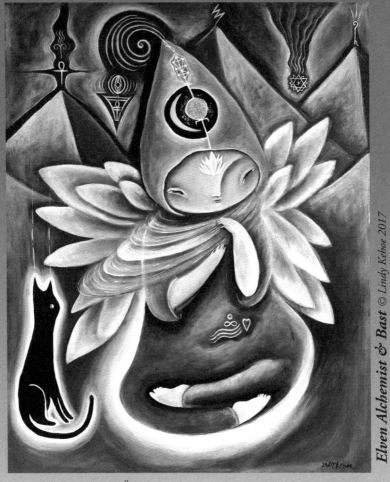

Elven Alchemist & Bast © *Lindy Kehoe 2017*

♋
♌

Saturday
10

☽□♂ 3:05 am
☽☍♇ 3:36 am
☽♂♄ 9:04 am
♀△♅ 4:08 pm
☽→♌ 5:24 pm

♌

Sunday
11

☉□♃ 6:34 am
☉⊼♆ 8:30 am
☽□♅ 10:27 am
☽□♉ 1:50 pm

October
Mí Deireadh Fomhair

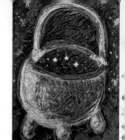

Cauldron

ⅮⅮⅮ Dé Luain ————————

♌
♍

Monday
12

♃ ✶ ♆ 12:06 am
☉ ✶ ☽ 4:09 am
☽ △ ♂ 7:29 am
☿ ✶ ♀ 9:39 am
☽→♍ 9:56 pm

—————— ♂♂♂ Dé Máirt ——————

♍

Tuesday
13

☽ △ ♅ 1:35 pm
☉ ☍ ♂ 4:26 pm
☽ ✶ ♇ 5:19 pm
☿ R 6:05 pm
☽ ☌ ♀ 7:55 pm

—————— ☿☿☿ Dé Céadaoin ——————

♍
♎

Wednesday
14

☽ ☍ ♆ 4:47 am
☽ △ ♃ 5:12 am
☽ △ ♇ 10:55 am
☽ △ ♄ 3:47 pm
☽→♎ 10:54 pm

—————— ♃♃♃ Dé Ardaoin ——————

♎

Thursday
15

☉ ☐ ♇ 3:15 am

—————— ♀♀♀ Dé Haoine ——————

♎
♏

Friday
16

☽ ☐ ♃ 5:06 am
☽ ☍ ♂ 6:49 am
☽ ☐ ♇ 10:22 am
☉ ☌ ☽ 12:31 pm
☽ ☐ ♄ 3:11 pm
☽ PrG 5:00 pm
☽→♏ 10:05 pm

New Moon in ♎ Libra 12:31 pm PDT

ALL ASPECTS IN PACIFIC DAYLIGHT TIME; ADD 3 HOURS FOR EDT; ADD 7 HOURS FOR GMT

Remember Witch, Remember

Take your feathers, leaves, and bones.
Add to them your roots, your stones.
Mix them in your cauldron's womb.
Dance for rain and add that, too.
Your time is now, each heartbeat rings:
Remember Witch, Remember.

You know the way, you know the song.
You've walked this path your whole life long.
Drumbeat sounding, heartbeat pounding
The Ones before you, love resounding.
With every turn of season, moon
With every deosil swirl of spoon
You chant the words, you hum the tune:
Remember Witch, Remember.

The stars are out, your feet are bare.
Your arms are raised into the air.
No one told you what to do.
You knew the way, the Way knows you.
So let it go. Release it down.
Heart and blood and bones to ground:
Remember Witch, Remember.

☐ *Brandi Woolf 2017*

ᚻᚻᚻ Dé Sathairn

♏ Saturday
17

☽☍♅	12:37 pm
☽☌☿	2:52 pm

☉☉☉ Dé Domhnaigh

♏ ♐ Sunday
18

☽⚹♀	3:05 am	☽⚹♇	9:42 am
☽△♆	3:28 am	☽⚹♄	2:43 pm
☽⚹♃	4:39 am	☽→♐	9:43 pm
☉□♄	6:58 am	♂□♃	10:37 pm
♀☍♆	7:49 am		

A swirling mist rises as they descend and as they arise. They arrive cloud-hewn and dew-drenched from their travels through time, culture, and place at a convergence of lake, river, stream, and ocean. They ride oak brooms and lope in on shining braided horses. They whirl dervish on air streams and whoosh in on flying tapestries. Some ride chariots ablaze, some themselves not cloaked in purely human bodies, their fur ruffed from the long travels. Some are carrying the serenade songs of the holy waters, some bring the healing balm.

Some appear as black rock mothers, volcanoes, earth emerging. Others, ancient crones, wrinkles crazed with passion, savvy, and wisdom accompany fresher faces that shine with a resonant ardor, desire to share learning, and activate wisdom. Some carry babes in their arms or starmilk on the breast, while others heft lightning, arrows, balsam, or doves as they groundswell. The stars shine brightly from within, among, and upon this growing convergence.

Paints fly out across sacred texts, forming words. Strings, flutes, and tambourine delight and ripple out: music in a welcome echoes in the constellations. Women and goddesses awaken, on the move, converge. A bridgework forms from our worlds to this exceptional convergence. These sentinels—the wisdom carriers, the path blazers, summoners, stokers of powers, old friends, world makers, heart tenders, catalysts of gifts—turn to welcome us and crowd the bridge from their realms to ours.

<div align="right">◻ marna 2013</div>

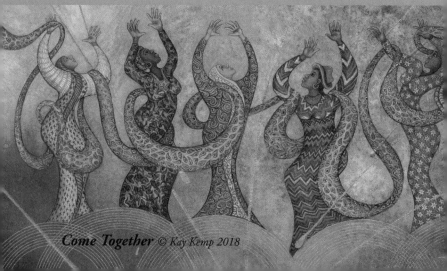

Come Together © Kay Kemp 2018

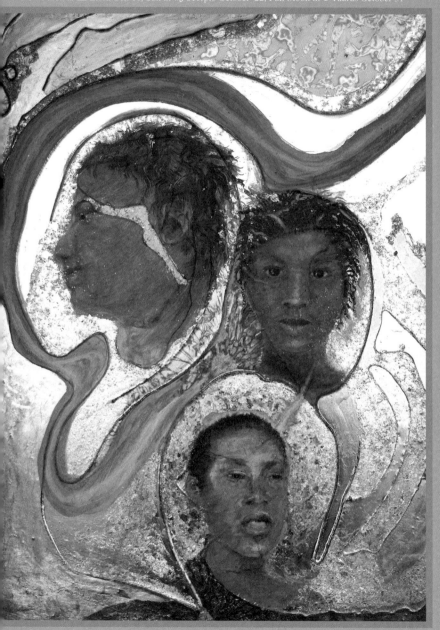

Highest Tracts of Soul © *Ruth Gourdine 2016*

October
octubre

Cry of the Raven
© *Pat Malcolm 2007*

─────── ☽☽☽ lunes ───────

Monday
19

♀☌♂ 12:03 am
♀△♃ 12:35 am
☿☍♅ 7:53 pm

─────── ♂♂♂ martes ───────

Tuesday
20

☽□♆ 4:19 am
☽△♂ 5:08 am
☽□♀ 8:28 am
☉⚹☽ 8:38 pm
☽→♑ 11:44 pm

─────── ☿☿☿ miércoles ───────

♑

Wednesday
21

☽⚹☿ 12:49 pm
♀△♇ 2:42 pm
☽△♅ 3:32 pm

─────── ♃♃♃ jueves ───────

Thursday
22

☽□♂ 8:16 am
☽⚹♆ 8:23 am
☽☌♃ 10:44 am
☽☌♇ 3:40 pm

☉→♏ 3:59 pm
☽△♀ 6:09 pm
☿☍♅ 6:34 pm
☽☌♄ 9:35 pm

Sun in ♏ Scorpio 3:59 pm PDT

─────── ♀♀♀ viernes ───────

Friday
23

☽→♒ 5:17 am
☉□☽ 6:23 am
☽□☿ 2:49 pm
☽□♅ 10:02 pm

Waxing Half Moon in ♒ Aquarius 6:23 am PDT

ALL ASPECTS IN PACIFIC DAYLIGHT TIME; ADD 3 HOURS FOR EDT; ADD 7 HOURS FOR GMT

2020 Year at a Glance for ♏ Scorpio (Oct. 22–Nov. 21)

saturn and pluto have been working with you for years to take responsibility for your words and thoughts. as above, so below. as within, so without. what you think and speak is what will come to be! listen on january 12, when pluto and saturn join in your third house of listening, sharing and the mind. what lessons are pouring through? open yourself to new thoughts and new words. keep going, keep grounding, keep breathing.

jupiter meets pluto three times in 2020 (april 4, june 30, and november 12). cut away words, thoughts and actions that block your blessings. if you yearn to shift your external reality, start with your inner mindscapes.

the full moon in your sign falls on may 7; be dynamic in your commitments and imbue them with your life energy and attention. begin again on the new moon in your sign november 14. what new terrain are you ready to navigate?

by year's end, saturn and jupiter move into aquarius, your fourth house, where you create foundations for the collective to thrive. empower yourself as an innovative builder of family, community and space. you may be called to be a warrior for your people and to protect those who need shelter and care. there is no other better suited for this work, dear scorpio.

naimonu james © mother tongue ink 2019

© Sudie Rakusin 1992

───── ♄♄♄ sábado ─────

≈ Saturday
24

♀PrH 4:10 am
♀△♄ 8:40 am
☽⚹♂ 2:54 pm

───── ☉☉☉ domingo ─────

≈ ♓ Sunday
25

☉♂♀ 11:23 am
☽→♓ 2:18 pm
☽△♀ 6:59 pm
☉△☽ 8:30 pm

October

shí yuè

♓

Monday

26

☽✶♅ 7:44 am

♓

Tuesday

27

☽☌♆ 2:40 am
☽✶♃ 6:38 am
☽✶♇ 10:58 am
☽✶♄ 5:46 pm
☿→♎ 6:33 pm
♀→♎ 6:41 pm

♓
♈

Wednesday

28

☽→♈ 1:44 am
☽☍♀ 2:32 am
☉⚻♂ 2:32 pm

♈

Thursday

29

☽☌♂ 11:33 am
☽□♃ 7:39 pm
☽□♇ 11:26 pm

♈
♉

Friday

30

☽□♄ 6:30 am
☽☍♅ 9:12 am
☽ApG 11:43 am
☽→♉ 2:19 pm
♅PrH 10:22 pm

Samhain

The witches' new year. Time when the fields lie empty and the year lies down. The gates of life swing open, the dead lean in. Our world's veil is at its thinnest; we peer through the lace to find that growing edge. We meet in Deep Time, everywhere and nowhere, to greet the triple goddess who is the circle of rebirth. Over one shoulder lean the ancestors; over the other, unborn future beings peer. Remember this: we are 4 billion years old. It's taken evolution all this time to produce us, and our action will express that genius. We're an unfinished animal, fighting metaphysical battles in the physical world; flesh and breath in confrontation with abstractions. This is the battle of the human epic. Modern stories of our powerful vision express a reclaimed, authentic future, a remedy. Exalt in the never-ending journey of change. Seed becomes fruit. Fruit becomes seed. The beloved dead surround us, calling us to use our lives while we can in the service of the bigger life. The unborn future crowds 'round, waiting. It's up to us. This chaos is a seedbed for the future.

Oak Chezar © Mother Tongue Ink 2019

I am You © Qutress 2018

Outraged Ancestral Mother Prayer

Outraged Ancestral Mother
fill my veins
with your singing

Sweep me up.
Stir my passion
until I might be worthy
of your chorus
of enraged beauty.

Embed your
call for action in my feet
that I may never again
walk in thoughtlessness
or inattention
each step becoming
a beat of your drum.

I will howl with you
in the hurricane's roar
and the tornado's fury

I will crack my lightning
and split my life open
gaze at the red
pomegranate seeds within
and I will eat
Knowing that
some part of me
will belong
in the underworld
forever.

Lash the remainder
of my heart
to hope
bind my heartstrings
around destiny
and open my throat
that I might bellow
on the winds of change
and inspiration . . .

© Molly Remer 2013

Moondancer
© Debra Hall 2016

Ancestral Healing

It is liberating
to consider that
when we heal
an ancestral pattern,
we are not only freeing
future generations,
but healing backwards
through time,
liberating all those souls
who were left
unresolved,
unforgiven
and misunderstood.

excerpt from Belonging:
Remembering Ourselves Home ©
Toko-pa Turner 2017

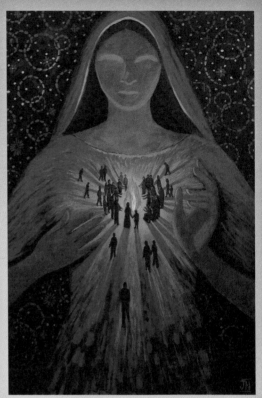

Refuge © *Jenny Hahn 2016*

♉ **Saturday**
31

Samhain

⊙☍☽ 7:49 am
☽☌♅ 7:55 am
⊙☍♅ 8:53 am

Full Moon in ♉ Taurus 7:49 am PDT

♉ **Sunday**
1

November

☽⚹♆ 2:31 am ☽△♇ 11:14 am
☽△♃ 8:07 am ♀☍♅ 11:55 am
☿☌♅ 11:12 am ☽△♄ 6:29 pm

Daylight Saving Time Ends 2:00 am PDT

MOON XI

November
Kartik

© Shelley Anne Tipton Irish 2009

Surrender

─── ☽☽☽ sombar ───

♉
♊

Monday
2

☽→♊ 2:00 am
☽△♀ 4:31 pm

─── ♂♂♂ mongolbar ───

♊

Tuesday
3

☿D 9:50 am
☽✱♂ 9:56 am
☽□♆ 2:43 pm
♀⚹♅ 6:22 pm

─── ☿☿☿ budhbar ───

♊
♋

Wednesday
4

☽△☿ 5:48 am
☽→♋ 1:45 pm

─── ♃♃♃ brihospotibar ───

♋

Thursday
5

☽✱♅ 6:18 am
☽□♀ 10:22 am
☉△☽ 5:07 pm
☽□♂ 8:08 pm

─── ♀♀♀ sukrobar ───

♋
♌

Friday
6

☿□♄ 1:08 am
☽△♆ 1:13 am
☽☍♃ 8:00 am
☽☍♇ 9:41 am
☽☍♄ 4:52 pm
☽□☿ 5:26 pm
☽→♌ 11:18 pm

ALL ASPECTS IN PACIFIC STANDARD TIME; ADD 3 HOURS FOR EST; ADD 8 HOURS FOR GMT

Missing You

What would a celebration
of women be
without holding space
for the absence
of you? All of you.

You, who were taken
leaving no trace but
the salt of our tears.
It has been years, yet
all the red tape
in the nation
will not silence
this endless grief.

Her auntie said that red
is the only colour
the spirits can see.
So this is my bleeding
invitation
to attend,
to witness,
to be among
celebrated women,

to know
you are honoured,
to know
you are missed.

In 2010, artist Jaime Black from Winnipeg, Manitoba started "The REDress Project." Empty red dresses were installed in public spaces, symbolizing murdered and missing indigenous women. "The REDress Project" installations and individual art pieces of all media have continued to demand attention across my nation.

© *Janis McDougall 2017*

--- ꓭꓭꓭ sonibar ---

♌

Saturday
7

☉⚹♂ 3:41 am
☽□♅ 2:49 pm

--- ๐๐๐ robibar ---

♌

Sunday
8

☽⚹♀ 12:36 am
☽△♂ 3:39 am
☉□☽ 5:46 am

Waning Half Moon in ♌ Leo 5:46 am PST

November
Mí na Samhna

Doña Rosa

---- ☽☽☽ Dé Luain ----

♌
♍

Monday
9

☽✶♅	3:04 am
☽→♍	5:30 am
♀☍♂	8:08 am
☽△♅	7:50 pm
☉△♆	9:11 pm

---- ♂♂♂ Dé Máirt ----

♍

Tuesday
10

☽☍♆	12:42 pm
☉✶☽	1:53 pm
☿→♏	1:56 pm
☽△♃	7:55 pm
☽△♇	8:20 pm

---- ☿☿☿ Dé Céadaoin ----

♍
♎

Wednesday
11

☽△♄	2:58 am
☽→♎	8:09 am
♀⊼♆	4:31 pm

---- ♃♃♃ Dé Ardaoin ----

♎

Thursday
12

☽☍♂	8:50 am
♃♂♇	1:39 pm
☽♂♀	3:31 pm
☽□♇	9:00 pm
☽□♃	9:04 pm

---- ♀♀♀ Dé Haoine ----

♎
♏

Friday
13

☽□♄	3:32 am
☽→♏	8:19 am
☽♂☿	1:44 pm
♂☽	4:36 pm
☽☍♅	9:10 pm

ALL ASPECTS IN PACIFIC STANDARD TIME; ADD 3 HOURS FOR EST; ADD 8 HOURS FOR GMT

I Will Fling My Wanton Heart

I will fling my wanton heart, with every fiber of my being,
to touch the face of distant stars
I will dream the happiness life and live the happiness dream
I will live like an expanding universe and pop black holes like candy
hitch rides on shooting stars, travel in caravans of light
I will spiral through the galaxies, go skinny dipping in the Milky Way
I will fly into the sun
just to see how it's done

the crone's life may seem to be a shrinking
a quieting, a disengaging into stillness and resignation
a withdrawl to small, as one awaits the fading light
and the closing of the curtain
but, no.

the crone, in her marrow, knows otherwise
tends her inner garden
like an astronaut preparing for missions in space
the heart cannot but expand like the universe itself
reaching outward, forever reaching outward
with love, with resilience, with gratitude, into spirit
into the realms, into the domains of spirit
I will fling my wanton heart, with every fiber of my being,
to touch the face of distant stars

¤ *Shelley Blooms 2018*

ᚻᚻᚻ Dé Sathairn

♏︎ Saturday 14 Lunar Samhain

☽PrG 3:43 am
☉✶♇ 11:48 am
☽△♆ 1:05 pm
☉✶♃ 7:57 pm

☽✶♇ 8:31 pm
☽✶♃ 9:03 pm
☉☌☽ 9:07 pm

New Moon in ♏︎ Scorpio 9:07 pm PST

☉☉☉ Dé Domhnaigh

♏︎ Sunday 15
♐

♅⊼♂ 1:35 am
☽✶♄ 3:13 am
☽→♐ 7:47 am
♀□♇ 11:43 am
♀□♃ 9:33 pm

Awaken

We are in the wake
of a great shifting
awaken

you better free your mind
before they illegalize thought

there's a war going on
the first casualty was truth
and it's inside you

the universe is counting on
our belief that faith
is more powerful than fear

and that in
the shifting moment
we'll all remember
why we're here

in a world
where you're assassinated
for having a dream
and the rich
spend 9 billion a year
to control our ideas
and visions are televised
so things aren't what they seem

we gotta believe
in a world where
there's room enough
for everyone
to breathe

we were born right now
for a reason
we can be whatever
we give ourselves
the power to be
and right now we need

day dreamers
 gate keepers
 truth speakers
 light bearers
bridge builders
 web weavers
 food growers
 wound healers
trail blazers
 cage breakers
 life lovers
 peace makers

give what you most deeply
desire to give
every moment
you are choosing to live
or you are waiting

why would a flower
hesitate to open?
now is the only moment

rain drop
let go
become the ocean

excerpt from Climbing PoeTree, *Whit Press (2015)*
© *Naima Penniman, Climbing PoeTree. Used by permission of Whit Press*

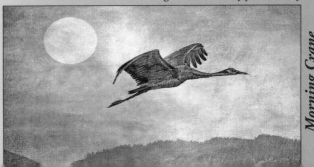

Morning Crane
© *Lyndia Radice 2018*

XII. LIBERATION
Moon XII: November 14–December 14
New Moon in ♏ Scorpio Nov. 14; Sun in ♐ Sagittarius Nov. 21; Full Moon in ♊ Gemini Nov. 30

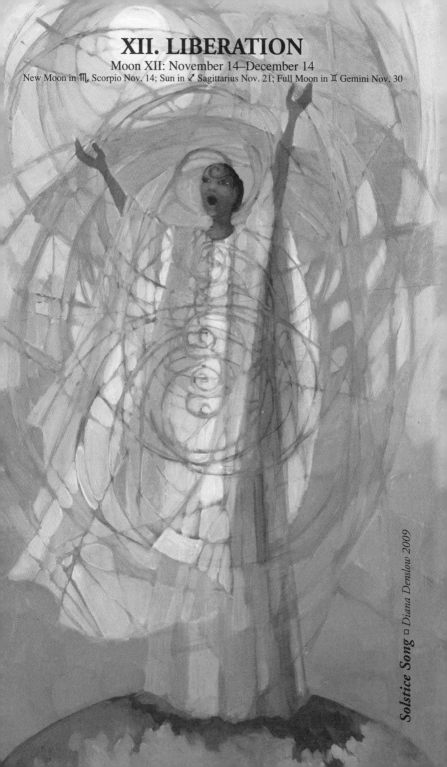

Solstice Song □ *Diana Denslow 2009*

November
noviembre

―――――― ༉ lunes ――――――

 ♐

Monday
16

☽△♂ 8:21 am
☽□♆ 1:06 pm
☽⚹♀ 11:54 pm

***Shine Your Light for
the Whole World to See***

―――――― ♂♂♂ martes ――――――

 ♐
♑

Tuesday
17

☿⚋♅ 12:07 am
☽→♑ 8:35 am
☽△♅ 10:00 pm

―――――― ☿☿☿ miércoles ――――――

 ♑

Wednesday
18

☽⚹☿ 12:31 am
☽□♂ 10:42 am
☽⚹♆ 3:34 pm
☉⚹♄ 11:17 pm
☽♂♇ 11:58 pm

―――――― ♃♃♃ jueves ――――――

 ♑
♒

Thursday
19

☽♂♃ 1:43 am
♀□♄ 3:28 am
☽♂♄ 7:51 am
☽□♀ 8:16 am
☉⚹☽ 8:30 am
☽→♒ 12:25 pm

―――――― ♀♀♀ viernes ――――――

♒

Friday
20

☽□♅ 2:41 am
☽□♉ 12:15 pm
☽⚹♂ 4:49 pm

―――――――――――――――――――――

2020 Year at a Glance for ♐ Sagittarius (Nov. 21–Dec. 21)

you are worthy, dear sagittarius, not because of the work you do, or the people you help, or your potent intuition. you are worthy simply because you are. saturn and pluto join in your second house of value, resources and worth on january 12. the pressure of these two may crush any external sources of worth that keep you slurping the illusion that you need something outside of yourself to be whole. these two may also bring some stark money realities to your surface. move breath by breath, moment by moment.

jupiter meets pluto three times in 2020 (april 4, june 30, and november 12). (re)build your resources and sense of self-worth from the ground up if you need to. tend to your physical, tangible reality—money, home, body—so your spirit is supported in its deep transformation work.

the full moon in your sign falls on june 5. how can you cultivate a practice of choosing joy in the face of uncertainty and challenge? begin again on the new moon in your sign on december 14. shake off anything threatening to dull your shine, and move firm and deliberate toward yourself.

by year's end, saturn and jupiter move into aquarius, your third house of communication and the mind. open yourself to new thoughts and new words to describe the shifts in your foundations.

naimonu james © mother tongue ink 2019

——— ᚺᚺᚺ sábado ———

♒
♓

Saturday
21

♀→♏ 5:22 am
☉→♐ 12:40 pm
☽→♓ 8:06 pm
☉□☽ 8:45 pm
☽△♀ 9:43 pm

Sun in ♐ Sagittarius 12:40 pm PST
Waxing Half Moon in ♓ Pisces 8:45 pm PST

——— ☉☉☉ domingo ———

♓

Sunday
22

♉⊼♂ 6:00 am
☽✶♅ 11:10 am

November

shí yī yuè

♓

Monday
23

☽△♅ 5:37 am
☽☌♆ 7:31 am
☽⚹♇ 5:17 pm
☿△♆ 8:40 pm
☽⚹♃ 8:47 pm

© Jan Kinney 1999

♓
♈

Tuesday
24

☽⚹♄ 2:44 am
☽→♈ 7:05 am
☉△☽ 1:12 pm

♈

Wednesday
25

♀⚻♂ 8:46 am
☽☌♂ 3:39 pm

♈
♉

Thursday
26

☽□♇ 5:50 am
☽□♃ 10:15 am
☉△♂ 1:52 pm
☽□♄ 3:46 pm
☽ApG 4:27 pm
☽→♉ 7:43 pm

♉

Friday
27

☿⚹♇ 2:38 am
♀⚹♅ 9:11 am
☽☌♅ 11:10 am
☽☍♀ 11:25 am

The Art of Load-Bearing and Distribution

Last night under a sky
that was filled
with more starlight
than blackness
I threw up my
attachments
Aiming the big,
heavy bundle
At a shooting star
In a hope
it would take
my burden
with its burning speed
Dispersing it into
the universe
Shredding it
to pieces

¤ Jules Bubacz 2018

Freedom from the Imprint
© Gaia Orion 2017

ꀂꀂꀂ xīng qī liù

♉ ◯ ## Saturday
28

☽✶♆	8:28 am
♆D	4:36 pm
☽△♇	6:40 pm
☿✶♃	6:51 pm
☽△♃	11:53 pm

⊙⊙⊙ lǐ bài rì

♉
♊ ◯ ## Sunday
29

⊙⚹♅	12:20 am
☽☌♅	12:33 am
☽△♄	4:48 am
☽→♊	8:16 am

Nov. / Dec.
Kartik / Ogrohaeon

Nagakanya Artist at Work © *KT InfiniteArt 201*

───── ☽☽☽ sombar ─────

♊

Monday
30

☉☍☽ 1:30 am
☿⚹♄ 11:01 am
☽⚹♂ 6:12 pm
☽☐♆ 8:22 pm

Full Moon in ♊ Gemini 1:30 am PST
Penumbral Lunar Eclipse 1:43 am PST*

───── ♂♂♂ mongolbar ─────

♊
♋

Tuesday
1

☿→♐ 11:51 am
☽→♋ 7:33 pm

December

───── ☿☿☿ budhbar ─────

♋

Wednesday
2

☽⚹♅ 10:00 am
☽△♀ 11:42 pm

───── ♃♃♃ brihospotibar ─────

♋

Thursday
3

☽☐♂ 5:28 am
☽△♆ 6:32 am
☽☍♇ 4:21 pm
☽☍♃ 10:52 pm

───── ♀♀♀ sukrobar ─────

♋
♌

Friday
4

☽☍♄ 2:29 am
☽→♌ 4:53 am
☽△☿ 1:51 pm
☿△♅ 4:40 pm
☽☐♅ 6:38 pm

*Eclipse visible over Asia, Australia, Pacific, Americas

The Black Sheep Gospel

1. Give up your vows of silence which only serve to protect the old and the stale.

2. Unwind your vigilance, soften your belly, open your jaw and speak the truth you long to hear.

3. Be the champion of your right to be here.

4. Know that you must accept your rejected qualities, adopting them with the totality of your love and commitment. Aspire to let them never feel outside of love again.

5. Venerate your too-muchness with an enduring vow to become increasingly weird and eccentric.

6. Send out signals of originality with frequency and constancy, honoring whatever small trickle of response you get until you reach a momentum.

7. Notice your helpers and not your unbelievers.

8. Remember that your offering needs no explanation. It is its own explanation.

9. Go it alone until you are alone with others. Support each other without hesitation.

10. Become a crack in the network that undermines the great towers of establishment.

11. Make your life a wayfinding, proof that we can live outside the usual grooves.

12. Brag about your escape.

13. Send your missives into the network to be reproduced. Let your symbols be adopted and adapted and transmitted broadly into the new culture we're building together.

excerpt from Belonging: Remembering Ourselves Home © *Toko-pa Turner 2017*

ᚺᚺᚺ sonibar

♌

Saturday
5

⊙△☽ 6:41 am
☽☐♀ 1:47 pm
☽△♂ 2:28 pm
♀△♆ 8:53 pm
♀☍♂ 10:41 pm

⊙⊙⊙ robibar

♌
♍

Sunday
6

☿☍♅ 4:42 am
☽→♍ 11:46 am

December
Mí na Nollag

♍

Monday
7

☽△♅ 12:45 am
☽□♉ 3:24 am
☉□☽ 4:36 pm
☽☌♆ 7:45 pm

Waning Half Moon in ♍ Virgo 4:36 pm PST

ᾊᾊᾊ Dé Máirt

♍
♎

Tuesday
8

☽⚹♀ 12:21 am
☽△♇ 4:52 am
☽△♃ 12:09 pm
☽△♄ 2:35 pm
☽→♎ 4:01 pm

☿☿☿ Dé Céadaoin

♎

Wednesday
9

☉□♆ 11:40 am
☽⚹♉ 1:13 pm
☉⚹☽ 11:22 pm

♃♃♃ Dé Ardaoin

♎
♏

Thursday
10

☽☌♂ 12:31 am
♀⚹♇ 3:52 am
☽□♇ 7:21 am
☽□♃ 2:58 pm
☽□♄ 4:56 pm
☽→♏ 5:58 pm
☉△♂ 10:01 pm

♀♀♀ Dé Haoine

♏

Friday
11

☽☌♅ 5:43 am
☽△♆ 11:35 pm

No Fear

The year cancer came
to ask me for the next dance
i was booked solid.
those sharp teeth cut through
every other circumstance
to bite my life clean
and set an unforgettable edge
on eternity.

one moment at a time,
you learn the steps:
when to lead, where to follow
how to be still . . .
floating on trust as on a deep pool
while fiery hands and sterile rooms
work their magic

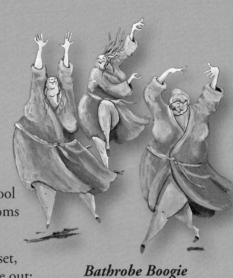

Bathrobe Boogie
© Jakki Moore 2013

Open the door to Pandora's closet,
and unexpected miracles tumble out:
angels, sharks, friends and lovers;
strangers offering hope and healing.
And at the bottom of the heap,
love enough to transform the whole world.
Open the door, and you're free.

¤ *Mimi Foyle 2013*

ᚻᚻᚻ Dé Sathairn

♏
♐

Saturday
12

☽⚹♇ 8:17 am ☽⚹♃ 4:23 pm
☽PrG 12:52 pm ☽⚹♄ 5:58 pm
☽☌♀ 12:59 pm ☽→♐ 6:39 pm

☉☉☉ Dé Domhnaigh

♐

Sunday
13

☿□♆ 3:38 am

For the Courageous

You
who replants today despite unwelcoming soil
so tomorrow can be worthy of the roots;
Your children will grow up to be oak trees

You
who cracks lies
until the grass finds enough spine
to break concrete and taste rain
for the first time;
Your children will sing unconquered through hurricanes

You
who have named the nameless
and spoken of their suffering
so we never forget the familiarity of their essence;
Your children will be unashamed of their reflection

You
who pushes against the jagged perimeters
thrusting your weight until you can mold freedom
regardless of the danger;
Your children will dance bravely through sorrow

You
who goes barefoot and empty handed
despite the boots heavy and gun you've been given
leaving destiny untouched;
Your children will be prophets,
have fate pressed against their eyes

You
who has been brave enough to move through the
earthquakes of heart-break
and carry with permanence love into ancestry;
Your children will forgive the ghosts who have haunted
their nights
and open the door for their departure in the morning

excerpt from Climbing PoeTree, *Whit Press (2015)*
© *Alixa Garcia, Climbing PoeTree. Used by permission of Whit Press*

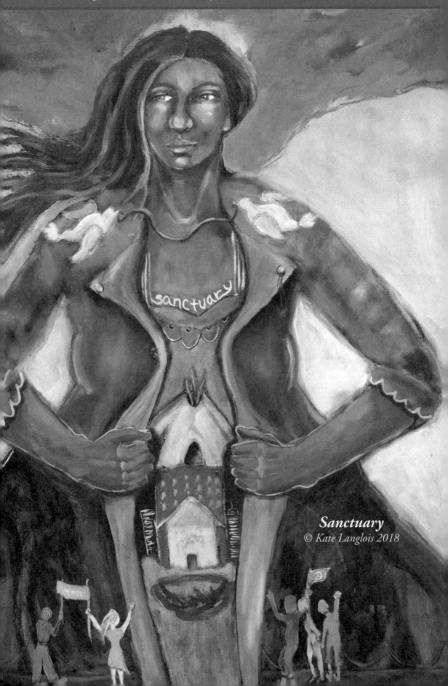

Sanctuary
© Kate Langlois 2018

December
diciembre

────────── ☽☽☽ lunes ──────────

♐
♑

Monday
14

☽□♆ 12:15 am
☽☌♅ 2:42 am
☽△♂ 4:14 am
☉☌☽ 8:17 am
♀⚹♃ 12:58 pm
☽→♑ 7:35 pm
☿△♂ 8:24 pm

□ Viandara 2018

Primordial Prayer

Total Solar Eclipse 8:15 am PST*
New Moon in ♐ Sagittarius 8:17 am PST

────────── ♂♂♂ martes ──────────

♑

Tuesday
15

♀⚹♄ 5:00 am
☽△♅ 7:22 am
♀→♐ 8:21 am
⚷D 1:08 pm

────────── ☿☿☿ miércoles ──────────

♑
♒

Wednesday
16

☽⚹♆ 2:11 am
☽□♂ 7:32 am
☽☌♇ 11:33 am
♄→♒ 9:04 pm
☽☌♃ 9:34 pm
☽→♒ 10:27 pm
☽☌♄ 10:28 pm

────────── ♃♃♃ jueves ──────────

♒

Thursday
17

☽⚹♀ 2:16 am
☽□♅ 10:50 am
☿ApH 11:46 am

────────── ♀♀♀ viernes ──────────

♒

Friday
18

☽⚹♂ 2:08 pm
☽⚹♅ 11:49 pm

──────────────────────────────

* Eclipse visible over Pacific, S. America, Antartica, Chili, Argentina, Atlantic

My Grief, My Love for the World

I watch the dancer, one arm framing her face,
one hip drawing upward in the belly's rhythm.
The dance of mature women, Raqs Sharqi,
born of the sensuous music of the Middle East.
Her hips pull us into infinity,
an inward-outward shout of beauty and desire.

In Cameroon, babies learn music
while strapped to Mama's back.
Coming of age, boys leap high,
beaming with the village's newfound respect.

In Bali, the gamelan orchestra cues the dancer
with clangs and thumps,
the bodies telling stories of monsters and gods,
each movement of eyes, and fingers, and feet
a perfectly timed posture of sacred geometry.

Oh humans, can't you love all this? Each culture born of each unique place, and each of us expressing in our own way? Doesn't this beauty tear at your heart, that everywhere we draw up our Earth's strength through our feet, though our hands, and we thank Her with leaps and turns? Oh humans, oh infinite diversity, aren't you breathtaken, aren't you amazed? Don't you treasure each other, for the vastness of what, together, we are? *excerpt © Annelinde Metzner 2014*

───────── ♄♄♄ sábado ─────────

≈
♓

Saturday
19

⊙⚹☽ 12:45 am ☽□♀ 2:40 pm
☽→♓ 4:39 am ☽⚹♅ 5:50 pm
♃→≈ 5:07 am ⊙♂♉ 7:26 pm
♀△♅ 7:22 am

───────── ☉☉☉ domingo ─────────

♓

Sunday
20

♉→♑ 3:07 pm
☽♂♆ 3:34 pm
♀☌♅ 10:11 pm

Winter Solstice

The longest night gifts us with time to enter the darkness, fully. We hold our breaths with nature, where life is suspended, waiting in extremis. The stillness behind action gathers as we empty and trust in our renewal. What will you give/lose to the night?

Death is a metaphor; learn to keep dying. The old symbol systems are dissolving at our feet. We need a new language to speak to the crisis of denial and despair. Imagine new models of love, work, health, education, security. Claim your inner resources, and fasten your seat belt. Like Copernicus, we're engaged in a cultural rescue attempt—we're not the center, but one species among millions. Like Cassandra, we shake others awake from the slumber overtaking them. We've got to see through the assumptions and fears, awaken to the warning signs of a world slipping away—in fire, in water, in our human collusion, in all directions. Our stories close their circle to enfold us. All the old laws are thrown into the cauldron of Solstice, as we embrace the ground of what death doesn't touch.

Oak Chezar © Mother Tongue Ink 2019

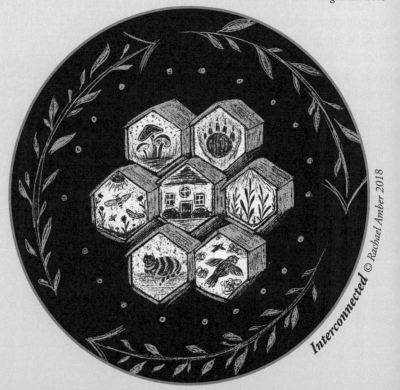

Interconnected © Rachael Amber 2018

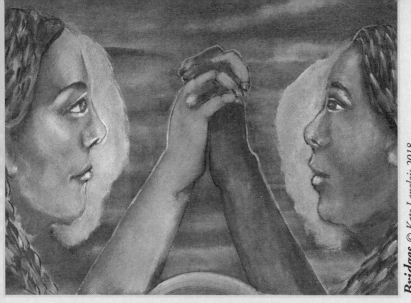

A Paradigm of Plenty

Our planet's ills are too many, too large, too seemingly hopeless—daily the tales of injustice and further insults to all I cherish bombard my awareness. What to do? I take heart from those, so often women, around the globe—planting crops in Kenya to nourish families and halt erosion; learning solar techniques to bring light to villages in Asia; winning battles to halt environmental degradation in Columbia, Canada, the United States . . . My spirit soars when I read of ecologically sound fish farming in Spain, of new methods of water purification in India, of the small house movement in the States. My goal is to focus on the local, the hopeful, the constructive, to exchange despair for a paradigm of plenty.

I look to my own communal home—five diverse women sharing land, learning to honor differences, cooperate, thrive. Easy? Not always, though we grow accustomed now to the work of consensus. I take heart from small achievements: each struggle towards harmony a vital stitch in the world's glorious fabric we mend with our willingness to create new ways of living. Do we disagree on where to build a new chicken coop? How can we match our areas of agreement to the needs of the land, each other? What will work best for the environment? Can we each yield a little here, take a little there, strive for balance and contentment? Of course we can. And we do. The end result: healthy hens, delicious eggs, abundance.

◻ *Helen Laurence 2018*

December
shí èr yuè

─── ☽☽☽ xīng qī yī ───

Monday
21

☉→♑ 2:02 am	☽⚹♄ 3:33 pm
☽⚹♇ 2:24 am	☽⚹♃ 3:36 pm
♃♂♄ 10:20 am	☉□☽ 3:41 pm
☽→♈ 2:32 pm	☽□♅ 6:04 pm

Winter Solstice

Sun in ♑ Capricorn 2:02 am PST
Waxing Half Moon in ♈ Aries 3:41 pm PST

─── ♂♂♂ xīng qī èr ───

Tuesday
22

☽△♀ 7:56 am	

─── ☿☿☿ xīng qī sān ───

Wednesday
23

♂□♇ 6:53 am	
☽□♇ 2:36 pm	
☽♂♂ 2:51 pm	
☿□♇ 6:11 pm	

─── ♃♃♃ xīng qī sì ───

Thursday
24

☽→♉ 2:55 am	☉△☽ 9:48 am
☽□♄ 4:31 am	☽△♅ 3:57 pm
☽□♃ 5:10 am	☽♂♅ 4:56 pm
☽ApG 8:35 am	☿△♅ 11:05 pm

─── ♀♀♀ xīng qī wǔ ───

Friday
25

☽⚹♆ 4:10 pm	
☉□♇ 11:37 pm	

ALL ASPECTS IN PACIFIC STANDARD TIME; ADD 3 HOURS FOR EST; ADD 8 HOURS FOR GMT

2020 Year at a Glance for ♑ Capricorn (Dec. 21–Jan. 19)

your shedding continues in 2020. commit to honesty with yourself and others, for integrity of spirit and soul is how you will make it through this high pressure, high stakes year.

on january 12, pluto and saturn will join together in your sign, an opportunity for soul-level (pluto) restructuring (saturn) of how you relate to your selves. what rises up for your gentle edits will likely change for good. praise! for even through heartbreak, you are heading toward your truth.

jupiter will join with pluto three times in 2020 (april 4, june 30, and november 12), open up to (re)membering who you are and what it is you are here to do. expect your relationships to change as you

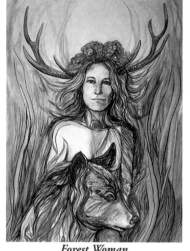

do, particularly during the full moon lunar eclipse in your house of intimate relationships on july 4. work with the wild energies of pluto, jupiter, and saturn—they are key to your greatness and legacy.

saturn and jupiter move into aquarius, ruler of your second house of resources in december—vision what you yearn to manifest and go after it.

naimonu james © mother tongue ink 2019

Forest Woman
□ Cary Wyninger 2018

━━━━━ ♄♄♄ xīng qī liù ━━━━━

♉
♊

Saturday
26

☽△♇ 3:32 am
☽→♊ 3:32 pm
☽△♄ 5:41 pm
☽△♃ 6:54 pm

━━━━━ ☉☉☉ lǐ bài rì ━━━━━

♊

Sunday
27

☉△♅ 7:25 pm
☽☍♀ 10:47 pm

December 2020 / January 2021

Ogrohaeon / Poush

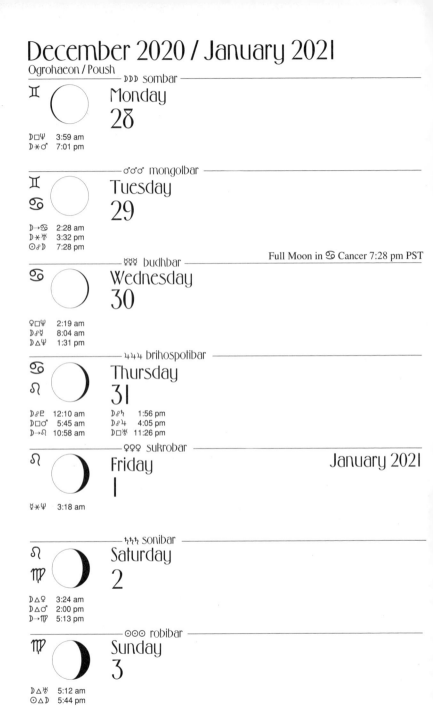

———— ☽☽☽ sombar ————

♊

☽□♆ 3:59 am
☽⚹♂ 7:01 pm

Monday
28

———— ♂♂♂ mongolbar ————

♊
♋

☽→♋ 2:28 am
☽⚹♅ 3:32 pm
☉☍☽ 7:28 pm

Tuesday
29

Full Moon in ♋ Cancer 7:28 pm PST

———— ☿☿☿ budhbar ————

♋

♀□♆ 2:19 am
☽☍♅ 8:04 am
☽△♆ 1:31 pm

Wednesday
30

———— ♃♃♃ brihospotibar ————

♋
♌

☽☍♇ 12:10 am
☽□♂ 5:45 am
☽→♌ 10:58 am

Thursday
31

☽☍♄ 1:56 pm
☽☍♃ 4:05 pm
☽□♅ 11:26 pm

———— ♀♀♀ sukrobar ————

♌

☿⚹♆ 3:18 am

Friday
1

January 2021

———— ♄♄♄ sonibar ————

♌
♍

☽△♀ 3:24 am
☽△♂ 2:00 pm
☽→♍ 5:13 pm

Saturday
2

———— ☉☉☉ robibar ————

♍

☽△♅ 5:12 am
☉△☽ 5:44 pm

Sunday
3

Eclipse

Go home!
Light a bonfire
in the heart of your community.
Hang lanterns from the trees
like constellations.
Dance circles in the dark,
alone and together
as the wheel turns.

excerpt © Sophia Rosenberg 2018

Ripple Effect © A. Levenmark 2013

WE'MOON EVOLUTION: A COMMUNITY ENDEAVOR

We'Moon is rooted in womyn's community. The datebook was originally planted as a seed in Europe where it sprouted on women's lands in the early 1980s. Transplanted to Oregon in the late '80s, it flourished as a cottage industry on We'Moon Land near Portland in the '90s and early 2000s, and now thrives in rural Southern Oregon.

The first We'Moon was created as a handwritten, pocket-size diary and handbook in Gaia Rhythms, translated into five languages, by womyn living together on land in France. It was self-published as a volunteer "labor of love" for years, mostly publicized by word-of-mouth and distributed by backpack over national borders. When We'Moon relocated to the US, it changed to a larger, more user-friendly format as we entered the computer age. Through all the technological changes of the times, we learned by doing, step by step, without much formal training. We grew into the business of publishing by the seat of our pants, starting with a little seed money that we recycled each year into printing the next year's edition. By the early '90s, when we finally sold enough copies to be able to pay for our labor, Mother Tongue Ink was incorporated as We'Moon Company, and it has grown abundantly with colorful new fruits: a datebook in full color, a wall calendar, greeting cards, a children's book, an Anthology of We'Moon Art and Writing, a Goddess-poetry book.

Whew! It was always exciting, and always a lot more work than anyone ever thought it would be! We learned how to do what was needed. We met and overcame major hurdles along the way that brought us to a new level each time. Now, the publishing industry has transformed: independent distributors, women's bookstores and print-based publications have declined. Nonetheless, We'Moon's loyal and growing customer base continues to support our unique womyn-created products, including the Anthology and the new We'Moon translation *en Español!* This home-grown publishing company is staffed by a steady and highly skilled multi-generational team—embedded in women's community—who inspire, create, produce and distribute We'Moon year in and year out.

Every year, We'Moon is created by a vast web of womyn. Our Call for Contributions goes out to thousands of women, inviting art and writing on that year's theme (see p. 234). The material is initially

reviewed in Selection Circles, where local area women give feedback. The We'Moon Creatrix then collectively selects, designs, edits, and weaves the material together in the warp and woof of natural cycles through the thirteen Moons of the year. In final production, we fine-tune through several rounds of contributor correspondence, editing and proofing. Approximately nine months after the Call goes out, the final electronic copy is sent to the printer. All the activity that goes into creating We'Moon is the inbreath; everything else we do to get it out into the world to you is the outbreath in our annual cycle. To learn more about the herstory of We'Moon, the growing circle of contributors, and the art and writing that have graced its pages over the past three and a half decades of women's empowerment, check out the anthology *In the Spirit of We'Moon* (see page 229).

Sister Organizations: We'Moon Land, the original home of the We'Moon datebook in Oregon, has been held by and for womyn since 1973. One of the first intentional womyn's land communities in Oregon, it has continued to evolve organically towards a sustainable women's community and retreat center, on 52 acres, one hour from Portland. Founded on feminist values, ecological practices and earth-based women's spirituality, we envision growing into a diverse, generationally interwoven community of women-loving-women, friends and family, sharing a vision of creative spirit-centered life on the land. We host individual and group retreats, visitors, camping, workshops, events, periodic holyday circles, lunar/solar/astrological cycles and land workdays. FFI Contact: wemoonland@gmail.com **We'Mooniversity** is a 501c3 tax-exempt organization created by We'Moon Land residents for outreach to the larger women's community. WMU co-sponsors occasional events and projects on the land and aspires to become a hub—online and on land—for women's lands, herstory, culture, consciousness, spirituality, and for We'Moon-related publications, classes, and networking resources. wemooniversity.org, wemoonland.org, wemoon.ws **OreGaia:** Northwest Womyn's Fest, now in its 3rd year, is the newest annual event on We'Moon Land. Contact us for camping, visits and events on the land: wemoonland.org, oregaia.com, wemooniversity.org, wemoon.ws

Musawa ¤ Mother Tongue Ink 2017

WE'MOON TAROT

Wild Card
© Jakki Moore 2013

Announcing a We'Moon Tarot Deck: now in the final stages of production . . . to be available next year with *We'Moon 2021*: the 40th Edition of We'Moon!

As a co-founder and editor of We'Moon since it began in 1981, I am excited to be able to sample the whole pallet of We'Moon art spanning the turn of this century—to create a We'Moon Tarot deck as an oracle for our times! We are tapping into the creative wisdom of We'Moon to re-configure a Tarot deck from a contemporary multi-cultural feminist perspective, grounded in earth-based women's spirituality/empowerment/consciousness, with diverse perspectives from international women's cultures and our individual life experiences.

A We'Moon Tarot deck has been a subliminal work-in-process since 1990, when we first started basing each annual edition on the archetypes of the Major Arcana cards in Tarot (the number of each card corresponding with the last two digits of the year). The spiritual quest of the Fool's journey (0) that started in 2000 comes full circle with The World Card (XXI) in 2021. The outcome—personally, planetarily or politically—remains to be seen. What we can foresee at this point is that it's In Her Hands! No matter what other forces are at play with The World card in *We'Moon 2021*.

While the 22 Major Arcana cards personify different aspects or stages of spiritual development, portraying the larger cosmic influences bearing upon us, the 56 cards of the Minor Arcana reflect the karmic influences that shape our individual personal life stories and how we respond to any given situation. The Minor Arcana consists of four elemental suits (like the four suits in an ordinary deck of playing cards) that represent the four elements in nature (earth, water, air and fire) and related dimensions in human nature (physical, emotional, mental, and energetic). By drawing from the treasure chest of We'Moon art over the years, the We'Moon Tarot provides intuitive keys to our inner guidance for finding our way through the transformations in our lives and in this pivotal period in herstory.

Musawa ▯ Mother Tongue Ink 2019

WE'MOON ON THE WEB

Come see what we're up to at wemoon.ws! Stay up to date with what's going on by signing up for **Weekly Lunar News**, a brief and lovely reminder of upcoming holy days, astrological and lunar events, and **We'News**, a periodic mailing announcing Mother Tongue Ink releases, specials and events! You can browse our products, old and new, keep an eye on the creation and conversation around We'Moon Tarot, and explore our astrological connection by reading the sun sign and weekly Starcodes! There's so much to learn by browsing the site—from how to donate to our Women in Prison program to exploring the history of We'Moon land and We'Mooniversity. Then you can dive into our vast web of artists and writers, get lost in spirituality and astrology, health and wellness, and even music, eco-friendly practices and green building! We hope you enjoy and come back often!

Kim Crown ▯ Mother Tongue Ink 2016

From left to right: Top Susie, Sue, Bethroot, Leah & Sequoia
Bottom: Ricky, Whiskey Pickle, Barb, Stella Bella & Dana

STAFF APPRECIATION

I want to send out big kudos to the amazing women I get to work with in the We'Moon office on a daily basis. Sequoia, crafty and agile graphic and web designer, brought more brilliant ideas to the table. Bethroot, wordwitch extraordinaire, also came out with a new book: *PreacherWoman for the Goddess: Poems, Plays, Invocations and Other Holy Writ* (see page 229). Leah, imaginative and resourceful production assistant and promo prodigy, energized us with innovative thoughts and perspectives. Sue, multitalented mastermind in production accounts and bookkeeping keeps the wheels of We'Moon oiled and lively. Susie, the many-armed goddess in the shipping department, and Dana, steadfast and hilarious shipping assistant, kept the office humming along and We'Moons flying out the door to their destinations, while keeping us laughing.

I also want to thank the talented and creative women whose work you see in these pages. You can read about each of them, starting on page 190, and become a contributor yourself! See page 234.

Barbara Dickinson © Mother Tongue Ink 2018

WE'MOON ANCESTORS

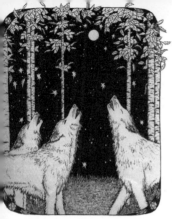

Moments of Prophecy and Promise
© *Sudie Rakusin 1992*

We honor wemoon who have gone between the worlds of life and death recently, beloved contributors to wemoon culture who continue to bless us from the other side. We appreciate receiving notice of their passing.

Beverly McClellan (1969–2018) An accomplished musician and singer in blues, rock and folk traditions, Beverly started playing piano at 4, and went on to learn guitar, trumpet, French horn, mandolin, ukulele, djembe, and a wide range of percussion instruments. She played with several bands before recording solo albums. An out lesbian, Beverly was a favorite performer at MichFest Women's Music Festival.

Sheila "Isis" Elaine Brown (1944–2018) lived in and around women's communities since the 1980s. She was all about Love, as a mother, sister, networker and organizer, a spirited human rights activist and environmentalist. She loved truth and stillness, was a dancer, artist, and a hard worker who often worked on crew for MichFest, as land steward for the Women's Peace Encampment, and as a Chief Firekeeper for Sanctuario Arco Iris. Proud of both her African and Native American roots, Sistah Isis was a warrior of prayer, called upon at times of life crisis. She serves in Spirit now.

Jeanette "Running Mouth" Spencer (1942–2019) Prolific author, poet, playwright, photographer, comic, friend and miraculous Survivor, Jeanette wrote: "Death is a fool/inside of me/something I have learned to live with" (*We'Moon 1990*). She was an early WOC resident of WHO Farm, originator of Oregon Critters, a founder of the Portland Saturday Market, and dedicated We'Moon devotee. Jeanette signed the customs papers to bring some of the first datebook copies into the US for distribution circa 1983.

Marion Woodman (1928–2018) was a distinguished psychoanalyst and author, who wrote and taught in mythopoetic language about primal archetypes at the heart of feminine identity. She popularized Jungian psychology and brought its elements into therapeutic work with women, especially those dealing with eating disorders and depression. Her books and "BodySoul Workshops" broke new ground in the liberation of women from patriarchal constraints on consciousness and self–understanding.

Mary Oliver (1935-2019) was a beloved and celebrated poet. Author of 20 volumes of poetry, winner of the Pulitzer prize and many other honors, she shared with us her reverent, plain-spoken wonder at the natural world. Every encounter—with flower, insect, songbird, swampland—became a fascinated, observant inquiry into the essential life force and a gently surprising lesson in everyday holiness. She was attentive to sharp edges and dark undertow, but her straightforward joy to be alive, always to be discovering, created devotion even among the poetry-shy.

Melanie Kaye Kantrowitz (1945–2018) was a Jewish lesbian feminist and a devoted activist against racism and for economic and social justice. She authored poems and essays, and was an early editor of the lesbian cultural journal *Sinister Wisdom*. As an academic, she taught Jewish studies, race theory, queer and gender studies; and she insisted on the intersectionality of oppressions before that phrase was in common use. She taught the first Women's Studies course at UC Berkeley, and her work against domestic violence in Portland, OR, was among the first such programs in the US.

Ntozake Shange (1948–2018) wrote plays, novels, childrens' books, poetry and essays, and was a unique voice in American literature. She created innovative writings on racial justice and women's empowerment, centering strong black women. Her most influential work is the choreopoem *For Colored Girls Who Have Considered Suicide When the Rainbow is Enuf.* Growing up during the tumults of the US civil rights movement, she was one of the first black children to attend formerly all–white public school. In the early 1970s, she adopted two Zulu names: "She who comes with her own things" and "One who walks like a lion."

Oxana Shachko (1987–2018) was a Ukrainian artist and a founder of the feminist activist group FEMEN, known for topless demonstrations protesting against sexual exploitation of women, and demanding women's rights/civil rights for all, worldwide. Oxana's artwork, called *Iconoclast*, featured traditional Orthodox icons satirized to confront religious dogma. She died of suicide at age 31 after long–term disappointments in her political and professional work.

Singing Breeze (1956–2019) Beloved community member, We'Moon devotee and writer, published in *We'Moon 2015*. She gracefully ended her own life, leaving 55 years of journals, tasking two close friends with the production of her book, on reclaiming death. Singing Breeze leaves a legacy of love. "I have not really gone away, I am between the winds, I am the ocean…I am the embers in the campfire, lifting, up to the sky….I am everywhere. I AM LOVE."

Sue Hubbell (1935–2018) wrote *A Country Year, A Book of Bees* and other insightful and contemplative books about the natural world, including the world of beekeeping where she landed as a middle–aged divorcee. She explores how a solitary older woman can fit into the scheme of things. A self–reliant feminist joy inhabits these meditative essays, these encounters with a forced competence which, she writes, "I realize as I lie here on the creeper under my Chevy, has made me outrageously happy."

Winnie Madikisela Mandela (1936–2018) was an outspoken and defiant leader of the anti–apartheid movement in South Africa and was fondly know by many as "the Mother of the Nation." She was married to Nelson Mandela and was his lifeline to the freedom struggle during his 27 years of imprisonment. Divorced from Mandela after the first two years of his presidency, Winnie continued her activism and served several terms in Parliament; her political reputation was tarnished by a number of scandals, but her place of honor is enshrined in the hearts of South Africans, proud of their liberation and their sovereignty.

© COPYRIGHTS AND CONTACTING CONTRIBUTORS

CONTRIBUTOR BYLINES AND INDEX

SEE PAGE 236 FOR INFO ABOUT HOW YOU CAN BECOME A WE'MOON CONTRIBUTOR!

A. Levemark (Tranas, Sweden) I'm a gardener & an illustrator, who is passionate about permaculture. My roots are in Scandinavia and Britain, and I'm drawn to the folklore of both places. ihox.deviantart.com, levemark@protonmail.com **p. 141, 183**

Abena Addo (London, UK) works with acrylics and collage techniques, exploring a range of topics. Engage with her on @abenaartistaddo and on Facebook: Abena Addo_Artist. She has just launched a new range of thought-provoking and exciting T-shirts: represent.com/store/abena-s-t-shack **p. 83**

Adriana M. Garcia (San Antonio, TX) Intimacy abounds in lives encountered. I aim to extract the inherent liminality of a moment before action as a way to articulate our stories. adrianamjgarcia.com, adrianamjgarcia@gmail.com **p. 132**

Alixa Garcia (New York, NY) is a professional poet, musician, and visual artist. Her work through Climbing PoeTree has taken her from the international halls of the United Nations and the world renown TED, to hundreds of stages nationally and internationally over the past 15 years. As a painter, she's received numerous grants and artists residencies. Her latest commissioned work was completed for Tony Award Winning playwright, Eve Ensler. climbingpoetree.com **p. 174**

Amy Alana Ehn (Eugene, OR) Healing Arts Practitioner, helicopter pilot, animal wellness advocate, world traveler, dreamer, and lover of words. Inspiring blissful balance, playing with magical manifestation, and breathing in creation. exquisitehealing.com **p. 73**

Amy Hyun Swart (San Francisco, CA) is a writer, artist, and psychotherapist living in San Francisco, CA. She can be contacted at amy@amystwart.com or visit her websites at visionkeeperart.com and amyswart.com. **p. 134**

Amy Nicole Purpura (West Palm Beach, FL) Peace panther, truth talker, ritual dancer, star watcher, and animal rights activist working towards peace for all. Currently bathing in the healing waters and tropical flora of S. Florida. amynicole4love@gmail.com **p. 91**

Anna Rose Renick (Talent, OR) is an intuitive life coach, writer, dancer, and muse with a passion for living dynamically and loving well in depth non-predictive clairvoyant work. annaroserenick.com **p. 53**

Anna Ruth Hall (Glendale, CA) A queer white woman from LA in her early 20s, Anna is a lover of nature, food, music, dance, clear communication, and travel. She is learning to listen to her intuition and follow its calling despite how wild the journey and strong the criticism. **p. 122**

Annelinde Metzner (Black Mountain, NC) All my creative work, composing music and poetry, is devoted to celebrating the reemergence of The Goddess on Earth. See more of my work at annelindesworld.blogspot.com, annelinde@hotmail.com **p. 97, 177**

Autumn Skye Morrison (Powell River, BC) I offer my artwork as a mirror, as an intimate personal reflection and a grand archetypical revelation. Within these visions, may you recognize your own sacred heart, your cosmic divinity, and the innate grace that dwells within. autumnskyeart.com **p. 35, 99**

Barbara Dickinson (Sunny Valley, OR) I'm doing what I love, and loving what I do. Homesteading, creating, getting muddy, and communing. **p. 187**

Barbara Landis (San Francisco, CA) is a fine art photographer creating images locally and abroad. Practicing nichiren Shoshu Buddhism since 1968, she belongs to Myoshinji Temple in Pinole, CA. barbara-landis.com **p. 80**

Barbara Levine (Corvallis, OR) is painting on wood these days as she renovates a very old shabby house. Her paintings celebrate nature and strong, nurturing women as natural conduits for bringing peace, beauty and healing into the world. **p. 101**

Beate Metz (Berlin, Germany) was an astrologer, feminist, translator & mainstay of We'Moon's German edition & the European astrological community. **p. 205**

Becky Bee (Azalea, OR) Ex-cobber, gardener, horseback rider, crybaby, lover of the atmosphere and the planet. beckybee.net **p. 23**

Beth Lenco (Hubbards, Nova Scotia) Beth's art is inspired by the land, sea, and her experiences as a rural shamanic witch. She leads Ancient practices/retreats, and is the creator of Starflower Essences. Bethlenco.com **p. 125**

Bethroot Gwynn (Myrtle Creek, OR) 24 years as WeMoon's Special Editor & 44 at Fly Away Home women's land, growing food, theater & ritual. For info about spiritual gatherings, summertime visits send SASE to POB 593, Myrtle Creek, OR 97457. For info about her new book of poetry and plays, *PreacherWoman for the Goddess*, see p. 229. **p. 32, 33**

Brandi Woolf (Crawford, CO) is a mama, witch and wild heart devoted to the Path of Priestess. A weaver of ceremony and words, she believes that courage and vulnerability are necessary and that the stories of women can heal the world. thewildsoul.net I.G: @brandiwoolf **p. 151**

Carmen R. Sonnes (Phoenix, OR) creates paintings to bring beauty, healing and balance to our planet. By acknowledging culture, the feminine and spirit in each work, she fulfills her purpose. Visit carmenrsonnes.com; carmenrsonnes@yahoo.com **p. 162**

Carol Newhouse (El Sobrante, CA) I am a photogrpher, writer, and Buddhist Meditation Teacher. My life's work seems to center on Womens' expression of Truth and Beauty through image, written word, spiirtual expresssion, and community. I can be reached at c.osmer.newhouse@gmail.com **p. 76**

Carrie Martinez (Gainesville, FL) Artist, muralist, and tarot deck illustrator whose work embodies nature, mysticism, dreamscapes, and Goddess. Carriemartinez.com; info@carriemartinez.com **p. 96, 130, 166**

Cary Wyninger (Trempealeau, WI) was born and raised in the Eastern Iowa river town of Lansing, Iowa. Receiving her BFA in Studio Arts from Viterbo University, just a few miles North along the Mississippi in Lacrosse, Wisconsin. She creates in oils, acrylics, watercolor and ink. carywyninger.com **p. 181**

Caryl Ann Casbon (Bend, OR) Interfaith minister, spiritual director, NW poet and writer, authored: *The Everywhere Oracle: A Guided Journey Through Poetry for an Ensouled World*. She was recognized as one of the top spiritual writers for 2017. carylanncasbon@squarespace.com **p. 127**

Casey Sayre Boukus (Nantucket, MA) is a collage artist, with a fabric addiction, dancer, performer, and eclectic witch. She lives on a beautiful island with her husband and two children and assorted critters. Esty: ByCasendra **p. 55**

Catherine McGagh (Leitrim, Ireland) An artist & yoga teacher living in the northwest of Ireland; she is inspired by nature, people & all things mystical. Most of her work can be viewed on her website catherinemcgaghartandyoga.squarespace.com or newirishart.com/irish-artists/catherine-mcgagh-artist **p. 69**

Catherine Molland (Santa Fe, NM) is a professional artist, showing and selling her artwork. She loves her organic farm, living there with her dogs and chickens. Visit. Catherinemolland.com or email her at cmolland@Q.com **p. 41**

Cathy Casper (Arvada, CO) celebrates life from the front range of the Rockies. Earth is the source of her inspiration and her love. **p. 83, 113**

Chantel Camille (Portland, OR) plays with words, and wool in the Pacific Northwest of America. When she is not doing that, she is tending her friends and family, studying ancestral and herbal wisdom, or working in the bookstore she loves. **p. 143**

Chasity Bleu (Keaau, HI) is an artist who draws inspiration from the Divine. She believes firmly in synchronicities, magic, and our connectedness with each other and the Universe, reflecting this through everything she makes. Chasitybleu.weebly.com **p. 119**

Cheryl Braganza (1945–2016) (Montreal, Quebec) 2008 Montreal Woman of the Year, Painter, Writer, Poet, Pianist, Cancer Survivor. Cheryl was born in India, studied art and music in Italy and the UK before arriving in Montréal in 1966 where she took sculpture and painting at l'École des Beaux Arts and Concordia University."I want my art to play a role in lifting people's spirits, in challenging their assumptions, in provoking thought...thus promoting dialogue between peoples towards peace. It is my belief that women will be the dynamic force to inspire a more caring, loving world." cherylbraganza.com **Back Cover**

Cinders Gott (Ashland, OR) M.F.A., is an expressionist visual/performance artist, melding ecofeminism with mysticism, a priestess of Arachne Circles, a wild woods witch, and love-shamaness in training. Cinders taught interdisciplinary arts in 50+ schools/colleges, Her Venus art is currently touring the world. lovecinders@gmail.com **p. 12**

Cindy Ruda (Sedona, AZ) loves the earth we walk upon and cannot abide the recklessness that others loose upon the planet's back. Yet, whether sensible or not, she holds firmly to hope and a willingness to believe. **p. 94**

Darlene Cook (Townsend, GA) My art seems to create itself. Learn more at Healingartspace.com **p. 148**

Dawn Sperber (Albuquerque, NM) is a writer and editor in New Mexico. Her stories and poems have appeared in *PANK Magazine, NANO fiction, Gargoyle, We'Moon*, and elsewhere. Find her at dawnsperber.com Tell her your dreams. **p. 42, 89**

Debra Hall (Castle Douglas, Scotland) I am a soulmaker, writer, dancer, and mindfulness teacher. I love life and the life of life. I love to be contacted about my work at debra.ha@hotmail.co.uk. **p. 158**

Denise Kester (Ashland, OR) is a mixed media printmaking artist, renowned teacher and founder/artistic director of Drawing on the Dream, an art distribution company. Announcing the new book *Drawing on the Dream—Finding My Way by Art.* drawingonthedream.com **p. 54, 85, 107**

Destiney Powell (Murfreesboro, TN) poeticallyillustrated.net **p. 135**

Diana Denslow (Poulsbo, WA) mother, artist, crone, We'Moon fan, and cat person is living happily and thankfully under cedars, in a diverse neighborhood, working on the art of living very well on very little. dianaherself66@gmail.com **p. 78, 165**

Dorrie Joy (Somerset, UK) is an intuitive artist working in many mediums in celebration of our shared indigeny as people of Earth. Originals, prints, commissions of all kinds at dorriejoy.co.uk **p. 79**

Earthdancer (Golconda, IL) Forest dweller of the Shawnee Forest, co-creator and multi-tasking mystic at Interwoven Permaculture Farm. interwovenpermaculture.com **p. 34**

Elizabeth Diamond Gabriel (St. Paul, MN) is a professional artist, illustrator and art teacher—in love with the Great Mother. In art life since the day she was born, she loves long, loving walks, the canine world, and good food with good friends. **p. 58**

Elsie Ula Luna Sula (Byron Bay, Australia) Art is an access point to the great mystery, a map that is shaped and born from our surrender to something beyond us and our desire to explore that. I am here to be a voice to the remembering of the Great Mother, in all her many forms, to remember and sing again the song of our ancient origins in a reality that honours the sacred within all. FB: Lunacreations111 Email: elsie_peters@hotmail.com **p. 81**

Elspeth McLean (Gooseberry Hill, Australia) creates her vivid and vibrant paintings completely out of dots. Each dot is like a star in the universe. Elspeth hopes her art connects people with their inner child and can bring some joy into their lives. elspethmclean.com **p. 15**

Emily Kedar (Toronto, ON) ia a writer, dancer and therapist living and working in Toronto and Salt Springs Island, Canada. Please contact her for writing inquiries at emilykedar222@gmail.com **p. 125**

Emily Kell (Boulder, CO) Visionary Goddess Art, emilykell.com or visit her on facebook at facebook.com/emilykellart **p. 139**

Francene Hart (Honaunau, HI) is an internationally recognized visionary artist whose work utilizes the wisdom and symbolic imagery of Sacred Geometry, reverence for the natural environment and the interconnectedness between all things. Francenehart.com **p. 57, 113**

Gaia Orion (Seabright, ON) creates simple, geometric, colorful oils unveiling universal and unifying themes. She has participated in many worldwide projects working towards constructive change and has exhibited in major cities all over Europe and North America. Gaiaorion.com or email her at art@gaiaorion.com **p. 8, 72, 169**

Gail Nyoka (Lorain, OH) is a storyteller, writer and award-winning playwright. As a Druid and a Fellowship of Isis Priestess, she conducts rites of passage of all kinds. Gailnyoka-stories.com, cyclesandrites.blogspot.com **p. 115**

Genevieve Scholl (Hood River, OR) is interested in how the mind finds refuge and healing amid suffering. Through painting, she seeks to offer the mind a place to rest. She believes in essential kindness. Genevievescholl.com **p. 24**

Gretchen Lawlor (Seattle, WA and Tepoztlan, Mexico) We'Moon oracle, now mentor to new oracles & astrologers. Passionate about providing astrological perspective & support to worldwide wemoon re: creativity, work, love, $, health. My first book, *Windows of Time—Tools for Right Timing*, is available through Amazon. For consultations & info, contact me at light@whidbey.com; gretchenlawlor.com **p. 18, 26**

Heather L. Crowley (East Kingston, NH) is a mother, wife, sister, daughter, visual artist, poet, mindfulness meditation teacher, and M.D. Willow Road Watercolors & The Circle Studio, LLC. "Art exploring the beauty and mystery of nature and spirit." willowroadwc.com **p. 95, 228**

Heather McElwain (Sandpoint, ID) is a freelance essayist, poet, and editor who writes about exploring the natural world as well as the wilderness within. bardontheroam. wordpress.com **p. 86**

Heather Roan Robbins (Ronan, MT) ceremonialist, spiritual counselor, & astrologer for 40 years, author of *Moon Wisdom*, *Everyday Palmistry* & several children's books (Cico books, avail. on Amazon), writes weekly Starcodes columns for We'Moon & The Santa Fe New Mexican, works by phone & Skype, practices in Montana, with working visits to Santa Fe, NM, MN, & NYC. roanrobbins.com **p. 10, 12, 15**

Helen Laurence (Roseburg, OR) lives at Rainbow's End, joyously tending garden, writing, teaching and learning from nature. **p. 179**

Jakki Moore (Oslo, Norway) divides her time between Ireland, Norway and Bulgaria. An artist and storyteller, her books can be found on Amazon. Open to commissions, projects and exhibitions, she would love to hear from you. Jakkiart.com **p. 43, 118, 173, 186**

Jan Kinney (Seattle, WA) I was inspired by the beauty of the Pacific Northwest to create the *Tarot of Compassion*. I work in education, sing, preach, create ritual, and work with beads. tarotofcompassion.com **p. 168**

Janis Dyck (Golden, BC) is a mother, artist and art therapist who feels a deep connection to the earth and the power of the feminine to heal, renew and bring positive change. The creative process continues to teach her that it is through connection, community and creativity that we will come to know our potential as human beings. janisdyck@persona.ca **p. 86**

Janis McDougall (Tofino, BC) I write poetry for discovery. For harmony, I sing with our community choir. For play, I explore collage painting. For inspiration, I go outside by the sea or the forest. I feel gratitude for having a daughter. **p. 161**

Jennifer Lothrigel (Lafayette, CA) is an artist, poet and healer in the San Francisco Bay area. Find her online at: JenniferLothrigel.com **p. 103**

Jenny Hahn (Kansas City, MO) captures the inward journey through bold, colorful expression using acrylic paint. As cofounder of Creative Nectar Studio, she offers workshops across the country using painting as a tool for mindfulness and self-discovery. jennyhahnart.com **p. 53, 145, 159**

Jo Jayson (Harrison, NY) is a spiritual artist, teacher, author, and has channeled the Sacred Feminine in her work for 8 years now. Jojayson.com **p. 81**

Joanne Clarkson (Port Townsend, WA) Her book of poems, *The Fates* won the Bright Hill Press contest and was published in 2017. Joanne is a retired RN and besides writing poetry, loves to read palms and Tarot. Joanneclarkson.com **p. 61, 70**

Joyce McCallister (Albany, CA) is a California writer and poet. She is a working on her first novel, a historical romance set in the 1920's Bay Area. **p. 37**

Judith Prest (Duanesburg, NY) is a poet, photographer, mixed media artist and creativity coach. She believes that creativity is our birthright as human beings. She lives and works at Spirit Wind Studio in Duanesburg, NY. jeprest@aol.com and spiritwindstudio.net **p. 75**

Jules Bubacz (Portland, OR) I reside in Portland, OR where my partner, my cat and my garden are sources and receptacles of my inspiration and love. **p. 169**

Katalin Pazmandi (Cottekill, NY) creates visionary paintings and sacred spaces that materialize through her from higher realms. Katalinpazmandi.com fufaeg@gmail.com **p. 25**

Kate Langlois (San Francisco, CA) In my creative practice, I bring beauty to shadows. Celebrating diversity through the many spaces of the feminine. I view ordinary lives as extraordinary. Through the fractures of experiences I strive to amplify wholeness. Katelangloisart.com **p. 175, 179**

Kauakea Winston (Honokáa, HI) is an astrologer and energy sound healer who lives in Honokáa on the Big Island of Hawaii. Healingresourcehawaii.com **p. 50**

Kay Kemp (Houston, TX) creates heart-centered art celebrating Mother Nature and the feminine spirit. Her visionary paintings amplify messages of love and respect intended to inspire positive change throughout the world. Kaykemp.com **p. 152**

Kendra Ward (Portland, OR) is a writer/teacher/healer, braiding these roles like sweetgrass to wear as a crown on her head. For the last 15 years she has worked as an acupuncturist/herbalist in mossy Portland, OR. kendraward.com **p. 46**

Kersten Christianson (Sitka, AK) is a raven-watching, moon-gazing Alaskan. When not exploring the summerlands and dark winter of the Yukon, she lives in Sitka, Alaska where she writes poetry. Kerstenchristianson.com **p. 35**

Kim Crown (Chicago, IL) is an artist and renaissance woman with a raging rash of wanderlust. **p. 186**

Kimberly Webber (Taos, NM) Priestess of painting, alchemy and bees. Advocate for the Divine Feminine, personal freedom, youth, pollinators, biodiversity, animals, oceans, forests. Planter of flowers and corn. Pollinator of empowerment. Amplifier of hope. Kimberlywebber.com **p. 93**

KT InfiniteArt (Freeport, NY) Creatrix, artist, writer inspired by sensuality and spirit. Instagram: KTInfiniteArt. Prints available. **p. 59, 170**

L. Sixfingers (Sacramento, CA) is an intersectional herbalist and witch helping folks to radically re-enchant their lives and re-member their way back home. She offers online and in-person courses for starry-hearted healers and magickal people at wortsandcunning.com **p. 143**

Laurie Bauers (Hakalau, HI) is currently loving life in gratitude in Hawaii with her family. Constantly awed by Mother Earth's beauty, she gleefully paints in a harmonious relationship with her. **p. 112**

Leah Marie Dorion (Prince Albert, SK) is an indigenous artist from Prince Albert, Saskatewan, Canada. leahdorion.ca **p. 1, 121**

Leah Markman (Williams, OR) aka Cerulean Tango, has been reading Tarot and studying astrology in the beautiful Applegate Valley of Southern Oregon. She spends her time in the sunshine with her dog, horse and VW Bus. She writes poetry and practices mounted archery. Leahdmarkman@gmail.com **p. 25**

Linda James (Seattle, WA) is an intuitive watercolor painter, educator, and flower essence practitioner creating her life in the wondrous environment of the Pacific Northwest. Lindajamesart.com **p. 74**

Lindy Kehoe (Gold Hill, OR) paints living portals of magic and love. She lives in beautiful Southern Oregon and is surrounded by the faerie realm. Visit me at Lindykehoe.com **p. 19, 149**

Liz Darling (Pittsburg, KS) is a visual artist from Kansas. Deliberate and intricate, Darling uses watercolor, ink, and other water-based media to create cosmic, organic compositions that often center on themes of spirituality, transience, the divine feminine, and the natural world. lizdarlingart.com **p. 122**

Liza Wolff-Francis (Albuquerque, NM) is a poet and writer with an M.F.A. in Creative Writing from Goddard College. She has a chapbook called *Language of Crossing* (Swimming with Elephants Publications) which is a collection of poems about the Mexico-U.S. border. **p. 100**

Lorraine Schein (Sunnyside, NY) is a NY writer. Her work has appeared in *Syntax and Salt, Mosaics, VICE Terraform* and *Tragedy Queens: Stories Inspired by Lana Del Ray & Sylvia Plath. The Futurist's Mistress,* her poetry book, is available from mayapplepress.com **p. 77**

Louie Laskowski (Brookston, IN) living in the small town of Brookston, IN, where I work in my art studio, is such a treat to me. I teach art as a spiritual path since it has been true for me. RCGI ordained priestess. louielaskowski@gmail.com, louielaskowski.com **p. 126**

Lucy H. Pearce (Co Cork, Ireland) is an award-winning author of life-changing women's non-fiction, including *Medicine Women, Burning Woman, Moon Time, The Rainbow Way* and *Full Circle Health*. She is founder of Womancraft Publishing. dreamingaloud.net **p. 39, 138, 147**

Lucy Pierce (Yarra Junction, Australia) Mother, artist, word-smith, musician, living by the Yarra River beside Mount Donna Buang in Victoria, Australia. My work is born of dream and myth, vision and dance, grief and quest, song and ceremony. lucypierce.com, etsy.com/shop/lucypierce, soulskinmusings.blogspot.com **p. 51**

Lyndia Radice (Magdalena, NM) I live in rural NM, and I paint and portray the natural world around me. **p. 164**

Lyrion ApTower (Wilton, NH) has discovered the strength of the wisdom of the crone and its ability to alter the course of events; she urges others to lift up their voices. sbmillet@tds.net **p. 133**

Mandalamy Arts (Topeka, KS) Amy is an artist, mother, teacher, nature lover, and a believer in respect for all life. Her mandalas and paintings primarily have themes of celestial objects and events, connection, and growth. Find her as Mandalamy Arts on Facebook and Instagram. **p. 128**

Margaret Karmazin (Susquehanna, PA) Her artwork has appeared in regional, literary and national magazines and in galleries in PA, NY, and the Caribbean. Margaretkarmazin.blogspot.com **p. 88**

Maria Strom (Athens, GA) is a feminist, artist, illustrator and cat lady. Her most recent creation is Hip Chick Tarot, a diverse, modern deck that's both spiritual and practical; it reminds women of their inner divinity and their worldly power. instagram: mariahipchicktarot **p. 40**

marna (Portland, OR) frolics in Pacifica Cascadia bioregion nurturing Gaian thriving. She initiates programs at the convergence of creativity, ecological restoration and the living wisdom traditions (earthregenrative.org) and encourages womyn to Moonifest their artistic and earth-enhancing projects with micro-grants and service. Moonifest.org **p. 152**

Maryruth Chorbajian (Racine, WI) felt the Goddess' presence when she created through painting, writing and tending to a garden. She was crazy about the moon, flowers and nature, and loved to image her beauty through all art mediums. Passionate about gifting her hand dyed silk scarves to homeless and abused women. **p. 102**

Melissa Harris (West Hurley, NY) Artist, author and intuitive. Join me for art-making workshops. Read my books on creativity and psychic development or have your Spirit Essence Portrait painted. I have created card decks and other products featuring my visionary art. melissaharris.com **p. 37, 49, 87**

Melissa Kae Mason, "MoonCat!" (Florida, Montana, Texas) Traveling Astrologer, Artist, Radio DJ, Photographer, Jewelry Creator, PostCard Sender, Goddess Card Inventor, Seer of Patterns, Adventurer and Home Seeker. See LifeMapAstrology.com, CatOvertheMoon.com and TravelingAstrologer.com Contact: LifeMapAstrology@gmail.com **p. 204**

Melissa Winter (San Antonio, TX) has been painting and drawing since she was a child. Her inspirations come through meditation and ceremony. Favorite themes in her work include: the Divine Feminine, LGBT, and Oneness. Honeybart.com **p. 56**

Meredith Heller (Tiburon, CA) is a poet, and singer/songwriter. She teaches creative writing classes for teenage girls, leads outdoor hiking and writing adventures, and hosts Siren Song, a women's music night. She is mused by nature, synchronicity, and kindred souls. meredithhellermusic@gmail.com **p. 68, 80**

Mimi Foyle (Rio Guaycuyacu, Ecuador) My passion is for the rivers, forests, and people with whom I live and work for the well-being of self, planet, and all-our-relations. With gratitude. guaycuyacu@gmail.com **p. 173**

Miri Hunter Haruach (Joshua Tree, CA) is a scholar, musician, writer and performance artist currently residing in the high-desert of Southern Ca. She fronts an Americana Folk Band, is the Artistic Director for Thought Theatre and co-producer of the Hi-Desert Fringe Festival. projectsheba.com **p. 92**

Mojgan Abolhassani (Vancouver, BC) is an artist and Expressive Art Therapist living in Vancouver, Canada. She also obtained solid training in a wide variety of intuitive art programs, Cyclic Meditation, Theta Healing and many other healing modalities. mojgana66@gmail.com **p. 90**

Molly Remer (Rolla, MO) is a priestess, artist, and educator in Central Missouri. She creates original story goddesses, publishes Womanrunes sets, and blogs about life in the hand of the Goddess at brigidsgrove.com **p. 140, 158**

Monika Andrekovic (Stratford, ON) A grateful volunteer for Cedar Farm Sanctuary in Ontario, Canada. Compassion for all beings is vital and healing in our collective journey. Nourishing energies to all. Veganmonika.com **p. 104**

Musawa (Estacada, OR & Tesuque, NM) I am excited to be creating a We'Moon Tarot Deck drawn from art in We'Moon over the years! It will come out with *We'Moon 2021* when the magic of We'Moon takes a new turn with We'Moon images as divinatory art for women in the 21st century. **p. 6, 28, 184, 186, 202**

Naima Penniman (Brooklyn, NY) Co-founder & steward of WILDSEED Community Farm & Healing Village, performance activist through Climbing PoeTree, food-justice educator at Soul Fire Farm, & healing practitioner at Harriet's Apothecary, Naima cultivates collaborations that elevate the healing of our earth, ourselves, our communities, lineages & descendants. climbingpoetree.com **p. 111, 164**

naimonu james (new orleans, la) is a writer and astrologer based in new orleans, louisiana. you can find them on facebook, instagram, and twitter: @naimonujames. you can also find free horoscopes and schedule a reading with them at naimonujames.com **p. 19, 45, 57, 69, 79, 93, 105, 119, 131, 145, 155, 167, 181**

Nancy Schimmel (Berkeley, CA) Songs, poems and stories are available at sisterschoice. com; political parodies at occupella.org, a website for activist song-leaders. **p. 67**

Nancy Watterson (Oakland, OR) is an artist, a mother, and a grandmother. She lives and works along the Umpqua River in Oregon where she finds an unlimited source for inspiration and balance. Nwattersonscharf.com **p. 103, 115,**

Natasha Stanton (Sierraville, CA) Changing consciousness through art. natashastanton.com **p. 38**

Nicole Nelson (Topanga, CA) is an ARTivist, published poet, and photographer using words and images to explore Feminine empowerment, decolonization and self-inquiry—heavily influenced by Buddhism, Lakota spirituality and the wisdom of Earth. nicovisuals.com, nicolemiz.com **p. 41**

Oak Chezar (Jamestown, CO) a radical dyke, performance artist, Women's Studies professor, psychotherapist, writer, & semi-retired barbarian. She lives in a straw bale, womyn-built house. She just published *Trespassing,* a memoir about Greenham Common Womyn's Peace Camp. Whilst working & playing towards the decimation of patriarchy & industrial civilization, she carries water. oakchezar@gmail.com **p. 30, 49, 66, 85, 102, 121, 142, 157, 178**

The Obsidian Kat (Silver Spring, MD) Lucky number seven. The child who waited for the fairies under the pear tree. A conscious curator of wellness. Mother and grandmother, all girls, divine feminine expressed. Happy crone. **p. 62**

Pamela Read (Solon, IA) I live on a beautiful lake with my husband and cat, where I paint, pray, play, and plant whenever I can! **p. 17**

Patricia Dines (Sebastopol, CA) I love the Divine and feel honored to serve her with my art and writing. Nurture yourself with my gorgeous full-color illustrated storybook, *The Goddess Who Forgot That She Was a Goddess.* Art and greeting cards available too! healthyworld.org/GB and patriciadines.info **p. 137**

Pat Malcolm (Albuquerque, NM) My work has been focused on the understanding that we humans are an intrinsic part of the natural world. I began painting wildlife in the early 1990's and they evolved into "Icons of Nature," using egg tempera paints on traditional gesso boards to capture the essence of the animals I met in both the outer world and my own inner world. malcolm-bernal.com **p. 154**

Paula Franco (Buenos Aries, Argentina) Italo-Argentine Artist, Shaman woman, visual and visionary illustrator, teacher in sacred art, writer and poet, astrologer, tarot reader, creator of goddess cards and coloring book: *The Ancestral Goddess and Heaven and Earth.* ladiosaancestral.com and paulafranco.net **p. 33**

Peggy Sue McRae (San Juan Island, WA) Dancing the dharma of the Goddess in my little patch of woods on San Juan Island. manymoonsart.biz **p. 120**

Penn King (Enid, OK) Feisty old Romani womun, dream painter, Earth activist. Blessed by the Mother of All to know both tears and laughter, she loves soul-deep with boundless hope. lquixotly@gmail.com FB: Lady Quixote's Studio. **p. 129**

Pi Luna (Santa Fe, NM) is a visionary artist in Santa Fe. She is also a business coach for creatives. To learn more visit pilunapress.com **p. 136**

Qutress (Chicago, IL) a Chicago artist with an afrofuturist touch to bruja realms. Visit more of her art on ig @qutress or write her via qutress@gmail.com **p. 65, 157**

Rachael Amber (Philadelphia, PA) is an ecofeminist illustrator and designer who focuses on environmental awareness and humanity's connection to nature in her artwork. She aims to deepen the roots, so we can more easily find our way back to nature. Rachaelamber.com **p. 60, 71, 117, 178**

Rachel Houseman (Santa Fe, NM) is an artist, gallery owner, and art therapist living in the Santa Fe railyard district. Her work has been featured across the southwest and in many major publications. Her goal is healing humanity through color and visionary symbolism. rachelhouseman.com **p. 94**

Rachel Kaiser (Lake Havasu City, Arizona) Rachel designs ceramic tiles and paints bold bright murals. Her paintings of empowered woman in harmonious yet surrealist environments are close to her heart, as she hopes woman loving woman becomes ever more a reality to save our earth and each other. kaisercreates@gmail.com, instagram: @rachelkaiserart, FB: @Kaisercreates **p. 70**

Rebecca Tidewalker (Jacksonville, OR) an expressive arts therapist, artist, herbalist and dreamer dedicated to healing connections with our roots in transforming the wounds of our intergenerational lineages and reclaiming the wisdom of those ancestors who lived in balance and reciprocity with the earth. Rebecca passed away on August 11, 2016; her work was submitted to We'Moon via her dear friend Amara Hollow Bones. Saphichay.org **p. 109**

Rose Flint (Wiltshire, England) is a Poet-Priestess living in Wiltshire, UK. She has presented poetry at the Glastonbury Goddess Conference for 23 years. poetrypf.co.uk/roseflintpage.shtml **p. 106**

Rosella (London, England) Mandalas for meditation and self-empowerment. The mandalas are hand drawn and painted in iridescent watercolors. Rosella-creations.co.uk **p. 30**

Ruth Gourdine (Milwaukie, OR) In today's world we are constantly thinking with our minds, but not reasoning with our hearts. Working with precious metal leaf (gold, copper, and silver) on oils represents the link between ourselves and a higher source. The vibration that feeds our spirit. This nourishment fosters connectivity and unity, and provides the foundation for healthy, loving communities to grow. Ruthgourdine.com **p. 153**

Saba Taj (Durham, NC) is a Pakistani-American artist based in Durham, North Carolina. Saba can be found on instagram @itssabataj, and on the web at itssabataj.com **Front Cover**

Sally Snipes (Julian, CA) A Californian native, raised on the coast, Sally Snipes has embraced the mountain for the last 40 years. Open spaces, shadows and light capture her imagination and fuel her art. Gardening keeps her spirit alive. **p. 116**

Sandra Pastorius aka Laughing Giraffe (Ashland, OR) has been a practicing Astrologer since 1979, and writing for We'Moon since 1990. Look for her collected We'Moon essays under "Galactic Musings" at wemoon.ws. As a Gemini she delights in blending the playful and the profound. Email her about Birth chart readings and local Astrology Study Groups at: sandrapastorius@gmail.com. Peace Be! **p. 20, 22, 206**

Sandy Bot-Miller (St. Cloud, MN) makes art and writes poetry. Art gives her the courage to express what she sees unfolding in her inner landscape as well as in the world-at-large. sandybotmiller@gmail.com and sandybotmiller.com **p. 39**

Sandy Eastoak (Sebastopol, CA) Shamanic painter and poet, prays for climate, habitat and spiritual healing. Her newest book, *Food as Love*, explores the consciousness of plants and animals before they are food. She thanks trees, water, and all our relations. Sandyeastoak.com **p. 29, 67**

Sara Steffey McQueen (Bloomington, IN) Grandmother, sister and Tree Sister volunteer. A founding momma of an intentional community in the hills of Southern Indiana. Facilitator of Art of Allowing & Wild Soul Woman. Paints inner and outer Nature. Sarasteffymcqueen.com **p. 138**

Sarah Satya (Salt Spring Island, BC) Intuitive mermaid, bringing form to dreams and songs of the heart. She breathes her art into form, blending spirit, human, animal, elements and energy into piercing images that evoke the wild nature of being. Her poetry is made of golden thread etched from her heart sown onto paper, relating her intimate experience of being alive and conversing with creation. **p. 116**

Serena Supplee (Moab, UT) has been "Artist on the Colorado Plateau" since 1980. An oil painter, watercolorist and sculptor, she welcomes you to visit her website if you are interested in purchasing her work. Serenasupplee.com **p. 3**

Shauna Crandall (Driggs, ID) Artist, singer and seeker of the strange and beautiful. Shaunacrandall.com and skcrandall@yahoo.com **p. 137**

Shelley Anne Tipton Irish (Seattle, WA) Through passionate color and visionary storytelling, I infuse classically rendered oil paintings with transcendental exploration. It is my life ritual, sharing it with you, my bliss, best blessings. Gallerysati.com **p. 160**

Shelly Blooms (Cleveland, OH) is a Spirit Pilgrim, ever on the trail of cosmic breadcrumbs by which the muses choose to amuse the noodle, through picture, poem, kit and caboodle. **p. 163**

Sheryl J. Shapiro (Seattle, WA) seeks to explore and reveal the depths of her Judaic roots, whispers from nature, and the complex beauty of community. Contact her at ruachhalev@gmail.com **p. 128**

Sophia Faria (Salt Spring Island, BC) is a sex educator, retreat facilitator and writer. Her private practice and home are on Salt Spring Island. She supports individuals and couples in their sexual journeys and co-creates nature, based on retreats for women. soulfoodsex.com **p. 65**

Sophia Rosenberg (Lasqueti Island, BC) is continually grateful to We'Moon for supporting women artists and writers, and creating beauty. Thank you for your sustained vision and good work for so many, many moons. Sophiarosenberg.com and bluebeatlestudio on Etsy **p. 55, 84, 150, 183**

Stephanie A. Sellers (Fayetteville, PA) is a poet and homesteader in the mountains of Pennsylvania. I founded the virtual global organization Sedna's Daughters to raise awareness about family aggression against women. Sednasdaughters.com **p. 58, 63**

Sudie Rakusin (Hillsborough, NC) is a visual artist, sculptor, and children's book author and illustrator for established authors Mary Daly and Carolyn Gage. She lives in the woods with her dogs, on the edge of a meadow, surrounded by her gardens. Sudierakusin.com and wingedwillowpress.com **p. 77, 155**

Sue Burns (Portland, OR) is a feminist, witch, writer, herbalist, teacher, mother. She is renewed in bodies of water, puts salt in her coffee, and looks for magick everywhere. **p. 24**

Susa Silvermarie (Ajijic, Mexico) Waking Up has been accelerated by my living in Mexico for the past three years. Please visit me at susasilvermarie.com **p. 110**

Susan Baylies (Durham, NC) sells her lunar phases as cards, larger print charts and posters at snakeandsnake.com Email her at sbaylies@gmail.com **p. 226**

Susan Bolen (Mariposa, CA) is the artist Manterbolen, Represented by Williams Gallery West, in Oakhurst, CA. Her work can be found on Redbubble, Facebook, and Manterbolen.com. She lives in a fortress of semi-solitude with her loving husband, and five cats. **p. 66**

Susan Levitt (San Francisco, CA) is an astrologer, tarot card reader, and feng shui consultant. Her publications include *Taoist Astrology* and *The Complete Tarot Kit*. Follow her astrology blog for new moon and full moon updates at susanlevitt.com **p. 23, 109, 203**

Tamara Phillips (Vancouver, BC) is inspired by the raw beauty of the natural world. Her watercolour paintings are woven together in earth tones, and she explores the connection between myth, dream, intuition and reality. Tamaraphillips.ca **p. 47, 106**

tanina munchkina (L'auberson, Switzerland) A lover of words, art, travels and the oneness of all. Tanina lives with her musician husband on a peaceful Swiss mountain. She draws and paints electric mandalas, childlike goddesses and faires. She also writes poetry and lyrics. taninamunchkina.com **p. 48**

Toko-pa Turner (Salt Spring Island, BC) is the award-winning author of the book, *Belonging: Remembering Ourselves Home*. As a teacher and dreamworker, she blends Sufism with a Jungian approach to dreamwork in online courses and around the world. Toko-pa.com **p. 159, 171**

Toni Truesdale (Bidetorn, ME) Artist, muralist, teacher and illustrator, Toni celebrates women, the natural environment and the diversity of the world's cultures. Contact her at tonitruesdale@gmail.com Prints and cards available through tonitruesdale.com **p. 4, 45**

Viandara (Tacoma, WA) I am an emissary of love, here to uplift humanity's vibration through the expressions of my soul's voice. I actively imagine a new cosmology. Painting mystic metarealism: pictorial poetry where image converages with myth. HeART offerings for our collective evolutions. Viandarasheart.com **p. 123, 146, 176**

Winter Ross (Crestone, CO) works in the medium of the imagination as an ecofeminist artist, writer and shamanic practitioner. She is convinced that the creative mind has the power to heal both individuals and the world. Info at ceremonialvisions.com **p. 142**

Xelena González (San Antonio, TX) has been writing daily in her We'Moon planner for the past 8 years. She has appeared in its pages as a muse of artist Adriana M. Garcia with whom she created the award-winning picture book, *All Around Us*. allaroundus.info **p. 99**

Zoë Rayne (Sydney, Australia) is an oil painter and word weaver whose works create a narrative of her spiritual Journeys and vivid dreams. Zoë aspires to follow a shamanic path of healing through nature, and to bring this into the world through her art. zoerayne.com **p. 95**

ERRORS/CORRECTIONS

In *We'Moon 2019*, we note a graphical error on page 7: the lunar phase progression in the inside circle is incorrect. You can see the corrected version on page 229 of *We'Moon 2020*.

We appreciate all feedback that comes in, and continually strive to get closer to perfection. Please let us know if you find anything amiss, and check our website near the beginning of the year for any posted corrections for this edition of We'Moon.

WE'MOON SKY TALK

Gaia Rhythms: We show the natural cycles of the Moon, Sun, planets and stars as they relate to Earth. By recording our own activities side by side with those of other heavenly bodies, we may notice what connection, if any, there is for us. The Earth revolves around her axis in one day; the Moon orbits around the Earth in one month ($29^1/_2$ days); the Earth orbits around the Sun in one year. We experience each of these cycles in the alternating rhythms of day and night, waxing and waning, summer and winter. The Earth/Moon/Sun are our inner circle of kin in the universe. We know where we are in relation to them at all times by the dance of light and shadow as they circle around one another.

The Eyes of Heaven: As seen from Earth, the Moon and the Sun are equal in size: "the left and right eye of heaven," according to Hindu (Eastern) astrology. Unlike the solar-dominated calendars of Christian (Western) patriarchy, We'Moon looks at our experience through both eyes at once. The **lunar eye of heaven** is seen each day in the phases of the Moon, as she is both reflector and shadow, traveling her $29^1/_2$-day path around the Earth in a "Moon" Month (from each new moon to the next, 13 times in a lunar year). Because Earth is orbiting the Sun at the same time, it takes the Moon $27^1/_3$ days to go through all the signs of the Zodiac—a sidereal month. The **solar eye of heaven** is apparent at the turning points in the Sun's cycle. The year begins with Winter Solstice (in the Northern Hemisphere), the dark renewal time, and journeys through the full cycle of seasons and balance points (solstices, equinoxes and the cross-quarter days in between). The **third eye** of heaven may be seen in the stars. Astrology measures the cycles by relating the Sun, Moon and all other planets in our universe through the backdrop of star signs (the zodiac), helping us to tell time in the larger cycles of the universe.

Measuring Time and Space: Imagine a clock with many hands. The Earth is the center from which we view our universe. The Sun, Moon and planets are like the hands of the clock. Each one has its own rate of movement through the cycle. The ecliptic, a 17° band of sky around the Earth within which all planets have their orbits, is the outer band of the clock where the numbers are. Stars along the ecliptic are grouped into constellations forming the signs of the zodiac—the twelve star signs are like the twelve numbers of the clock. They mark the movements of the planets through the 360° circle of the sky, the clock of time and space.

Whole Earth Perspective: It is important to note that all natural cycles have a mirror image from a whole Earth perspective—seasons occur at opposite times in the Northern and Southern Hemispheres, and day and night are at opposite times on opposite sides of the Earth as well. Even the Moon plays this game—a waxing crescent moon

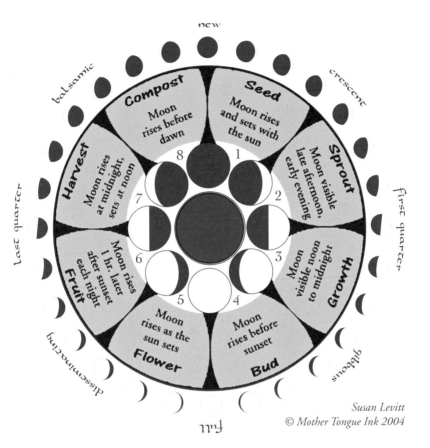

new

balsamic

crescent

Compost
Moon rises before dawn

Seed
Moon rises and sets with the sun

Harvest
Moon rises at midnight, sets at noon

Sprout
Moon visible late afternoon, early evening

last quarter

first quarter

Fruit
Moon rises 1 hr. later after sunset each night

Growth
Moon visible noon to midnight

8 1
7 2
6 3
5 4

Flower
Moon rises as the sun sets

Bud
Moon rises before sunset

disseminating

gibbous

full

Susan Levitt
© Mother Tongue Ink 2004

in Australia faces right (☽), while in North America, it faces left (☾). We'Moon uses a Northern Hemisphere perspective regarding times, holy days, seasons and lunar phases. Wemoon who live in the Southern Hemisphere may want to transpose descriptions of the holy days to match seasons in their area. We honor a whole Earth cultural perspective by including four rotating languages for the days of the week, from different parts of the globe.

Whole Sky Perspective: It is also important to note that all over the Earth, in varied cultures and times, the dome of the sky has been interacted with in countless ways. The zodiac we speak of is just one of many ways that hu-moons have pictured and related to the stars. In this calendar we use the Tropical zodiac, which keeps constant the Vernal Equinox point at 0° Aries. Western astrology primarily uses this system. Vedic or Eastern astrology uses the Sidereal zodiac, which bases the positions of signs relative to fixed stars, and over time the Vernal Equinox point has moved about 24° behind 0° Aries.

Musawa © Mother Tongue Ink 2008

KNOW YOURSELF—MAP OF PLANETARY INFLUENCES

Most people, when considering astrology's benefits, are familiar with their Sun Sign; however, each of the planets within our solar system has a specific part to play in the complete knowledge of "The Self." Here is a quick run-down of our planets' astrological effects:

☉ **The Sun** represents our soul purpose—what we are here on Earth to do or accomplish, and it informs how we go about that task. It answers the age-old question "Why am I here?"

☽ **The Moon** represents our capacity to feel or empathize with those around us and within our own soul as well. It awakens our intuitive and emotional body.

☿ **Mercury** is "The Thinker," and involves our communication skills: what we say, our words, our voice, and our thoughts, including the Teacher/Student, Master/Apprentice mode. Mercury affects how we connect with all the media tools of the day—our computers, phones, and even the postal, publishing and recording systems!

♀ **Venus** is our recognition of love, art and beauty. Venus is harmony in its expressed form, as well as compassion, bliss and acceptance.

♂ **Mars** is our sense of "Get Up and GO!" It represents being in motion and the capacity to take action and do. Mars can also affect our temperament.

♃ **Jupiter** is our quest for truth, living the belief systems that we hold and walking the path of what those beliefs say about us. It involves an ever-expanding desire to educate the Self through knowledge toward higher law, the adventure and opportunity of being on that road—sometimes literally entailing travel and foreign or international culture, language and/or customs.

♄ **Saturn** is the task master: active when we set a goal or plan then work strongly and steadily toward achieving what we have set out to do. Saturn takes life seriously along the way and can be rather stern, putting on an extra load of responsibility and effort.

⚷ **Chiron** is the "Wounded Healer," relating to what we have brought into this lifetime in order to learn how to fix it, to perfect it, make it the best that it can possibly be! This is where we compete with ourselves to better our own previous score. In addition, it connects to our health-body—physiological and nutritional.

♅ **Uranus** is our capacity to experience "The Revolution," freedom to do things our own way, exhibiting our individual expression or even "Going Rogue" as we blast towards a future collective vision. Uranus inspires individual inclination to "Let me be ME" and connect to an ocean of humanity doing the same.

♆ **Neptune** is the spiritual veil, our connection to our inner psychology and consciousness, leading to the experience of our soul. Psychic presence and mediumship are influenced here too.

♇ **Pluto** is transformation, death/rebirth energy—to the extreme. In order for the butterfly to emerge, the caterpillar that it once was must completely give up its life! No going back; burn the bridge down; the volcano of one's own power explodes. Stand upon the mountaintop and catch the lightning bolt in your hand!

Ascendant or Rising Sign: In addition, you must consider the sign of the zodiac that was on the horizon at the moment of your birth. Your Rising sign describes how we relate to the external world and how it relates back to us—what we look like, how others see us and how we see ourselves.

It is the combination of all of these elements that makes us unique among all other persons alive! We are like snowflakes in that way! Sharing a Sun sign is not enough to put you in a singular category. Here's to our greater understanding! Know Yourself!

Melissa Kae Mason, MoonCat! © Mother Tongue Ink 2011

GODDESS PLANETS: CERES, PALLAS, JUNO AND VESTA

"Asteroids" are small planets, located between the inner, personal planets (Sun to Mars) that move more swiftly through the zodiac, and the outer, social and collective planets (Jupiter to Pluto) whose slower movements mark generational shifts. Ceres, Pallas, Juno and Vesta are faces of the Great Goddess who is reawakening in our consciousness now, quickening abilities so urgently needed to solve our many personal, social, ecological and political problems.

⚳ **Ceres** (Goddess of corn and harvest) symbolizes our ability to nourish ourselves and others in a substantial and metaphoric way. As in the Greek myth of Demeter and Persephone, she helps us to let go and die, to understand mother-daughter dynamics, to re-parent ourselves and to educate by our senses.

⚵ **Juno** (Queen of the Gods and of relationships) shows us what kind of committed partnership we long for, our own individual way to find fulfillment in personal and professional partnering. She wants partners to be team-workers, with equal rights and responsibilities.

⚴ **Pallas** (Athena) is a symbol for our creative intelligence and often hints at the sacrifice of women's own creativity or the lack of respect for it. She brings to the fore father-daughter issues, and points to difficulties in linking head, heart and womb.

⚶ **Vesta** (Vestal Virgin/Fire Priestess) reminds us first and foremost that we belong to ourselves and are allowed to do so! She shows us how to regenerate, to activate our passion, and how to carefully watch over our inner fire in the storms of everyday life.

excerpt Beate Metz © Mother Tongue Ink 2009

Ephemeris 101

A Planetary Ephemeris provides astronomical data showing the daily positions of celestial bodies in our solar system.

The planets have individual and predictable orbits around the sun and pathways through the constellations that correlate with the astrological signs of the Zodiac. This regularity is useful for sky viewing and creating astro charts for a particular date.

The earliest astrologers used these ephemeris tables to calculate individual birth and event charts. These circular maps plot planetary positions and the aspects—angles of relationships—in a "state of the solar system" as a permanent representation of a moment in time. The ephemeris can then be consulted to find when real-time or "transiting" planets will be in the same sign and degree as planets in the birth or event chart. For instance, use the ephemerides to follow the Sun through the houses of your own birth chart, and journal on each day the Sun conjuncts a planet. The sun reveals or sheds light on a sign or house, allowing those qualities to shine and thrive. Ephemerides can also be used to look up dates of past events in your life to learn what planets were highlighted in your chart at that time. In addition, looking up dates for future plans can illuminate beneficial timing of available planetary energies.

Read across from a particular date, ephemerides provide the sign and degree of all the Planets, the Sun and Moon and nodes of the Moon on that day. The lower box on the page offers a quick look at Astro data such as, when a planet changes sign (an ingress occurs), aspects of the outer planet, and their change in direction or retrograde period and much more. The larger boxes represent two different months as labeled.) Use the Signs and Symbols at a Glance on page 229 to note the symbols or glyphs of planets, signs and aspects.

Sandra Pastorius © Mother Tongue Ink 2018

Moon: O hr=Midnight and Noon=12PM

R=Planet Retrogrades shown in shaded boxes

Planet Glyphs (p. 229)

Ingress: January 1st the Sun moves into 10° Capricorn

Day	Sid.Time	⊙	0 hr ☽	Noon ☽	True ☊	☿
1 Tu	6 41 28	10ß15 21	12♏21 35	18♏49 44	26♋52.2	23✗51.2
2 W	6 45 22	11 16 31	25 14 11	1✗35 10	26R50.0	25 19.2
3 Th	6 49 19	12 17 42	7✗52 52	14 07 28	26 47.6	26 47.7
4 F	6 53 15	13 18 52	20 19 08	26 28 04	26 45.5	28 16.7
5 Sa	6 57 12	14 20 03	2ß34 27	8ß38 27	26 43.9	29 46.2
6 Su	7 01 08	15 21 14	14 40 17	20 40 08	26 42.9	1ß16.2
7 M	7 05 05	16 22 25	26 38 13	2�ออ34 48	26D42.6	2 46.7
8 Tu	7 09 01	17 23 36	8�ออ30 08	14 24 32	26 42.9	4 17.6

Mars Ingress Aries
January 1 @ 2:21 PM

Astro Data Dy Hr Mn		Planet Ingress Dy Hr Mn		Last Aspe Dy Hr Mn
♂○N	2 0:50	♂ ♈	1 2:21	1 22:27 ♀
♛ D	6 20:28	☿ ß	5 3:41	4 17:43 ☿
☊ D	7 0:06	♀ ✗	7 11:19	7 6:21 ♀

2020 PLANETARY EPHEMERIS

LONGITUDE January 2020

Day	Sid.Time	☉	0 hr ☽	Noon ☽	True ☊	☿	♀	♂	♃	♄	♅	♆	♇	
1 W	6 40 28	10♑00 31	4H07 44	22H04 31	8☊23.0	4♑22.9	14♒24.5	28♏23.0	17♑54.3	6♑40.2	21♉23.7	2♓41.6	16H15.9	22♑23.1
2 Th	6 44 25	11 01 41	28 00 35	3♈56 32	8R22.8	5 57.6	15 38.0	29 03.4	18 18.3	6 54.0	21 30.7	2R41.1	16 17.0	22 25.1
3 F	6 48 21	12 02 51	11♈52 55	15 50 21	8D22.7	7 32.5	16 51.5	29 43.8	18 42.3	7 07.9	21 37.8	2 40.7	16 18.2	22 27.1
4 Sa	6 52 18	13 04 01	21 49 26	27 50 45	8 22.8	9 07.8	18 04.9	0♐24.2	19 06.2	7 21.7	21 44.8	2 40.3	16 19.5	22 29.1
5 Su	6 56 14	14 05 10	3♉54 51	10♉02 19	8 23.1	10 43.5	19 18.3	1 04.6	19 30.2	7 35.5	21 51.9	2 40.0	16 20.7	22 33.1
6 M	7 00 11	15 06 19	16 13 39	22 29 18	8 23.7	12 19.4	20 31.6	1 45.0	19 54.2	7 49.3	21 58.9	2 39.7	16 22.0	22 33.1
7 Tu	7 04 07	16 07 28	28 49 41	5♊15 08	8 24.5	13 55.8	21 44.9	2 25.5	20 18.2	8 03.0	22 06.0	2 39.4	16 23.3	22 35.1
8 W	7 08 04	17 08 36	11♊44 54	18 22 09	8 25.3	15 32.4	22 58.1	3 05.9	20 42.2	8 16.8	22 13.1	2 39.2	16 24.7	22 37.1
9 Th	7 12 01	18 09 45	25 03 56	1♋51 11	8R26.0	17 09.8	24 11.3	3 46.4	21 06.1	8 30.6	22 20.2	2 39.1	16 26.1	22 39.1
0 F	7 15 57	19 10 53	8♋43 42	15 41 18	8 26.2	18 47.3	25 24.4	4 26.9	21 30.1	8 44.3	22 27.3	2 39.0	16 27.5	22 41.1
1 Sa	7 19 54	20 12 00	22 43 29	29 49 45	8 25.9	20 25.4	26 37.4	5 07.5	21 54.1	8 58.0	22 34.4	2D39.0	16 28.9	22 43.1
2 Su	7 23 50	21 13 08	6♌59 30	14♌12 04	8 24.9	22 03.8	27 50.4	5 48.0	22 18.1	9 11.7	22 41.5	2 39.0	16 30.4	22 45.1
3 M	7 27 47	22 14 15	21 26 44	28 42 42	8 23.4	23 42.7	29 03.3	6 28.6	22 42.1	9 25.4	22 48.6	2 39.1	16 31.9	22 47.2
4 Tu	7 31 43	23 15 22	5♍59 14	13♍15 36	8 21.4	25 22.1	0H16.2	7 09.2	23 06.0	9 39.1	22 55.7	2 39.2	16 33.4	22 49.2
5 W	7 35 40	24 16 28	20 31 06	27 45 07	8 19.5	27 01.9	1 29.0	7 49.9	23 30.0	9 52.7	23 02.8	2 39.4	16 34.9	22 51.2
6 Th	7 39 36	25 17 35	4♎57 06	12♎06 37	8 17.9	28 42.2	2 41.7	8 30.5	23 53.9	10 06.4	23 10.0	2 39.6	16 36.5	22 53.2
7 F	7 43 33	26 18 41	19 13 18	26 16 52	8D17.0	0♒23.0	3 54.3	9 11.2	24 17.9	10 20.0	23 17.1	2 39.9	16 38.1	22 55.2
8 Sa	7 47 30	27 19 48	3♏17 09	10♏14 01	8 16.9	2 04.2	5 06.9	9 51.9	24 41.8	10 33.5	23 24.2	2 40.2	16 39.7	22 57.2
9 Su	7 51 26	28 20 54	17 07 25	23 57 20	8 17.3	3 45.8	6 19.5	10 32.6	25 05.8	10 47.1	23 31.3	2 40.6	16 41.3	22 59.2
20 M	7 55 23	29 22 00	0♐47 43	7♐32 54	8 19.1	5 27.9	7 31.9	11 13.3	25 29.7	11 00.6	23 38.4	2 41.1	16 43.0	23 01.2
21 Tu	7 59 19	0♒23 05	14 06 39	20 43 09	8 20.7	7 10.3	8 44.3	11 54.1	25 53.6	11 14.1	23 45.5	2 41.5	16 44.7	23 03.2
22 W	8 03 16	1 24 10	27 16 19	3♑44 46	8R21.9	8 53.1	9 56.6	12 34.9	26 17.6	11 27.6	23 52.5	2 42.1	16 46.4	23 05.2
23 Th	8 07 12	2 25 15	10♑13 46	16 37 53	8 22.3	10 36.2	11 08.8	13 15.7	26 41.5	11 41.0	23 59.6	2 42.7	16 48.1	23 07.2
24 F	8 11 09	3 26 19	22 59 00	29 17 18	8 21.5	12 19.5	12 21.0	13 56.5	27 05.3	11 54.4	24 06.7	2 43.3	16 49.9	23 09.2
25 Sa	8 15 06	4 27 23	5♒32 43	11♒45 25	8 19.2	14 02.9	13 33.0	14 37.3	27 29.2	12 07.8	24 13.7	2 44.0	16 51.7	23 11.2
26 Su	8 19 02	5 28 25	17 55 19	24 02 42	8 15.6	15 46.4	14 45.0	15 18.2	27 53.1	12 21.1	24 20.8	2 44.8	16 53.5	23 13.2
27 M	8 22 59	6 29 27	0H07 41	6H10 25	8 10.8	17 29.8	15 56.9	15 59.0	28 16.9	12 34.4	24 27.8	2 45.6	16 55.3	23 15.2
28 Tu	8 26 55	7 30 27	12 11 08	18 10 07	8 05.4	19 12.9	17 08.7	16 39.8	28 40.7	12 47.6	24 34.8	2 46.5	16 57.1	23 17.1
29 W	8 30 52	8 31 27	24 07 39	0♈04 06	7 59.9	20 55.6	18 20.4	17 20.8	29 04.5	13 00.8	24 41.9	2 47.4	16 59.0	23 19.1
30 Th	8 34 48	9 32 25	5♈59 52	11 55 24	7 54.9	22 37.7	19 32.0	18 01.7	29 28.3	13 14.0	24 48.7	2 48.3	17 00.9	23 21.0
31 F	8 38 45	10 33 23	17 51 10	23 47 42	7 51.0	24 18.9	20 43.6	18 42.6	29 52.0	13 27.1	24 56.0	2 49.2	17 02.8	23 23.0

LONGITUDE February 2020

Day	Sid.Time	☉	0 hr ☽	Noon ☽	True ☊	☿	♀	♂	♃	♄	♅	♆	♇	
1 Sa	8 42 41	11♒34 19	29♈45 34	5♉45 20	7♊48.7	25♒58.9	21H54.9	19♐23.6	0♒15.8	13♑40.1	25♉02.6	2♓50.4	17H04.7	23♑24.9
2 Su	8 46 38	12 35 14	11♉47 36	17 52 59	7D47.8	27 37.4	23 06.2	20 04.6	0 39.5	13 53.2	25 09.5	2 51.5	17 06.7	23 26.9
3 M	8 50 34	13 36 07	24 02 00	0♊15 06	7 48.4	29 14.0	24 17.4	20 45.6	1 03.2	14 06.1	25 16.4	2 52.6	17 08.6	23 28.8
4 Tu	8 54 31	14 36 59	6♊33 57	12 57 46	7 49.8	0H48.2	25 28.5	21 26.6	1 26.8	14 19.0	25 23.2	2 53.9	17 10.6	23 30.7
5 W	8 58 28	15 37 50	19 27 11	25 57 49	7 51.5	2 19.5	26 39.5	22 07.5	1 50.4	14 31.9	25 30.1	2 55.1	17 12.6	23 32.6
6 Th	9 02 24	16 38 40	2♋33 46	9♋33 07	7R52.6	3 47.4	27 50.3	22 48.6	2 14.1	14 44.7	25 36.9	2 56.4	17 14.6	23 34.5
7 F	9 06 21	17 39 28	16 32 07	23 35 07	7 52.3	5 11.9	29 01.0	23 29.7	2 37.7	14 57.5	25 43.7	2 57.8	17 16.7	23 36.3
8 Sa	9 10 17	18 40 15	0♌44 27	7♌59 39	7 50.3	6 30.5	0♈11.6	24 10.8	3 01.2	15 10.2	25 50.5	2 59.2	17 18.7	23 38.2
9 Su	9 14 14	19 41 00	15 19 03	22 44 36	7 46.3	7 44.2	1 22.0	24 51.9	3 24.7	15 22.9	25 57.2	3 00.7	17 20.7	23 40.1
10 M	9 18 10	20 41 44	0♍12 29	7♍44 20	7 41.8	8 51.8	2 32.3	25 33.0	3 48.2	15 35.4	26 03.9	3 02.1	17 22.8	23 41.9
11 Tu	9 22 07	21 42 27	15 18 28	22 54 11	7 37.6	9 52.5	3 42.5	26 14.1	4 11.7	15 48.0	26 10.6	3 03.7	17 24.9	23 43.7
12 W	9 26 04	22 43 09	0♎13 28	7♎40 14	7 34.6	10 45.5	4 52.6	26 55.3	4 35.1	16 00.4	26 17.2	3 05.3	17 27.1	23 45.6
13 Th	9 30 00	23 43 49	15 03 44	22 22 40	7 33.1	11 30.2	6 02.6	27 36.5	4 58.5	16 12.8	26 23.8	3 06.9	17 29.1	23 47.4
14 F	9 33 57	24 44 28	29 36 55	6♏44 05	7D 13.1	12 31.8	7 12.5	28 17.7	5 21.9	16 25.2	26 30.4	3 08.6	17 31.2	23 49.1
15 Sa	9 37 53	25 45 06	13♏44 05	20 37 41	7D13.1	12 31.8	8 22.4	28 58.9	5 45.2	16 37.5	26 36.9	3 10.3	17 33.3	23 50.9
16 Su	9 41 50	26 45 43	27 39 18	4♐26 02	7 12.4	12 47.8	9 31.8	29 40.1	6 08.5	16 49.7	26 43.4	3 11.9	17 35.5	23 52.7
17 M	9 45 46	27 46 19	11♐07 34	17 44 01	7 13.0	12R53.4	10 40.6	0♑21.4	6 31.7	17 01.8	26 49.9	3 13.9	17 37.7	23 54.4
18 Tu	9 49 43	28 46 54	24 16 14	0♑44 05	7 14.2	12 48.6	11 49.8	1 02.6	6 55.0	17 13.9	26 56.3	3 16.0	17 39.9	23 56.1
19 W	9 53 39	29 47 28	7♑06 33	13 24 51	7 13.9	12 33.4	12 58.8	1 43.9	7 18.1	17 25.9	27 02.7	3 17.7	17 42.1	23 57.8
20 Th	9 57 36	0H48 00	19 40 00	25 51 42	7 12.3	12 08.3	14 07.6	2 25.2	7 41.3	17 37.8	27 09.0	3 19.5	17 44.3	23 59.6
21 F	10 01 33	1 48 31	2♒00 21	8♒05 35	7 09.8	11 33.8	15 16.3	3 06.6	8 04.4	17 49.7	27 15.3	3 21.6	17 46.5	24 01.2
22 Sa	10 05 29	2 49 00	14 09 46	20 09 26	7 05.1	10 50.9	16 24.8	3 47.9	8 27.4	18 01.4	27 21.6	3 23.6	17 48.7	24 02.9
23 Su	10 09 26	3 49 28	26 11 39	2H11 29	6 56.7	10 00.6	17 33.1	4 29.3	8 50.3	18 13.2	27 27.8	3 25.7	17 50.9	24 04.5
24 M	10 13 22	4 49 54	8H42 00	14 02 09	6 46.2	9 04.3	18 41.2	5 10.6	9 13.2	18 24.8	27 34.0	3 27.9	17 53.1	24 06.2
25 Tu	10 17 19	5 50 19	20 00 43	26 03 43	6 34.4	8 03.6	19 49.0	5 52.0	9 36.0	18 36.3	27 40.1	3 30.1	17 55.4	24 07.8
26 W	10 21 15	6 50 42	2♈01 34	8♈00 08	6 22.9	6 59.9	20 57.0	6 33.4	9 59.2	18 47.8	27 46.1	3 32.2	17 57.6	24 09.4
27 Th	10 25 12	7 51 02	14 25 41	20 53 07	6 12.9	5 54.9	22 04.5	7 14.8	10 22.0	18 59.1	27 52.1	3 34.5	17 59.8	24 10.9
28 F	10 29 08	8 51 21	26 56 56	3♉03 17	6 01.2	4 50.3	23 11.9	7 56.2	10 44.8	19 10.4	27 58.1	3 36.7	18 01.1	24 12.5
29 Sa	10 33 05	9 51 39	8♉10 53	14 10 00	5 53.9	3 47.6	24 19.0	8 37.6	11 07.5	19 21.6	28 04.0	3 39.0	18 04.3	24 14.0

Astro Data

Dy Hr Mn
☊ D 3 4:28
☽ON 3 4:52
♀ R 9 23:37
♀ D 11 1:50
♂ OS 16 12:13
☊ D 17 13:03
☽OS 18 22:20
☽ON 30 12:19
☊ D 2 1:29
♀ R 6 9:02
☽ON 8 16:26
☊ D 12 18:54
☽ D 15 22:22
♀ R 17 0:55

Planet Ingress

Dy Hr Mn
♂ ♐ 3 9:39
♀ H 16 13:22
☿ ♒ 16 18:32
☉ ♒ 20 14:56
♀ ♒ 31 8:02
♀ H 3 11:39
♀ ♈ 7 20:04
♂ ♑ 16 11:34
☉ H 19 4:58
☿ R 19 0:14
♃✶✶20 15:57
☽ON 26 18:30

Last Aspect

Dy Hr Mn
2 2:15 ♂ △
4 1:19 ☉ □
6 12:09 ♀ △
8 22:17 ☉ △
10 23:59 ♀ ♂
13 13:43 ☉ ♂
15 12:13 ☿ △
17 13:00 ☉ □
19 21:23 ☿ ✶
21 4:47 ♀ □
24 2:10 ☉ ♂
25 09:48 ♀ ✶
29 1:10 ☿ ✶

☽ Ingress

Dy Hr Mn
♈ 2 4:02
♉ 4 16:16
♊ 7 2:12
♋ 9 8:44
♌ 11 12:17
♍ 13 13:43
♎ 15 14:04
♏ 17 18:22
♐ 19 22:22
♑ 22 5:01
♒ 24 14:39
H 27 2:22
♈ 29 11:52

Last Aspect

Dy Hr Mn
31 15:11 ☿ ✶
3 11:29 ♀ □
5 14:21 ♀ ✶
7 15:44 ♀ ♂
9 16:10 ♂ △
11 18:27 ♀ □
13 21:41 ♂ ✶
15 22:21 ☿ ✶
18 10:38 ♂ ♂
20 14:19 ♀ ♂
22 4:09 ♀ △
25 14:13 ☽ ✶
28 3:26 ♄ □

☽ Ingress

Dy Hr Mn
♉ 1 0:29
♊ 3 11:30
♋ 5 19:04
♌ 7 23:22
♍ 10 0:53
♎ 12 1:13
♏ 14 1:29
♐ 16 3:30
♑ 18 10:38
♒ 20 19:43
H 23 6:38
♈ 25 18:46
♉ 28 7:31

☽ Phases & Eclipses

Dy Hr Mn
☽ 12♈15
○ 10 19:22
✶ A 0.895
◐ 26♋52
● 4♒22
☽ 12♉40
○ 20♌00
◐ 26♏41
● 4♓29

Astro Data

1 January 2020
Julian Day # 43830
SVP 4H59'06"
GC 27♐07.1 ♀ 22✶51.6
Eris 23♈13.9R ‡ 17♑21.8
♂ 1♈35.8 ♀ 12♑06.4
☽ Mean ☊ 8♑14.3

1 February 2020
Julian Day # 43861
SVP 4H59'01"
GC 27♐07.2 ♀ 5♓20.2
Eris 23♈15.7 ‡ 21♑28.1
♂ 2♈31.3 ♀ 15♑40.6
☽ Mean ☊ 6♑35.8

*Giving the positions of planets daily at midnight, Greenwich Mean Time (0:00 UT)
Each planet's retrograde period is shaded gray.

2020 PLANETARY EPHEMERIS

March 2020 — LONGITUDE

Day	Sid.Time	☉	0 hr ☽	Noon ☽	True ☊	☿	♀	♂	⚷	♃	♄	♅	♆	♇
1 Su	10 37 01	10♓51 54	26♒15 05	2♓15 05	5♋49.2	2♓48.0	25♒26.0	9♑19.0	11♑30.2	19♑32.7	28♑09.9	3♉41.4	18♓06.6	24♑15.5
2 M	10 40 58	11 52 07	2♓22 12	8♓33 12	5D 47.0	1R 52.7	26 32.7	10 00.5	11 52.8	19 43.7	28 15.7	3 43.8	18 08.9	24 16.0
3 Tu	10 44 55	12 52 18	14 48 40	21 09 16	5 46.5	1 02.6	27 39.4	10 42.0	12 15.4	19 54.6	28 21.4	3 46.2	18 11.1	24 16.5
4 W	10 48 51	13 52 27	27 35 34	4♈08 07	5R 46.9	0 18.4	28 45.4	11 23.4	12 37.9	20 05.4	28 27.1	3 48.7	18 13.4	24 19.9
5 Th	10 52 48	14 52 34	10♈47 26	17 33 53	5 47.0	29♒40.0	29 51.4	12 04.9	13 00.3	20 16.2	28 32.8	3 51.2	18 15.7	24 21.3
6 F	10 56 44	15 52 39	24 27 45	1♉29 08	5 45.6	29 09.5	0♓57.1	12 46.4	13 22.7	20 26.8	28 38.4	3 53.7	18 18.0	24 22.7
7 Sa	11 00 41	16 52 42	8♉37 56	15 53 52	5 42.0	28 45.2	2 02.6	13 27.9	13 45.1	20 37.3	28 43.9	3 56.3	18 20.3	24 24.1
8 Su	11 04 37	17 52 42	23 16 25	0♊44 48	5 35.6	28 27.7	3 07.8	14 09.4	14 07.3	20 47.8	28 49.4	3 58.9	18 22.5	24 25.5
9 M	11 08 34	18 52 41	8♊10 01	15 54 53	5 26.8	28 17.0	4 12.8	14 51.0	14 29.6	20 58.1	28 54.8	4 01.5	18 24.8	24 26.8
10 Tu	11 12 30	19 52 38	23 34 02	1♋14 00	5 16.3	28D 12.8	5 17.4	15 32.5	14 51.7	21 08.3	29 00.1	4 04.2	18 27.1	24 28.1
11 W	11 16 27	20 52 32	8♋53 19	16 30 33	5 05.4	28 14.9	6 21.8	16 14.1	15 13.8	21 18.4	29 05.4	4 06.9	18 29.4	24 29.4
12 Th	11 20 24	21 52 25	24 04 21	1♌33 33	4 55.4	28 23.0	7 25.9	16 55.7	15 35.8	21 28.4	29 10.7	4 09.6	18 31.6	24 30.7
13 F	11 24 20	22 52 16	8♌57 14	16 14 38	4 47.3	28 36.9	8 29.6	17 37.3	15 57.8	21 38.4	29 15.8	4 12.4	18 33.9	24 31.9
14 Sa	11 28 17	23 52 05	23 25 18	0♍28 57	4 41.9	28 56.1	9 33.1	18 18.9	16 19.7	21 48.2	29 20.9	4 15.1	18 36.2	24 33.1
15 Su	11 32 13	24 51 53	7♍25 32	14 15 09	4 39.0	29 20.5	10 36.2	19 00.5	16 41.5	21 57.8	29 25.9	4 18.0	18 38.4	24 34.3
16 M	11 36 10	25 51 39	20 58 06	27 34 44	4D 38.1	29 49.6	11 39.1	19 42.1	17 03.3	22 07.4	29 30.9	4 20.8	18 40.7	24 35.5
17 Tu	11 40 06	26 51 24	4♎05 29	10♎30 53	4R 38.1	0♈23.3	12 41.5	20 23.8	17 25.0	22 16.9	29 35.8	4 23.7	18 43.0	24 36.6
18 W	11 44 03	27 51 06	16 51 28	23 07 44	4 37.7	1 01.2	13 43.7	21 05.4	17 46.6	22 26.2	29 40.6	4 26.6	18 45.2	24 37.7
19 Th	11 47 59	28 50 47	29 20 15	5♏29 30	4 35.8	1 43.0	14 45.5	21 47.1	18 08.2	22 35.5	29 45.4	4 29.5	18 47.5	24 38.8
20 F	11 51 56	29 50 27	11♏35 58	17 40 05	4 31.4	2 28.5	15 46.9	22 28.8	18 29.6	22 44.6	29 50.1	4 32.5	18 49.7	24 39.9
21 Sa	11 55 53	0♈50 04	23 42 14	29 42 47	4 24.0	3 17.5	16 47.9	23 10.5	18 51.0	22 53.5	29 54.7	4 35.4	18 52.0	24 40.9
22 Su	11 59 49	1 49 39	5♐42 01	11♐40 12	4 13.7	4 09.8	17 48.6	23 52.1	19 12.4	23 02.4	29 59.3	4 38.5	18 54.2	24 41.9
23 M	12 03 46	2 49 13	17 37 35	23 34 21	4 00.9	5 05.1	18 48.9	24 33.8	19 33.6	23 11.1	0♒03.7	4 41.5	18 56.5	24 42.9
24 Tu	12 07 42	3 48 44	29 30 41	5♑26 45	3 46.4	6 03.4	19 48.7	25 15.5	19 54.8	23 19.7	0 08.1	4 44.6	18 58.7	24 43.9
25 W	12 11 39	4 48 14	11♑22 41	17 18 41	3 31.5	7 04.3	20 48.1	25 57.2	20 15.8	23 28.2	0 12.4	4 47.7	19 00.9	24 44.7
26 Th	12 15 35	5 47 41	23 14 54	29 11 31	3 17.4	8 07.9	21 47.1	26 38.9	20 36.8	23 36.6	0 16.7	4 50.8	19 03.1	24 45.7
27 F	12 19 32	6 47 07	5♒08 46	11♒06 55	3 05.2	9 13.9	22 45.6	27 20.6	20 57.8	23 44.8	0 20.8	4 53.9	19 05.3	24 46.6
28 Sa	12 23 28	7 46 30	17 06 14	23 07 05	2 55.6	10 22.2	23 43.7	28 02.3	21 18.6	23 52.9	0 24.9	4 57.0	19 07.5	24 47.4
29 Su	12 27 25	8 45 51	29 09 49	5♓14 53	2 49.0	11 32.8	24 41.2	28 44.0	21 39.3	24 00.8	0 28.9	5 00.2	19 09.7	24 48.2
30 M	12 31 21	9 45 10	11♓22 44	17 33 54	2 45.0	12 45.5	25 38.3	29 25.7	22 00.0	24 08.6	0 32.9	5 03.4	19 11.8	24 49.0
31 Tu	12 35 18	10 44 26	23 48 53	0♈08 16	2D 43.8	14 00.3	26 34.8	0♒07.4	22 20.5	24 16.3	0 36.7	5 06.6	19 14.0	24 49.8

April 2020 — LONGITUDE

Day	Sid.Time	☉	0 hr ☽	Noon ☽	True ☊	☿	♀	♂	⚷	♃	♄	♅	♆	♇
1 W	12 39 15	11♈43 40	6♈32 36	13♈02 27	2♋43.6	15♈17.0	27♓30.8	0♒49.1	22♑41.0	24♑23.8	0♒40.5	5♉09.8	19♓16.1	24♑50.5
2 Th	12 43 11	12 42 52	19 38 19	26 20 40	2R 43.5	16 35.6	28 26.2	1 30.8	23 01.4	24 31.2	0 44.2	5 13.1	19 18.3	24 51.2
3 F	12 47 08	13 42 02	3♉09 53	10♉06 13	2 42.3	17 56.0	29 21.1	2 12.5	23 21.6	24 38.4	0 47.8	5 16.3	19 20.4	24 51.9
4 Sa	12 51 04	14 41 09	17 09 47	24 20 31	2 39.1	19 18.2	0♈15.3	2 54.2	23 41.8	24 45.5	0 51.3	5 19.6	19 22.5	24 52.6
5 Su	12 55 01	15 40 14	1♊38 07	9♊00 05	2 33.2	20 42.2	1 08.9	3 35.9	24 01.9	24 52.5	0 54.7	5 22.9	19 24.6	24 53.2
6 M	12 58 57	16 39 16	16 31 40	24 05 54	2 25.0	22 07.9	2 01.9	4 17.6	24 21.9	24 59.3	0 58.1	5 26.2	19 26.7	24 53.8
7 Tu	13 02 54	17 38 17	1♋43 33	9♋23 21	2 14.9	23 35.3	2 54.1	4 59.3	24 41.8	25 05.9	1 01.3	5 29.5	19 28.8	24 54.4
8 W	13 06 50	18 37 15	17 03 47	24 43 23	2 04.3	25 04.3	3 45.7	5 41.0	25 01.5	25 12.4	1 04.5	5 32.8	19 30.8	24 54.9
9 Th	13 10 47	19 36 11	2♌20 15	9♌54 21	1 54.4	26 34.9	4 36.5	6 22.7	25 21.2	25 18.8	1 07.6	5 36.1	19 32.8	24 55.4
10 F	13 14 44	20 35 05	17 23 12	24 46 15	1 46.4	28 07.1	5 26.7	7 04.4	25 40.8	25 25.0	1 10.6	5 39.5	19 34.9	24 55.9
11 Sa	13 18 40	21 33 58	2♍04 32	9♍12 12	1 40.8	29 41.0	6 15.9	7 46.1	26 00.3	25 31.0	1 13.5	5 42.9	19 36.9	24 56.3
12 Su	13 22 37	22 32 48	16 14 18	23 08 59	1 37.8	1♉16.4	7 04.5	8 27.8	26 19.6	25 36.9	1 16.3	5 46.2	19 38.9	24 56.7
13 M	13 26 33	23 31 37	29 56 22	6♎33 61	1D 36.9	2 53.4	7 52.2	9 09.6	26 38.9	25 42.7	1 19.1	5 49.6	19 40.8	24 57.1
14 Tu	13 30 30	24 30 24	13♎10 21	19 37 50	1R 37.2	4 32.0	8 39.0	9 51.2	26 58.0	25 48.2	1 21.7	5 53.0	19 42.8	24 57.5
15 W	13 34 26	25 29 10	25 59 39	2♏16 20	1 37.5	6 12.2	9 24.9	10 32.9	27 17.0	25 53.7	1 24.3	5 56.4	19 44.7	24 57.8
16 Th	13 38 23	26 27 54	8♏28 30	14 37 01	1 36.8	7 53.9	10 10.1	11 14.6	27 35.9	25 59.0	1 26.9	5 59.8	19 46.6	24 58.1
17 F	13 42 19	27 26 36	20 42 05	26 44 20	1 34.1	9 37.3	10 54.0	11 56.3	27 54.7	26 04.0	1 29.1	6 03.3	19 48.6	24 58.4
18 Sa	13 46 16	28 25 16	2♐44 30	8♐42 52	1 29.0	11 22.1	11 37.1	12 38.0	28 13.4	26 09.2	1 31.4	6 06.7	19 50.5	24 58.7
19 Su	13 50 12	29 23 55	14 39 50	20 36 11	1 21.4	13 08.8	12 19.2	13 19.6	28 31.9	26 13.6	1 33.6	6 10.1	19 52.3	24 58.9
20 M	13 54 09	0♉22 31	26 31 53	2♑27 24	1 11.7	14 57.0	13 00.1	14 01.3	28 50.3	26 18.3	1 35.7	6 13.6	19 54.2	24 59.1
21 Tu	13 58 06	1 21 06	8♑23 00	14 18 57	1 00.6	16 46.8	13 40.0	14 42.9	29 08.6	26 22.5	1 37.7	6 17.0	19 56.0	24 59.2
22 W	14 02 02	2 19 39	20 15 27	26 12 40	0 49.1	18 38.2	14 18.7	15 24.5	29 26.8	26 24.5	1 39.6	6 20.4	19 57.8	24 59.3
23 Th	14 05 59	3 18 11	2♒10 53	8♒10 10	0 38.1	20 31.3	14 56.2	16 06.1	29 44.9	26 30.9	1 41.4	6 23.9	19 59.6	24 59.4
24 F	14 09 55	4 16 40	14 10 43	20 12 42	0 28.6	22 26.0	15 32.5	16 47.6	0♒02.7	0♒02.7	1 43.1	6 27.3	20 01.4	24R 59.5
25 Sa	14 13 52	5 15 08	26 16 20	2♓21 48	0 21.3	24 22.1	16 07.5	17 29.2	0 20.5	26 38.5	1 44.7	6 30.8	20 03.1	24R 59.5
26 Su	14 17 48	6 13 33	8♓29 21	14 39 15	0 16.5	26 20.2	16 41.1	18 10.7	0 38.1	26 42.0	1 46.2	6 34.3	20 04.8	24 59.5
27 M	14 21 45	7 11 57	20 51 48	27 07 20	0D 14.1	28 19.7	17 13.3	18 52.2	0 55.6	26 45.4	1 47.7	6 37.7	20 06.5	24 59.5
28 Tu	14 25 42	8 10 19	3♈26 11	9♈48 45	0 13.6	0♊20.8	17 44.1	19 33.7	1 12.9	26 48.6	1 49.1	6 41.2	20 08.2	24 59.5
29 W	14 29 38	9 08 39	16 15 26	22 46 37	0 14.4	2 23.3	18 13.4	20 15.1	1 30.1	26 51.6	1 50.4	6 44.6	20 09.9	24 59.4
30 Th	14 33 35	10 06 56	29 22 13	6♉04 03	0R 15.5	4 27.3	18 41.1	20 56.6	1 47.2	26 54.4	1 51.6	6 48.1	20 11.5	24 59.3

Astro Data / Planet Ingress / Last Aspect & Ingress / Phases & Eclipses

Astro Data

	Dy Hr Mn
☊ D	2 19:46
♀ R	4 15:02
♀ D	10 3:50
) OS	11 4:16
☊ D	16 9:39
☊ R	17 1:04
⊙ N	20 3:51
) ON	25 0:14
☊ D	31 16:50
☊ R	1 10:17
4 ♂ ♇	5 2:46
) OS	7 15:21
☊ D	13 2:58
⊙ N	14 16:08
☊ R	23 23:09

Planet Ingress

	Dy Hr Mn
☿ ⚹ R	4 11:09
♀ ♈	5 3:08
♀ ♉	16 7:44
☿ ♈	16 11:36
♂ ♒	30 19:44
♀ ⚷	3 17:12
♀ ♉	11 4:49
☉ ♉	19 14:47
☿ ♉	23 20:21
♂ ♉	27 19:54

Last Aspect) Ingress

Dy Hr Mn		Dy Hr Mn
1 15:53 ♄ □	♊	1 19:22
4 2:21 ♀ ⚹	♋	4 4:26
7 6:13 ♄ △	♌	6 9:29
8 8:14 ♂ ♂	♍	8 10:48
10 8:33 ♄ △	♎	10 10:04
12 8:13 ♄ □	♏	12 9:27
14 10:07 ♄ ⚹	♐	14 11:10
16 9:35 ⊙ □	♑	16 16:26
19 0:49 ♄ ♂	♒	19 1:17
20 9:01 ♀ □	♓	21 12:34
23 14:52 ♂ ⚹	♈	24 0:59
26 7:18 ♂ ♂	♉	26 12:07
28 23:06 ♂ △	♊	29 1:39
30 15:11 ♀ □	♋	31 11:44

Last Aspect) Ingress

Dy Hr Mn		Dy Hr Mn
2 16:50 ♀ ⚹	♌	2 18:27
3 19:30 ⊙ △	♍	4 22:49
6 13:30 ♄ △	♎	6 21:17
8 12:51 ♄ □	♏	8 20:18
10 19:36 ♀ △	♐	10 20:36
12 11:47 ⊙ □	♑	13 0:30
13 23:49 ♂ ♂	♒	15 7:38
17 14:35 ⊙ ⚹	♓	17 18:11
19 23:32 ♂ ⚹	♈	20 7:01
22 12:33 ♀ □	♉	22 19:37
25 0:44 ♄ △	♊	25 7:21
27 17:01 ♀ ⚹	♋	27 17:29
29 19:31 ♀ ♂	♌	30 1:07

) Phases & Eclipses

Dy Hr Mn	
2 19:59) 12♊42
9 17:49	○ 19♍37
16 9:35	☾ 26♐16
24 9:29	● 4♈12
1 10:22) 12♋09
8 2:36	○ 18♎44
14 22:57	☾ 25♑27
23 2:27	● 3♉24
30 20:39) 10♌57

Astro Data

1 March 2020
Julian Day # 43890
SVP 4♓58'58"
GC 27♐07.3 ♀ 15♓48.1
Eris 23♈26.3 ‡ 20♈13.0R
δ 3♉56.7 ⋄ 23♋14.2
) Mean ☊ 5♋03.6

1 April 2020
Julian Day # 43921
SVP 4♓58'55"
GC 27♐07.3 ♀ 24♓48.8
Eris 23♈44.3 ‡ 23♈58.5R
δ 5♉44.3 ⋄ 3♋56.9
) Mean ☊ 3♋25.1

Giving the positions of planets daily at midnight, Greenwich Mean Time (0:00 UT)
Each planet's retrograde period is shaded gray.

2020 PLANETARY EPHEMERIS

LONGITUDE

May 2020

Day	Sid.Time	☉	0 hr ☽	Noon ☽	True ☊	☿	♀	♂	⚷	♃	♄	♅	♆	♇
1 F	14 37 31	11♉05 12	19♉43 41	6♊32.6	19♊07.1	21♈38.0	2♒04.1	26♑57.0	1♒52.4	6♉51.5	20♈13.1	24♑59.1		
2 Sa	14 41 28	12 03 25	26 42 20	3♊46 56	0R 14.9	8 39.2	19 31.5	22 19.4	2 20.8	26 59.5	1 53.3	6 55.0	20 14.7	24R 59.0
3 Su	14 45 24	13 01 36	10♊57 21	18 13 16	0 12.0	10 46.8	19 54.1	23 00.7	2 37.4	27 01.7	1 54.2	5 56.9	20 16.3	24 58.8
4 M	14 49 21	13 59 46	25 34 12	2♋59 29	0 07.3	12 55.4	20 14.8	23 42.0	2 53.8	27 03.8	1 54.9	7 01.8	20 17.8	24 58.6
5 Tu	14 53 17	14 57 53	10♋28 15	17 59 31	0 01.3	15 04.7	20 33.7	24 23.3	3 10.1	27 05.7	1 55.6	7 05.3	20 19.3	24 58.3
6 W	14 57 14	15 55 58	25 32 07	3♌04 52	29♊54.7	17 14.6	20 50.7	25 04.6	3 26.2	27 07.4	1 56.1	7 08.7	20 20.8	24 58.0
7 Th	15 01 11	16 54 02	10♌36 32	18 05 54	29 48.4	19 24.7	21 05.7	25 45.8	3 42.2	27 08.9	1 56.6	7 12.1	20 22.2	24 57.7
8 F	15 05 07	17 52 04	25 30 50	2♍53 20	29 43.3	21 34.9	21 18.6	26 27.1	3 58.0	27 10.3	1 56.9	7 15.5	20 23.7	24 57.4
9 Sa	15 09 04	18 50 04	10♍09 33	17 19 49	29 40.0	23 44.9	21 29.3	27 08.2	4 13.6	27 11.4	1 57.2	7 18.9	20 25.1	24 57.0
10 Su	15 13 00	19 48 03	24 23 39	1♎20 45	29D 38.6	25 54.4	21 38.0	27 49.4	4 29.1	27 12.4	1 57.3	7 22.3	20 26.5	24 56.6
11 M	15 16 57	20 46 01	8♎11 02	14 54 31	29 38.7	28 03.1	21 44.4	28 30.5	4 44.4	27 13.2	1R 57.4	7 25.7	20 27.8	24 56.2
12 Tu	15 20 53	21 43 57	21 31 24	28 02 00	29 39.9	0♊10.7	21 48.5	29 11.6	4 59.5	27 13.8	1 57.4	7 29.1	20 29.2	24 55.8
13 W	15 24 50	22 41 52	4♏26 42	10♏45 59	29 41.4	2 15.9	21R 50.3	29 52.6	5 14.4	27 14.2	1 57.3	7 32.4	20 30.5	24 55.3
14 Th	15 28 46	23 39 46	17 00 22	23 10 25	29R 42.6	4 21.5	21 49.8	0♓33.6	5 29.2	27R 14.4	1 57.0	7 35.8	20 31.7	24 54.8
15 F	15 32 43	24 37 38	29 16 43	5♐19 51	29 42.7	6 24.2	21 46.9	1 14.6	5 43.8	27 14.4	1 56.7	7 39.1	20 33.0	24 54.3
16 Sa	15 36 40	25 35 29	11♐20 25	17 18 57	29 41.4	8 24.7	21 41.6	1 55.5	5 58.1	27 14.2	1 56.3	7 42.5	20 34.2	24 53.7
17 Su	15 40 36	26 33 19	23 16 02	29 12 10	29 38.6	10 23.0	21 33.9	2 36.4	6 12.3	27 13.9	1 55.8	7 45.8	20 35.4	24 53.2
18 M	15 44 33	27 31 08	5♑07 50	11♑03 30	29 34.5	12 18.8	21 23.8	3 17.2	6 26.3	27 13.3	1 55.1	7 49.1	20 36.5	24 52.6
19 Tu	15 48 29	28 28 55	16 59 35	22 56 26	29 29.6	14 12.0	21 11.3	3 57.9	6 40.2	27 12.6	1 54.4	7 52.4	20 37.7	24 51.9
20 W	15 52 26	29 26 41	28 54 55	4♒53 48	29 24.3	16 02.4	20 56.4	4 38.7	6 53.8	27 11.6	1 53.6	7 55.7	20 38.8	24 51.3
21 Th	15 56 22	0♊24 27	10♒54 53	16 57 52	29 19.2	17 50.0	20 39.1	5 19.3	7 07.2	27 10.5	1 52.7	7 59.0	20 39.8	24 50.6
22 F	16 00 19	1 22 11	23 02 57	29 10 20	29 14.8	19 34.6	20 19.5	5 59.9	7 20.4	27 09.2	1 51.7	8 02.2	20 40.9	24 49.9
23 Sa	16 04 15	2 19 53	5♓20 09	11♓32 33	29 11.7	21 16.2	19 57.6	6 40.4	7 33.4	27 07.7	1 50.6	8 05.4	20 41.9	24 49.2
24 Su	16 08 12	3 17 34	17 47 40	24 05 37	29D 09.9	22 54.7	19 33.6	7 20.9	7 46.2	27 06.0	1 49.4	8 08.6	20 42.9	24 48.4
25 M	16 12 09	4 15 15	0♈26 32	6♈50 34	29 09.4	24 30.1	19 07.5	8 01.2	7 58.7	27 04.2	1 48.1	8 11.8	20 43.8	24 47.6
26 Tu	16 16 05	5 12 53	13 17 50	19 48 28	29 10.0	26 02.4	18 39.4	8 41.6	8 11.1	27 02.1	1 46.8	8 15.0	20 44.7	24 46.8
27 W	16 20 02	6 10 31	26 22 38	3♉00 27	29 11.3	27 31.4	18 09.5	9 21.8	8 23.2	26 59.8	1 45.3	8 18.1	20 45.6	24 46.0
28 Th	16 23 58	7 08 06	9♉42 04	16 27 37	29 12.8	28 57.2	17 37.9	10 02.0	8 35.1	26 57.4	1 43.7	8 21.3	20 46.5	24 45.2
29 F	16 27 55	8 05 41	23 17 10	0♊10 47	29 13.9	0♋19.7	17 04.8	10 42.1	8 46.8	26 54.8	1 42.1	8 24.4	20 47.3	24 44.3
30 Sa	16 31 51	9 03 14	7♊08 28	14 10 08	29R 14.5	1 38.9	16 30.3	11 22.1	8 58.2	26 52.0	1 40.3	8 27.5	20 48.1	24 43.4
31 Su	16 35 48	10 00 45	21 15 40	28 24 49	29 14.2	2 54.7	15 54.8	12 02.0	9 09.4	26 49.0	1 38.5	8 30.5	20 48.9	24 42.5

LONGITUDE

June 2020

Day	Sid.Time	☉	0 hr ☽	Noon ☽	True ☊	☿	♀	♂	⚷	♃	♄	♅	♆	♇
1 M	16 39 44	10♊58 15	5♋37 14	12♋52 30	29♊13.0	4♋07.1	15♊18.3	12♓41.9	9♒20.4	26♑45.9	1♒36.6	8♉33.6	20♈49.6	24♑41.6
2 Tu	16 43 41	11 54 44	20 10 03	27 29 14	29R 11.3	5 16.0	14R 41.2	13 21.6	9 31.1	26R 42.6	1R 34.6	8 36.6	20 50.3	24R 40.6
3 W	16 47 38	12 53 12	4♌48 29	12♌09 37	29 09.2	6 21.4	14 03.6	14 01.3	9 41.6	26 39.1	1 32.5	8 39.6	20 51.0	24 39.6
4 Th	16 51 34	13 50 38	19 31 06	26 47 12	29 07.3	7 23.2	13 25.8	14 40.9	9 51.9	26 35.4	1 30.3	8 42.6	20 51.6	24 38.5
5 F	16 55 31	14 48 03	4♍02 52	11♍15 24	29 05.8	8 21.3	12 48.1	15 20.5	10 01.9	26 31.6	1 28.1	8 45.5	20 52.2	24 37.4
6 Sa	16 59 27	15 45 28	18 24 06	25 28 22	29 05.0	9 15.7	12 10.5	15 59.9	10 11.6	26 27.6	1 25.7	8 48.5	20 52.8	24 36.6
7 Su	17 03 24	16 42 51	2♎27 41	9♎21 41	29 04.8	10 06.2	11 33.9	16 39.2	10 21.1	26 23.4	1 23.3	8 51.4	20 53.3	24 35.5
8 M	17 07 20	17 40 14	16 10 06	22 52 48	29 05.2	10 52.8	10 57.9	17 18.5	10 30.4	26 19.1	1 20.8	8 54.2	20 53.8	24 34.4
9 Tu	17 11 17	18 37 36	29 29 47	6♏00 01	29 05.6	11 35.5	10 22.7	17 57.6	10 39.3	26 14.6	1 18.2	8 57.1	20 54.3	24 33.4
10 W	17 15 13	19 34 58	12♏27 07	18 47 56	29 06.9	12 14.0	9 49.0	18 36.7	10 48.0	26 09.9	1 15.6	8 59.9	20 54.8	24 32.3
11 Th	17 19 10	20 32 18	25 04 00	1♐15 44	29 07.8	12 48.4	9 16.7	19 15.6	10 56.5	26 05.1	1 12.8	9 02.7	20 55.2	24 31.1
12 F	17 23 07	21 29 39	7♐23 36	13 28 08	29 08.3	13 18.5	8 45.9	19 54.5	11 04.6	26 00.1	1 10.0	9 05.5	20 55.6	24 29.9
13 Sa	17 27 03	22 26 58	19 29 53	25 29 25	29R 08.6	13 44.2	8 16.9	20 33.2	11 12.5	25 55.0	1 07.1	9 08.2	20 55.9	24 28.8
14 Su	17 31 00	23 24 18	1♑27 16	7♑24 03	29 08.5	14 05.6	7 49.8	21 11.8	11 20.1	25 49.7	1 04.2	9 10.9	20 56.2	24 27.6
15 M	17 34 56	24 21 37	13 20 19	19 16 36	29 08.2	14 22.4	7 24.8	21 50.3	11 27.4	25 44.3	1 01.3	9 13.6	20 56.5	24 26.4
16 Tu	17 38 53	25 18 55	25 13 27	1♒10 11	29 07.8	14 34.8	7 01.9	22 28.6	11 34.5	25 38.8	0 58.0	9 16.3	20 56.8	24 25.2
17 W	17 42 49	26 16 13	7♒10 43	13 12 14	29 07.4	14 42.6	6 41.2	23 06.8	11 41.2	25 33.1	0 54.9	9 18.8	20 57.0	24 24.0
18 Th	17 46 46	27 13 31	19 16 02	25 22 34	29 07.1	14R 45.7	6 22.8	23 44.9	11 47.6	25 27.3	0 51.6	9 21.4	20 57.2	24 22.7
19 F	17 50 42	28 10 49	1♓32 34	7♓44 59	29D 07.0	14 44.4	6 06.7	24 22.9	11 53.6	25 21.3	0 48.3	9 24.0	20 57.3	24 21.5
20 Sa	17 54 39	29 08 06	14 01 20	20 21 21	29 07.0	14 38.7	5 53.0	25 00.7	11 59.6	25 15.2	0 45.0	9 26.5	20 57.4	24 20.2
21 Su	17 58 36	0♋05 23	26 45 08	3♈12 43	29R 07.0	14 28.5	5 41.7	25 38.3	12 05.1	25 09.0	0 41.5	9 29.0	20 57.5	24 18.9
22 M	18 02 32	1 02 39	9♈43 57	16 19 19	29 06.9	14 14.2	5 32.8	26 15.8	12 10.4	25 02.7	0 38.1	9 31.4	20 57.6	24 17.7
23 Tu	18 06 29	1 59 55	22 58 11	29 40 09	29 06.8	13 55.9	5 26.3	26 53.2	12 15.2	24 56.3	0 34.4	9 33.8	20R 57.6	24 16.3
24 W	18 10 25	2 57 10	6♉24 50	13♉12 22	29 06.5	13 34.1	5 22.1	27 30.5	12 20.0	24 49.8	0 31.6	9 36.1	20 57.6	24 13.7
25 Th	18 14 22	3 54 25	20 02 07	26 52 49	29 06.3	13 08.4	5D 20.3	28 07.6	12 24.4	24 43.2	0 27.1	9 38.5	20 57.5	24 13.7
26 F	18 18 18	4 51 40	3♊46 00	10♊40 07	29 05.4	12 39.8	5 20.9	28 44.6	12 28.5	24 36.5	0 23.8	9 40.7	20 57.4	24 11.0
27 Sa	18 22 15	5 48 53	17 35 12	24 32 06	29 04.6	12 08.6	5 23.6	29 21.4	12 31.6	24 29.4	0 19.6	9 43.1	20 57.4	24 11.0
28 Su	18 26 12	6 46 07	1♋29 12	8♋28 12	29D 04.6	11 35.7	5 28.6	29 57.3	12 34.9	24 22.4	0 15.7	9 45.3	20 57.2	24 08.3
29 M	18 30 08	7 43 19	15 26 45	22 30 44	29 04.7	11 00.9	5 35.7	0♈33.6	12 37.9	24 15.4	0 11.9	9 47.5	20 57.0	24 08.3
30 Tu	18 34 05	8 40 31	29♋42 24	7♌50 46	29 05.2	10 25.1	5 45.1	1 09.7	12 40.5	24 08.3	0 07.9	9 49.7	20 56.8	24 06.9

Astro Data		Planet Ingress		Last Aspect	☽ Ingress	Last Aspect	☽ Ingress	☽ Phases & Eclipses		Astro Data
Dy Hr Mn		Dy Hr Mn		Dy Hr Mn	Dy Hr Mn	Dy Hr Mn	Dy Hr Mn	Dy Hr Mn		1 May 2020
☽OS	5 1:59	☿ ♊R 5 4:41	1 16:05 ♂ ♂ ♍	2 5:36	2 10:41 ♃ □	♏ 2 16:07	7 10:46	○ 17♏,20	Julian Day # 43951	
☽ΩD	10 9:01	♀ ♊ 11 21:59	4 2:26 ♃ △	♎ 4 7:01	4 11:38 ♃ ✶	♐ 4 17:18	14 14:04	☾ 24♒14	SVP 4♓58'51"	
♄R	11 4:10	♂ ♓ 13 4:18	6 2:32 ♃ □	♏ 6 7:06	6 4:12 ♀ □	♑ 6 19:45	22 17:40	● 2♊05	GC 27✗07.4 ♀ 0♏06.1	
♀ R	13 6:46	☉ ♊ 20 13:50	8 2:40 ♃ ✶	♐ 8 7:16	8 18:07 ♃ ♂	♒ 8 23:10	30 3:31	☾ 9♍12	Eris 24♈03.8 ♀ 25♈55.5R	
♀ R	14 14:17	☿ ☊ 28 18:10	10 6:12 ♂ ✶	♑ 10 9:40	10 14:36 ☉ △	♓ 11 9:33			♭ 7♈24.5 ♦ 15♓46.1	
⁴ R	14 14:17		12 10:31 ♀ ♂	♒ 12 15:40	13 12:46 ♀ ✶	♈ 13 20:41	5 19:14	☾ 15♏34	☾ Mean ☊ 1♊49.8	
☽ON	18 13:32	☉ ☊ 20 21:45	14 14:04 ☉ □	♓ 15 1:26	16 0:51 ♃ □	♉ 16 9:37	5 19:26	☾ A 0.568		
☿ D	24 21:33	☿ ☊ 28 1:46	17 8:00 ♃ ✶	♈ 17 13:37	18 12:03 ♃ △	♊ 18 21:25	13 6:25	☾ 22♓42	1 June 2020	
♀ R	30 3:26		19 20:34 ♃ □	♉ 20 2:12	20 21:49 ♃ □	♋ 21 6:03	21 6:43	● 0♋21	Julian Day # 43982	
☽OS	1 10:27	♀ ♊R 21 5:20	22 8:02 ♃ △	♊ 22 14:21	23 7:21 ♃ △	♌ 23 12:23	21 6:41:15 ✶ A 00'38"	SVP 4♓58'47"		
♀ D	6 18:05	♆ R23 4:33	24 11:11 ♀ ✶	♋ 24 23:10	24 5:35 ☿ □	♍ 25 17:06	28 8:17	☾ 7♎06	GC 27✗07.5 ♀ 0♏13.2R	
☽R	18 13:57	♀ ☊ 25 6:49	27 1:07 ♀ □	♌ 27 5:27	27 20:03 ♂ ♂	♏ 27 20:18			Eris 24♈21.2 ♀ 25♈52.5	
☽ON	14 21:17	♀ ☊ 28 8:08	28 13:31 ♀ ✶	♍ 29 11:41	29 13:03 ♃ □	♐ 29 22:29			♭ 8♈44.1 ♦ 28♓48.1	
♮ R	18 5:00	☽OS 28 16:31	31 9:18 ♃ △	♎ 31 14:39					☾ Mean ☊ 0♊11.3	
☽ D	19 21:59	♄♂♂ 30 5:48								

*Giving the positions of planets daily at midnight, Greenwich Mean Time (0:00 UT)
Each planet's retrograde period is shaded gray.

2020 Planetary Ephemeris

July 2020 — LONGITUDE

Day	Sid.Time	☉	0 hr ☽	Noon ☽	True Ω	☿	♀	♂	?	♃	♄	♅	♆	♇
1 W	18 38 01	9♋37 43	14♏58 41	22♏05 45	29♋05.9	9♋49.0	5♊56.5	1♈45.7	12♑42.8	24♑01.1	0♒04.0	9♉51.8	20♓56.6	24♑05.5
2 Th	18 41 58	10 34 55	29 11 32	6♐15 38	29 06.8	9R13.0	6 09.9	2 21.4	12 44.7	23R53.8	29♑59.9	9 53.9	20R56.3	24R04.1
3 F	18 45 54	11 32 06	13♐17 38	20 17 05	29 07.6	8 38.0	6 25.3	2 57.0	12 46.4	23 46.5	29 55.9	9 55.9	20 56.0	24 02.7
4 Sa	18 49 51	12 29 17	27 13 37	4♑06 51	29R08.0	8 04.3	6 42.7	3 32.3	12 47.6	23 39.1	29 51.8	9 57.9	20 55.7	24 01.3
5 Su	18 53 47	13 26 28	10♑42 04	17 42 04	29 07.7	7 32.7	7 01.9	4 07.5	12 48.6	23 31.7	29 47.7	9 59.9	20 55.3	23 59.9
6 M	18 57 44	14 23 39	24 23 33	1♒00 40	29 06.7	7 03.8	7 22.9	4 42.4	12 49.1	23 24.2	29 43.5	10 01.8	20 54.9	23 58.5
7 Tu	19 01 41	15 20 49	7♒33 21	14 01 32	29 05.0	6 37.9	7 45.6	5 17.1	12R49.3	23 16.6	29 39.3	10 03.7	20 54.5	23 57.0
8 W	19 05 37	16 18 01	20 25 18	26 44 44	29 02.7	6 15.6	8 10.0	5 51.6	12 49.3	23 09.0	29 35.1	10 05.5	20 54.1	23 55.6
9 Th	19 09 34	17 15 12	3♓00 03	9♓11 31	29 00.1	5 57.4	8 36.1	6 25.9	12 48.8	23 01.4	29 30.8	10 07.3	20 53.6	23 54.2
10 F	19 13 30	18 12 23	15 19 26	21 24 13	28 57.6	5 43.5	9 03.7	7 00.0	12 48.0	22 53.7	29 26.5	10 09.1	20 53.1	23 52.7
11 Sa	19 17 27	19 09 35	27 26 17	3♈26 07	28 55.5	5 34.2	9 32.9	7 33.7	12 46.8	22 46.0	29 22.2	10 10.8	20 52.5	23 51.3
12 Su	19 21 23	20 06 48	9♈24 15	15 21 13	28D54.1	5 30.9	10 03.5	8 07.3	12 45.2	22 38.3	29 17.9	10 12.4	20 51.9	23 49.8
13 M	19 25 20	21 04 01	21 17 36	27 13 59	28 53.6	5 30.7	10 35.4	8 40.6	12 43.3	22 30.6	29 13.5	10 14.1	20 51.3	23 48.4
14 Tu	19 29 16	22 01 14	3♉10 57	9♉09 07	28 54.1	5 36.7	11 08.8	9 13.6	12 41.1	22 22.9	29 09.1	10 15.6	20 50.7	23 46.9
15 W	19 33 13	22 58 28	15 09 03	21 11 20	28 55.3	5 48.1	11 43.4	9 46.3	12 38.5	22 15.1	29 04.7	10 17.2	20 50.0	23 45.5
16 Th	19 37 10	23 55 43	27 16 30	3♊25 03	28 56.9	6 04.9	12 19.3	10 18.8	12 35.5	22 07.4	29 00.3	10 18.7	20 49.3	23 44.0
17 F	19 41 06	24 52 58	9♊37 28	15 54 07	28 58.5	6 27.3	12 56.4	10 50.9	12 32.2	21 59.7	28 55.9	10 20.1	20 48.6	23 42.6
18 Sa	19 45 03	25 50 14	22 15 23	28 41 29	28R59.5	6 55.1	13 34.7	11 22.8	12 28.5	21 52.0	28 51.5	10 21.5	20 47.8	23 41.1
19 Su	19 48 59	26 47 30	5♋12 38	11♋48 53	28 59.5	7 28.5	14 14.0	11 54.4	12 24.4	21 44.3	28 47.1	10 22.9	20 47.1	23 39.7
20 M	19 52 56	27 44 48	18 30 14	25 16 33	28 58.2	8 07.3	14 54.4	12 25.6	12 20.0	21 36.6	28 42.6	10 24.2	20 46.3	23 38.2
21 Tu	19 56 52	28 42 05	2♌07 37	9♌03 04	28 55.6	8 51.5	15 35.9	12 56.5	12 15.3	21 29.0	28 38.2	10 25.5	20 45.4	23 36.8
22 W	20 00 49	29 39 22	16 02 31	23 05 26	28 51.8	9 41.2	16 18.3	13 27.1	12 10.1	21 21.3	28 33.7	10 26.7	20 44.6	23 35.4
23 Th	20 04 45	0♌36 42	0♍11 15	7♍19 23	28 47.2	10 36.2	17 01.6	13 57.3	12 04.7	21 13.8	28 29.3	10 27.9	20 43.7	23 33.9
24 F	20 08 42	1 34 00	14 29 10	21 40 00	28 42.5	11 36.4	17 45.9	14 27.2	11 58.8	21 06.3	28 24.9	10 29.0	20 42.7	23 32.5
25 Sa	20 12 39	2 31 20	28 51 15	6♎02 21	28 38.4	12 41.8	18 31.1	14 56.7	11 52.7	20 58.8	28 20.4	10 30.1	20 41.8	23 31.0
26 Su	20 16 35	3 28 39	13♎12 48	20 22 09	28 35.3	13 52.3	19 17.0	15 25.9	11 46.2	20 51.4	28 16.0	10 31.1	20 40.8	23 29.6
27 M	20 20 32	4 25 59	27 30 01	4♏36 06	28D34.0	15 07.8	20 03.8	15 54.7	11 39.3	20 44.0	28 11.6	10 32.1	20 39.8	23 28.2
28 Tu	20 24 28	5 23 20	11♏40 08	18 41 58	28 34.0	16 28.1	20 51.4	16 23.1	11 32.2	20 36.8	28 07.2	10 33.0	20 38.8	23 26.8
29 W	20 28 25	6 20 40	25 41 26	2♐38 26	28 35.0	17 53.2	21 39.7	16 51.2	11 24.7	20 29.6	28 02.8	10 33.9	20 37.8	23 25.4
30 Th	20 32 21	7 18 02	9♐32 53	16 24 45	28 36.3	19 22.8	22 28.8	17 18.8	11 16.8	20 22.4	27 58.5	10 34.7	20 36.7	23 24.0
31 F	20 36 18	8 15 24	23 13 35	0♑00 22	28R37.4	20 56.7	23 18.1	17 46.1	11 08.7	20 15.4	27 54.2	10 35.5	20 35.6	23 22.6

August 2020 — LONGITUDE

Day	Sid.Time	☉	0 hr ☽	Noon ☽	True Ω	☿	♀	♂	?	♃	♄	♅	♆	♇
1 Sa	20 40 14	9♌12 46	6♑44 01	13♑24 46	28♊37.2	22♋34.8	24♊09.1	18♈12.9	11♑00.3	20♑08.5	27♑49.8	10♉36.3	20♓34.5	23♑21.2
2 Su	20 44 11	10 10 10	20 02 33	26 37 16	28R35.3	24 16.8	25 00.2	18 39.3	10R51.5	20R01.6	27R45.6	10 37.0	20R33.3	23R19.8
3 M	20 48 08	11 07 34	3♒08 50	9♒37 10	28 31.4	26 02.4	25 52.0	19 05.3	10 42.5	19 54.9	27 41.3	10 37.6	20 32.2	23 18.5
4 Tu	20 52 04	12 04 58	16 02 12	22 23 54	28 25.6	27 51.3	26 44.3	19 30.8	10 33.1	19 48.2	27 37.1	10 38.2	20 31.0	23 17.1
5 W	20 56 01	13 02 24	28 42 15	4♓57 18	28 18.4	29 43.2	27 37.3	19 55.9	10 23.5	19 41.6	27 32.9	10 38.7	20 29.8	23 15.8
6 Th	20 59 57	13 59 51	11♓09 09	17 17 53	28 10.2	1♌37.8	28 30.9	20 20.5	10 13.6	19 35.2	27 28.7	10 39.2	20 28.5	23 14.4
7 F	21 03 54	14 57 19	23 23 28	29 26 58	28 02.1	3 34.6	29 25.0	20 44.7	10 03.9	19 28.9	27 24.6	10 39.7	20 27.3	23 13.1
8 Sa	21 07 50	15 54 48	5♈27 50	11♈26 08	27 54.8	5 33.4	0♋19.7	21 08.3	9 53.0	19 22.7	27 20.5	10 40.1	20 26.0	23 11.8
9 Su	21 11 47	16 52 18	17 24 04	23 20 19	27 49.0	7 33.8	1 14.9	21 31.5	9 42.3	19 16.6	27 16.4	10 40.4	20 24.7	23 10.5
10 M	21 15 43	17 49 50	29 15 59	5♉11 38	27 45.0	9 35.3	2 10.6	21 54.1	9 31.3	19 10.6	27 12.4	10 40.7	20 23.4	23 09.2
11 Tu	21 19 40	18 47 23	11♉05 07	17 00 12	27D43.0	11 37.7	3 06.9	22 16.2	9 20.2	19 04.8	27 08.4	10 41.0	20 22.1	23 07.9
12 W	21 23 37	19 44 57	23 04 24	29 06 00	27 42.7	13 40.6	4 03.5	22 37.8	9 08.8	18 59.1	27 04.5	10 41.2	20 20.7	23 06.5
13 Th	21 27 33	20 42 33	5♊10 18	11♊19 09	27 43.5	15 43.7	5 00.7	22 58.8	8 57.1	18 53.5	27 00.6	10 41.4	20 19.4	23 05.1
14 F	21 31 30	21 40 10	17 31 54	23 49 31	27R44.5	17 46.7	5 58.3	23 19.2	8 45.3	18 48.1	26 56.8	10 41.5	20 18.0	23 03.7
15 Sa	21 35 26	22 37 49	0♋11 23	6♋41 23	27 44.9	19 49.5	6 56.3	23 39.0	8 33.3	18 42.8	26 53.0	10R41.5	20 16.6	23 02.9
16 Su	21 39 23	23 35 30	13 16 21	19 57 42	27 43.7	21 51.8	7 54.8	23 58.3	8 21.1	18 37.7	26 49.3	10 41.5	20 15.1	23 01.7
17 M	21 43 19	24 33 11	26 45 29	3♌39 37	27 40.4	23 53.8	8 53.6	24 16.9	8 08.7	18 32.7	26 45.6	10 41.4	20 13.7	23 00.5
18 Tu	21 47 16	25 30 55	10♌39 54	17 44 54	27 34.8	25 54.1	9 52.9	24 34.9	7 56.2	18 27.9	26 41.9	10 41.3	20 12.2	22 59.2
19 W	21 51 12	26 28 39	24 57 03	2♍12 27	27 27.2	27 52.8	10 52.5	24 52.5	7 43.5	18 23.3	26 38.3	10 41.1	20 10.8	22 58.0
20 Th	21 55 09	27 26 25	9♍31 44	16 53 27	27 18.2	29 49.5	11 52.5	25 09.5	7 30.7	18 18.8	26 34.7	10 40.9	20 09.3	22 56.7
21 F	21 59 06	28 24 12	24 16 44	1♎40 33	27 08.9	1♍50.1	12 53.0	25 25.7	7 17.8	18 14.6	26 31.1	10 40.6	20 07.8	22 55.5
22 Sa	22 03 02	29 22 01	9♎00 53	16 25 49	27 00.5	3 46.5	13 53.5	25 40.3	7 04.8	18 10.5	26 27.6	10 40.2	20 06.3	22 54.2
23 Su	22 06 59	0♍19 50	23 46 33	1♏02 16	26 53.9	5 41.6	14 54.5	25 55.0	6 51.7	18 06.3	26 24.1	10 40.1	20 04.8	22 53.7
24 M	22 10 55	1 17 41	8♏05 31	15 24 51	26 49.6	7 35.4	15 55.9	26 09.0	6 38.5	18 02.4	26 21.6	10 39.7	20 03.2	22 52.1
25 Tu	22 14 52	2 15 33	22 30 09	29 30 50	26D47.5	9 27.9	16 57.6	26 22.2	6 25.2	17 58.6	26 18.3	10 39.3	20 01.7	22 50.6
26 W	22 18 48	3 13 26	6♐27 19	13♐19 32	26 47.2	11 19.1	17 59.5	26 34.7	6 11.9	17 55.3	26 15.0	10 38.3	20 00.1	22 49.6
27 Th	22 22 45	4 11 21	20 07 35	26 51 40	26R47.6	13 08.9	19 01.8	26 46.5	5 58.6	17 52.0	26 12.3	10 38.3	19 58.6	22 49.6
28 F	22 26 41	5 09 17	3♑31 58	10♑08 42	26 47.6	14 57.5	20 04.4	26 57.6	5 45.3	17 48.9	26 09.3	10 37.7	19 57.0	22 48.1
29 Sa	22 30 38	6 07 14	16 42 05	23 12 19	26 46.0	16 44.7	21 07.3	27 07.9	5 31.9	17 46.0	26 06.6	10 37.1	19 55.4	22 47.6
30 Su	22 34 34	7 05 12	29 39 32	6♒03 55	26 42.0	18 30.7	22 10.4	27 17.5	5 18.6	17 43.2	26 03.7	10 36.4	19 53.8	22 46.7
31 M	22 38 31	8 03 12	12♒25 33	18 44 33	26 35.2	20 15.3	23 13.9	27 26.2	5 05.3	17 40.7	26 00.9	10 35.7	19 52.2	22 46.1

Bottom data panels

Astro Data

	Dy Hr Mn
Ω R	4 3:25
♄ R	7 4:02
♂ON	11 12:19
♀ ON	12 5:03
♀ D	12 8:28
Ω D	12 8:28
Ω R	18 12:37
◐OS	25 21:35
Ω D	27 12:22
4✶♥	27 0:10
Ω R	31 9:35
♀ ON	8 11:17
Ω D	11 16:53
Ω R	14 19:26
♀ R	15 14:28

Planet Ingress

	Dy Hr Mn
♄ ♑R	1 23:39
☉ Ω	22 8:38
♀ ♊	5 3:33
☿ ♋	7 15:22
♂ ♈	20 1:31
☉ ♍	15:46
♀ 0S22	3:50
♀ D25	17:46
Ω R27	11:55

Last Aspect — ☽ Ingress

Dy Hr Mn		Dy Hr Mn
2 1:22 ♃ ✶	✗	2 1:22
3 13:07 ♀ □	♑	4 4:49
6 9:36 ♄ ♂	♒	6 10:09
7 4:39 ♅ □	♓	8 21:41
11 3:50 ♀ ✶	♈	11 5:07
13 15:55 ♀ □	♉	13 17:13
16 3:22 ♃ △	♊	16 5:20
17 21:16 ♀ ✶	♋	18 15:29
20 17:56 ♃ ✶	Ω	20 20:17
24 23:09 ♀ □	△	25 1:55
27 1:10 ♃ ✗	♏	27 4:13
29 4:02 ♃ ✗	✗	29 7:26
31 0:09 ♀ ♂	♑	31 11:59

Last Aspect — ☽ Ingress

Dy Hr Mn		Dy Hr Mn
2 14:01 ♄ ♂	♒	2 18:12
4 21:47 ♀ △	♓	5 4:31
7 12:55 ♀ □	♈	7 13:06
9 19:51 ♀ ✶	♉	10 1:31
12 7:56 ♃ △	♊	12 13:47
14 11:20 ♂ ✶	♋	15 0:00
17 0:00 ♀ ♂	Ω	17 7:40
19 5:39 ♀ ♂	♍	19 12:30
21 3:38 ♃ △	△	21 9:17
23 4:21 ♃ □	♏	23 12:50
25 6:28 ♃ ✶	✗	25 12:50
27 12:01 ♂ △	♑	27 17:38
29 19:32 ♂ □	♒	30 0:38

☽ Phases & Eclipses

Dy Hr Mn	
5 4:46	○ 13♑38
5 4:44	♣ A 0.354
12 23:30	☽ 21♈03
20 17:34	● 28♋27
27 12:34	☽ 4♏56
3 16:00	○ 11♒46
11 16:46	☽ 19♉28
18 2:42	● 26♌35
25 17:59	☽ 2♐59

Astro Data

1 July 2020
Julian Day # 44012
SVP 4♓58'41"
GC 27♐07.5 ♀ 24♑27.3R
Eris 24♈31.5 ‡ 8♈48.9
δ 9♈23.2 ‡ 11♋49.3
☽ Mean Ω 28♊36.0

1 August 2020
Julian Day # 44043
SVP 4♓58'36"
GC 27♐07.6 ♀ 16♑18.8R
Eris 24♈32.9R ‡ 15♋10.7
δ 9♈15.9R ‡ 25♋25.1
☽ Mean Ω 26♊57.5

*Giving the positions of planets daily at midnight, Greenwich Mean Time (0:00 UT)
Each planet's retrograde period is shaded gray.

2020 Planetary Ephemeris

LONGITUDE — September 2020

Day	Sid.Time	☉	0 hr ☽	Noon ☽	True ☊	☿	♀	♂	♃	♄	♅	♆	♇	
1 Tu	22 42 28	9♍01 13	25♏00 58	1♐14 52	26Ⅱ25.7	21♍58.7	24♋17.6	27♈34.1	4≈52.0	17♑38.3	25♈58.3	10☓34.9	19♑50.6	22♑44.9
2 W	22 46 24	9 59 16	7♐26 20	13 35 23	26R 14.1	23 40.8	25 21.5	27 41.3	4R 38.8	17R 36.1	25R 55.7	10R 34.1	19R 49.0	22R 44.0
3 Th	22 50 21	10 57 20	19 42 06	25 46 35	26 01.5	25 21.7	26 25.8	27 47.7	4 25.7	17 34.1	25 53.3	10 33.2	19 47.3	22 43.1
4 F	22 54 17	11 55 26	1♑48 58	7♑49 23	25 48.0	27 01.3	27 30.3	27 53.2	4 12.6	17 32.2	25 50.9	10 32.3	19 45.7	22 42.3
5 Sa	22 58 14	12 53 34	13 48 03	19 45 13	25 35.9	28 39.7	28 35.0	27 57.9	3 59.6	17 30.6	25 48.5	10 31.3	19 44.1	22 41.5
6 Su	23 02 10	13 51 44	25 41 12	1♒36 19	25 25.7	0♎17.0	29 40.0	28 01.7	3 46.8	17 29.2	25 46.3	10 30.3	19 42.4	22 40.7
7 M	23 06 07	14 49 56	7♒31 01	13 25 45	25 17.9	1 53.0	0♌45.2	28 04.7	3 34.0	17 27.9	25 44.1	10 29.3	19 40.8	22 39.9
8 Tu	23 10 03	15 48 09	19 20 01	25 17 22	25 12.9	3 27.9	1 50.7	28 06.9	3 21.4	17 26.8	25 42.1	10 28.2	19 39.1	22 39.2
9 W	23 14 00	16 46 25	1♓15 25	7♓15 46	25 10.3	5 01.6	2 56.3	28R08.0	3 08.9	17 26.0	25 40.1	10 27.0	19 37.5	22 38.4
10 Th	23 17 57	17 44 43	13 19 05	19 26 03	25 09.5	6 34.1	4 02.3	28 08.5	2 56.6	17 25.3	25 38.2	10 25.8	19 35.8	22 37.8
11 F	23 21 53	18 43 03	25 37 18	1♈53 31	25 09.5	8 05.5	5 08.4	28 08.0	2 44.4	17 24.8	25 36.4	10 24.6	19 34.2	22 37.1
12 Sa	23 25 50	19 41 25	8♈15 19	14 43 17	25 09.1	9 35.8	6 14.7	28 06.6	2 32.5	17 24.5	25 34.7	10 23.3	19 32.5	22 36.5
13 Su	23 29 46	20 39 49	21 17 52	27 59 30	25 07.3	11 04.8	7 21.3	28 04.3	2 20.7	17D 24.4	25 33.1	10 22.0	19 30.9	22 35.8
14 M	23 33 43	21 38 15	4♉48 25	11♉44 43	25 03.1	12 32.8	8 28.0	28 01.2	2 09.1	17 24.5	25 31.6	10 20.7	19 29.2	22 35.2
15 Tu	23 37 39	22 36 43	18 48 19	25 58 53	24 56.3	13 59.5	9 35.0	27 57.1	1 57.8	17 24.8	25 30.1	10 19.3	19 27.6	22 34.6
16 W	23 41 36	23 35 13	3♊11 56	10♊38 43	24 47.0	15 25.1	10 42.1	27 52.2	1 46.6	17 25.3	25 28.7	10 18.0	19 25.9	22 34.1
17 Th	23 45 33	24 33 45	18 06 17	25 37 30	24 36.1	16 49.4	11 49.5	27 46.3	1 35.8	17 25.9	25 27.6	10 16.6	19 24.3	22 33.6
18 F	23 49 29	25 32 20	3♋11 08	10♋45 51	24 24.7	18 12.6	12 57.0	27 39.7	1 25.1	17 26.8	25 26.4	10 15.2	19 22.6	22 33.1
19 Sa	23 53 26	26 30 55	18 20 19	25 53 14	24 14.1	19 34.4	14 04.7	27 32.1	1 14.8	17 27.8	25 25.4	10 13.9	19 21.0	22 32.7
20 Su	23 57 22	27 29 33	3♌25 23	10♌49 51	24 05.6	20 55.0	15 12.5	27 23.7	1 04.7	17 29.1	25 24.4	10 12.5	19 19.3	22 32.3
21 M	0 01 19	28 28 13	18 11 42	25 28 19	23 59.8	22 14.2	16 20.6	27 14.5	0 54.8	17 30.5	25 23.5	10 11.1	19 17.7	22 31.9
22 Tu	0 05 15	29 26 54	2♍39 17	9♍44 19	23 56.3	23 32.1	17 28.8	27 04.6	0 45.3	17 32.2	25 22.6	10 09.8	19 16.1	22 31.5
23 W	0 09 12	0♎25 37	16 43 23	23 36 32	23D 55.5	24 48.4	18 37.1	26 53.8	0 36.1	17 34.0	25 21.6	10 08.4	19 14.5	22 31.2
24 Th	0 13 08	1 24 22	0♀23 58	7♀05 57	23R 55.5	26 03.3	19 45.7	26 42.3	0 27.2	17 36.0	25 20.7	10 07.0	19 12.9	22 30.8
25 F	0 17 05	2 23 08	13 42 49	20 14 57	23 55.1	27 16.6	20 54.4	26 30.0	0 18.6	17 38.2	25 19.8	10 05.6	19 11.2	22 30.5
26 Sa	0 21 01	3 21 56	26 42 45	3♏05 43	23 53.4	28 28.2	22 03.2	26 17.1	0 10.3	17 40.6	25 20.7	10 01.3	19 09.7	22 30.3
27 Su	0 24 58	4 20 46	9♏26 51	15 43 54	23 49.2	29 38.0	23 12.2	26 03.4	0 02.3	17 43.2	25 20.5	9 59.5	19 08.1	22 30.0
28 M	0 28 55	5 19 38	21 58 02	28 09 33	23 42.2	0♏45.5	24 21.3	25 49.2	29≈54.7	17 46.0	25 20.3	9 57.6	19 06.5	22 29.8
29 Tu	0 32 51	6 18 31	4♐18 43	10♐25 44	23 32.4	1 51.8	25 30.6	25 34.3	29 47.4	17 49.0	25D 20.2	9 55.7	19 04.9	22 29.7
30 W	0 36 48	7 17 26	16 30 47	22 34 04	23 20.4	2 55.5	26 40.1	25 18.8	29 40.4	17 52.1	25 20.3	9 53.8	19 03.4	22 29.5

LONGITUDE — October 2020

Day	Sid.Time	☉	0 hr ☽	Noon ☽	True ☊	☿	♀	♂	♃	♄	♅	♆	♇	
1 Th	0 40 44	8♎16 23	28♐35 42	4♑33 51	23Ⅱ07.0	3♏56.9	27♌49.7	25♈02.8	29≈33.8	17♑55.4	25♈20.4	9☓51.8	19♑01.8	22♑29.4
2 F	0 44 41	9 15 22	10♑34 38	16 32 14	22R 53.5	4 55.7	28 59.4	24R46.3	29R 27.5	17 58.9	25 20.6	9R 49.8	19R 00.3	22R 29.3
3 Sa	0 48 37	10 14 23	22 28 47	28 24 29	22 40.8	5 51.8	0♍09.3	24 29.4	29 21.6	18 02.6	25 20.9	9 47.8	18 58.8	22 29.2
4 Su	0 52 34	11 13 26	4♒19 34	10♒14 16	22 30.1	6 44.9	1 19.3	24 11.9	29 16.0	18 06.5	25 21.4	9 45.7	18 57.3	22D 29.2
5 M	0 56 30	12 12 32	16 08 54	22 03 49	22 21.9	7 34.8	2 29.4	23 54.2	29 10.8	18 10.5	25 21.9	9 43.6	18 55.8	22 29.2
6 Tu	1 00 27	13 11 39	27 59 23	3♓56 03	22 16.5	8 21.2	3 39.7	23 36.0	29 05.9	18 14.8	25 22.5	9 41.5	18 54.3	22 29.2
7 W	1 04 24	14 10 49	9♓54 17	15 54 38	22 13.7	9 03.8	4 50.2	23 17.6	29 01.4	18 19.2	25 23.2	9 39.3	18 52.8	22 29.3
8 Th	1 08 20	15 10 01	21 57 39	28 03 56	22D 13.1	9 42.1	6 00.7	22 58.7	28 57.3	18 23.7	25 24.1	9 37.2	18 51.4	22 29.4
9 F	1 12 17	16 09 16	4♈13 04	10♈25 28	22 13.4	10 15.9	7 11.4	22 40.0	28 53.5	18 28.5	25 25.0	9 35.0	18 50.0	22 29.5
10 Sa	1 16 13	17 08 34	16 48 35	23 14 08	22R 13.7	10 44.6	8 22.2	22 21.0	28 50.1	18 33.4	25 26.0	9 32.8	18 48.5	22 29.6
11 Su	1 20 10	18 07 51	29 45 58	6♉29 53	22 13.1	11 07.9	9 33.1	22 02.0	28 47.1	18 38.5	25 27.1	9 30.5	18 47.1	22 29.8
12 M	1 24 06	19 07 13	13♉07 10	20 03 34	22 10.6	11 25.3	10 44.2	21 42.6	28 44.4	18 43.8	25 28.3	9 28.3	18 45.8	22 30.0
13 Tu	1 28 03	20 06 36	27 04 19	4♊12 22	22 05.8	11 36.1	11 55.3	21 23.4	28 42.1	18 49.2	25 29.7	9 26.0	18 44.4	22 30.2
14 W	1 31 59	21 06 02	11♊27 47	18 49 42	21 58.7	11R 40.2	13 06.5	21 04.2	28 40.2	18 54.8	25 31.1	9 23.7	18 43.1	22 30.5
15 Th	1 35 56	22 05 30	26 17 26	3♋50 23	21 50.1	11 36.7	14 18.0	20 45.2	28 38.6	19 00.6	25 32.6	9 21.4	18 41.7	22 30.8
16 F	1 39 53	23 05 01	11♋26 17	19 04 53	21 40.8	11 25.4	15 29.5	20 26.3	28 37.4	19 06.5	25 34.2	9 19.1	18 40.4	22 31.1
17 Sa	1 43 49	24 04 33	26 44 24	4♍23 25	21 32.2	11 05.7	16 41.1	20 07.7	28 36.6	19 12.6	25 35.9	9 16.7	18 39.2	22 31.5
18 Su	1 47 46	25 04 07	12♍00 32	19 34 28	21 25.2	10 37.6	17 52.8	19 49.1	28D 36.1	19 18.9	25 37.7	9 14.3	18 37.9	22 31.9
19 M	1 51 42	26 03 44	27 04 05	4♎28 27	21 20.5	10 00.7	19 04.6	19 31.0	28 36.1	19 25.3	25 39.6	9 12.0	18 36.7	22 32.3
20 Tu	1 55 39	27 03 22	11♎46 51	18 58 48	21D 18.2	9 15.3	20 16.4	19 13.4	28 36.7	19 31.9	25 41.7	9 09.6	18 35.4	22 32.7
21 W	1 59 35	28 03 02	26♎03 59	3♏02 20	21 17.9	8 21.8	21 28.4	18 56.3	28 37.8	19 38.7	25 43.8	9 07.2	18 34.3	22 33.2
22 Th	2 03 32	29 02 44	9♏53 53	16 38 50	21 18.8	7 20.9	22 40.5	18 39.9	28 39.3	19 45.6	25 46.0	9 04.8	18 33.1	22 33.7
23 F	2 07 28	0♏02 28	23 17 39	29 50 19	21R 19.4	6 13.6	23 52.7	18 24.0	28 41.2	19 52.7	25 48.3	9 02.4	18 31.9	22 34.3
24 Sa	2 11 25	1 02 13	6♐17 00	12♐40 40	21 19.8	5 01.4	25 05.0	18 08.7	28 43.5	19 59.7	25 50.6	8 59.9	18 30.8	22 34.8
25 Su	2 15 22	2 02 00	18 57 30	25 11 53	21 18.1	3 46.2	26 17.3	17 51.3	28 46.1	20 07.1	25 53.1	8 57.4	18 29.7	22 35.4
26 M	2 19 18	3 01 48	1♑22 13	7♑29 03	21 14.4	2 30.2	27 29.7	17 36.6	28 49.1	20 14.6	25 55.6	8 54.9	18 28.7	22 36.1
27 Tu	2 23 15	4 01 38	13 34 36	19 38 16	21 08.6	1 15.5	28 42.2	17 22.2	28 52.5	20 22.2	25 58.4	8 52.5	18 27.6	22 36.7
28 W	2 27 11	5 01 30	25 37 36	1♒35 44	21 01.0	0 04.5	29 54.8	17 09.0	28 56.3	20 30.0	26 01.1	8 50.1	18 26.6	22 37.4
29 Th	2 31 08	6 01 24	7♒33 14	13 31 34	20 52.4	28♎59.7	1♎07.5	16 56.2	29 00.4	20 37.9	26 04.0	8 47.6	18 25.6	22 38.1
30 F	2 35 04	7 01 19	19 27 47	25 23 30	20 43.6	28 02.2	2 20.3	16 44.1	29 04.8	20 46.0	26 06.9	8 45.1	18 24.6	22 38.8
31 Sa	2 39 01	8 01 17	1♓18 56	7♓14 18	20 35.4	27 14.4	3 33.1	16 32.7	29 09.4	20 54.2	26 09.9	8 42.7	18 23.7	22 39.5

Astro Data / Planet Ingress / Aspects / Phases

Astro Data Dy Hr Mn	Planet Ingress Dy Hr Mn	Last Aspect Dy Hr Mn	☽ Ingress Dy Hr Mn	Last Aspect Dy Hr Mn	☽ Ingress Dy Hr Mn	☽ Phases & Eclipses Dy Hr Mn	Astro Data
☽0N 4 18:51	☿ ♎ 5 19:47	1 4:57 ♂ □ ☿	♓ 1 9:35	30 17:31 ♄ □	♈ 1 2:48	2 5:23 ○ 10♓12	1 September 2020
⍦0S 6 6:27	♀ ♋ 6 7:23	3 14:35 ♀ △	♈ 3 20:23	3 5:48 ♄ □	♉ 3 15:14	10 9:27 ☾ 18♊08	Julian Day # 44074
♂ R 9 22:24	☉ ♎ 22 13:32	6 4:46 ♂ ♂	♉ 6 8:45	5 18:42 ♄ △	♊ 6 4:04	17 11:01 ● 25♍01	SVP 4♓58'32"
4 D 13 0:42	♀ ♍R 27 7:09	8 12:48 ♄ △	♊ 8 21:05	8 1:58 ♂ △	♋ 8 15:05	24 1:56 ☽ 1♑29	GC 27♐07.7 ♀ 12♍17.1R
☽0S 18 12:37	☿ ♏ 27 7:42	11 4:49 ♂ △	♋ 11 8:24	10 16:05 ♄ ♂	♌ 11 0:26		Eris 24♈24.5R ⚷ 23♋54.7
○0S 22 13:32		13 12:06 ♂ □	♌ 13 15:34	12 14:31 ♂ □	♍ 13 7:08		δ 8♉23.4R ⚵ 8♌54.1
♀ D 23 12:29	♀ ♏ 2 20:49	15 15:11 ♂ △	♍ 15 18:38	14 22:48 ♄ △	♎ 15 5:55	1 21:06 ○ 9♈08	☽ Mean ☊ 25Ⅱ19.0
♀ D 23 12:29	○ ♏ 22 23:01	17 11:43 ♄ △	♎ 17 18:57	16 22:13 ♄ ♂	♏ 17 5:00	10 0:41 ☾ 17♋10	
♄ D 29 5:13	♀ ♍R 28 1:35	19 14:30 ♂ ♂	♏ 19 18:34	18 21:44 ♀ ☌	♐ 19 4:44	16 19:32 ● 23♎53	1 October 2020
♀ D 29 5:13	♀ ☌ 28 1:42	21 18:14 ○ ∗	♐ 21 19:33	21 4:36 ♀ ☌	♑ 21 6:10	23 13:24 ☽ 0♑36	Julian Day # 44104
♇ D 4 13:34		23 17:33 ♂ △	♑ 23 23:17	23 4:36 ♄ ☌	♒ 23 12:18	31 14:50 ○ 8♉38	SVP 4♓58'29"
♀ D 8 0:30		26 3:37 ♀ □	♒ 26 6:09	25 23:04 ♄ ∗	♓ 25 21:20		GC 27♐07.7 ♀ 13♍56.5
♀ D 10 0:52		28 7:19 ♂ ∗	♓ 28 15:35	28 0:47 ♄ ∗	♈ 28 8:46		Eris 24♈09.5R ⚷ 25♋26.1
4∗♀ 12 7:07				30 16:14 ♀ ♂	♉ 30 21:20		δ 7♉06.4R ⚵ 21♌32.2
♀ R 14 1:06							☽ Mean ☊ 23Ⅱ43.7

*Giving the positions of planets daily at midnight, Greenwich Mean Time (0:00 UT)
Each planet's retrograde period is shaded gray.

2020 PLANETARY EPHEMERIS

November 2020 — LONGITUDE

Day	Sid.Time	☉	0 hr ☽	Noon ☽	True ☊	☿	♀	♂	♃	♄	♅	♆	♇	
1 Su	2 42 57	9♏01 16	13♊09 47	19♋05 37	20♊R28.5	26♎37.2	4♎46.0	16♈22.0	21♑02.5	26♑13.1	8♉R40.2	18♓R22.8	22♑40.3	
2 M	2 46 54	10 01 17	25 02 00	0♌59 13	20R 23.5	26R 11.3	5 59.1	16R 12.0	21 11.0	26 16.3	8 37.7	18R 21.9	22 41.2	
3 Tu	2 50 50	11 01 20	6♊51 37	12 57 12	20 20.5	25♎57.0	7 12.1	16 02.9	29 17.7	21 19.6	26 19.6	8 35.3	18 21.0	22 42.0
4 W	2 54 47	12 01 25	18 58 36	25 02 05	20D 19.5	25 54.2	8 25.3	15 54.4	29 23.2	21 28.4	26 22.9	8 32.8	18 20.2	22 42.9
5 Th	2 58 44	13 01 32	1♋08 02	7♋16 54	20 20.6	26 02.6	9 38.5	15 46.8	29 29.0	21 37.2	26 26.4	8 30.3	18 19.4	22 43.8
6 F	3 02 40	14 01 42	13 29 07	19 45 10	20 21.5	26 21.5	10 51.8	15 40.0	29 35.2	21 46.3	26 30.0	8 27.9	18 18.6	22 44.7
7 Sa	3 06 37	15 01 54	26 05 31	2♌30 40	20 23.1	26 50.1	12 05.2	15 33.9	29 41.6	21 55.4	26 33.8	8 25.4	18 17.9	22 45.7
8 Su	3 10 33	16 02 06	9♌01 05	15 37 12	20R 24.3	27 27.7	13 18.6	15 28.7	29 48.4	22 04.7	26 37.3	8 23.0	18 17.2	22 46.6
9 M	3 14 30	17 02 21	22 09 54	28 07 44	20 24.4	28 13.4	14 32.1	15 24.2	29 55.5	22 14.0	26 41.1	8 20.5	18 16.5	22 47.7
10 Tu	3 18 26	18 02 38	5♍03 00	13♍00 42	20 23.1	29 06.2	15 45.7	15 20.5	0♒02.9	22 23.6	26 45.0	8 18.1	18 15.9	22 48.7
11 W	3 22 23	19 02 58	20 12 56	27 27 26	20 20.4	0♏05.3	16 59.3	15 17.7	0 10.5	22 33.2	26 49.0	8 15.7	18 15.3	22 49.7
12 Th	3 26 20	20 03 19	4♎47 43	12♎13 08	20 16.5	1 09.9	18 13.0	15 15.7	0 18.5	22 42.9	26 53.1	8 13.3	18 14.7	22 50.8
13 F	3 30 16	21 03 42	19 42 52	27 15 53	20 12.2	2 19.3	19 26.8	15 14.4	0 26.8	22 52.8	26 57.2	8 10.9	18 14.1	22 51.9
14 Sa	3 34 13	22 04 07	4♏55 10	12♏27 06	20 08.1	3 32.8	20 40.6	15D 14.0	0 35.4	23 02.8	27 01.4	8 08.5	18 13.6	22 53.1
15 Su	3 38 09	23 04 34	20 02 48	27 36 50	20 04.8	4 49.7	21 54.4	15 14.4	0 44.2	23 12.9	27 05.7	8 06.1	18 13.1	22 54.3
16 M	3 42 06	24 05 02	5♐08 02	12♐35 17	20 02.7	6 09.7	23 08.4	15 15.6	0 53.4	23 23.1	27 10.1	8 03.8	18 12.6	22 55.4
17 Tu	3 46 02	25 05 32	19 57 39	27 14 21	20D 02.1	7 32.2	24 22.3	15 17.6	1 02.8	23 33.4	27 14.5	8 01.4	18 12.2	22 56.7
18 W	3 49 59	26 06 04	4♑27 36	11♑28 41	20 02.6	8 56.7	25 36.3	15 20.3	1 12.5	23 43.9	27 19.0	7 59.1	18 11.8	22 57.9
19 Th	3 53 55	27 06 37	18 25 42	25 15 50	20 03.9	10 23.1	26 50.4	15 23.9	1 22.5	23 54.4	27 23.7	7 56.8	18 11.5	22 59.2
20 F	3 57 52	28 07 11	1♒59 12	8♒36 01	20 05.5	11 50.9	28 04.5	15 28.2	1 32.7	24 05.1	27 28.3	7 54.5	18 11.2	23 00.5
21 Sa	4 01 49	29 07 46	15 06 38	21 31 27	20 06.8	13 19.9	29 18.6	15 33.3	1 43.3	24 15.9	27 33.1	7 52.3	18 10.9	23 01.8
22 Su	4 05 45	0♐08 23	27 50 57	4♓05 39	20R 07.4	14 49.9	0♏32.8	15 39.1	1 54.0	24 26.7	27 37.9	7 50.0	18 10.6	23 03.1
23 M	4 09 42	1 09 00	10♓16 05	16 22 47	20 06.1	16 20.8	1 47.1	15 45.7	2 05.1	24 37.7	27 42.8	7 47.8	18 10.4	23 04.5
24 Tu	4 13 38	2 09 39	22 26 19	28 27 13	20 05.9	17 52.3	3 01.3	15 53.0	2 16.4	24 48.7	27 47.7	7 45.6	18 10.2	23 05.8
25 W	4 17 35	3 10 19	4♈27 26	10♈23 09	20 03.9	19 24.3	4 15.6	16 01.0	2 27.9	24 59.9	27 52.7	7 43.4	18 10.0	23 07.2
26 Th	4 21 31	4 11 00	16 19 10	22 14 27	20 01.6	20 56.7	5 30.0	16 09.7	2 39.7	25 11.2	27 57.9	7 41.3	18 09.9	23 08.7
27 F	4 25 28	5 11 42	28 09 26	4♉04 29	19 59.0	22 29.5	6 44.3	16 19.1	2 51.7	25 22.5	28 03.0	7 39.2	18 09.8	23 10.1
28 Sa	4 29 24	6 12 26	9♉59 55	15 56 04	19 56.7	24 02.5	7 58.8	16 29.2	3 04.0	25 33.9	28 08.2	7 37.1	18 09.8	23 11.6
29 Su	4 33 21	7 13 10	21 53 13	27 51 37	19 54.9	25 35.7	9 13.2	16 39.3	3 16.5	25 45.5	28 13.5	7 35.0	18D 09.8	23 13.0
30 M	4 37 18	8 13 56	3♊51 30	9♊53 05	19 53.8	27 09.1	10 27.7	16 51.2	3 29.2	25 57.1	28 18.9	7 33.0	18 09.8	23 14.6

December 2020 — LONGITUDE

Day	Sid.Time	☉	0 hr ☽	Noon ☽	True ☊	☿	♀	♂	♃	♄	♅	♆	♇	
1 Tu	4 41 14	9♐14 43	15♊56 35	22♊02 11	19♊R53.3	28♏42.5	11♏42.2	17♈03.2	3♒42.2	26♑08.8	28♈24.3	7♉R31.0	18♓09.8	23♑16.1
2 W	4 45 11	10 15 31	28 10 06	4♋20 30	19D 53.3	0♐16.1	12 56.8	17 15.8	3 55.3	26 20.6	28 29.8	7R 29.0	18 09.9	23 17.6
3 Th	4 49 07	11 16 21	10♋33 37	16 49 38	19 53.9	1 49.7	14 11.4	17 29.0	4 08.7	26 32.5	28 35.3	7 27.1	18 10.0	23 19.2
4 F	4 53 04	12 17 11	23 08 47	29 31 16	19 54.6	3 23.4	15 26.0	17 42.7	4 22.4	26 44.4	28 40.9	7 25.2	18 10.2	23 20.8
5 Sa	4 57 00	13 18 03	5♌57 19	12♌27 10	19 55.4	4 57.1	16 40.7	17 57.1	4 36.2	26 56.5	28 46.6	7 23.3	18 10.4	23 22.4
6 Su	5 00 57	14 18 57	19 01 02	25 39 09	19 56.0	6 30.8	17 55.4	18 12.0	4 50.2	27 08.6	28 52.3	7 21.5	18 10.6	23 24.0
7 M	5 04 53	15 19 51	2♍20 11	9♍04 49	19 56.4	8 04.5	19 10.1	18 27.5	5 04.5	27 20.8	28 58.1	7 19.7	18 10.9	23 25.7
8 Tu	5 08 50	16 20 47	15 54 14	22 57 14	19R 56.5	9 38.3	20 24.9	18 43.4	5 18.9	27 33.1	29 03.9	7 17.9	18 11.2	23 27.3
9 W	5 12 47	17 21 44	29 58 32	7♎04 26	19 56.4	11 12.1	21 39.7	19 00.0	5 33.6	27 45.4	29 09.8	7 16.1	18 11.5	23 29.0
10 Th	5 16 43	18 22 42	14♎14 43	21 29 01	19 56.3	12 45.9	22 54.5	19 17.0	5 48.4	27 57.9	29 15.7	7 14.4	18 11.8	23 30.7
11 F	5 20 40	19 23 42	28 44 16	6♏00 46	19D 56.2	14 19.8	24 09.3	19 34.5	6 03.3	28 10.4	29 21.7	7 12.8	18 12.2	23 32.4
12 Sa	5 24 36	20 24 43	13♏09 56	20 55 34	19 56.2	15 53.7	25 24.2	19 52.6	6 18.7	28 22.9	29 27.7	7 11.2	18 12.7	23 34.1
13 Su	5 28 33	21 25 44	28 02 50	5♐47 47	19 56.3	17 27.7	26 39.0	20 11.1	6 34.2	28 35.6	29 33.8	7 09.6	18 13.1	23 35.8
14 M	5 32 29	22 26 47	13♐29 08	20 30 56	19R 56.4	19 01.7	27 53.9	20 30.1	6 49.8	28 48.3	29 40.0	7 08.1	18 13.6	23 37.6
15 Tu	5 36 26	23 27 51	27 49 17	5♑03 42	19 56.4	20 35.9	29 08.9	20 49.6	7 05.6	29 01.1	29 46.1	7 06.6	18 14.2	23 39.4
16 W	5 40 22	24 28 55	12♑13 27	19 17 58	19 56.1	22 10.1	0♐23.8	21 09.5	7 21.6	29 13.9	29 52.4	7 05.1	18 14.7	23 41.2
17 Th	5 44 19	25 30 00	26 16 15	3♒08 30	19 55.6	23 44.5	1 38.8	21 29.7	7 37.8	29 26.8	29 58.8	7 03.7	18 15.3	23 43.0
18 F	5 48 16	26 31 06	9♒56 01	16 36 18	19 54.9	25 19.0	2 53.7	21 50.7	7 54.1	29 39.8	0♉05.0	7 02.3	18 16.0	23 44.8
19 Sa	5 52 12	27 32 11	23 10 26	29 38 36	19 53.9	26 53.6	4 08.7	22 11.9	8 10.6	29 52.9	0 11.4	7 01.0	18 16.7	23 46.6
20 Su	5 56 09	28 33 17	6♓01 07	12♓18 24	19 53.0	28 28.4	5 23.7	22 33.6	8 27.3	0♒05.9	0 17.8	6 59.7	18 17.4	23 48.4
21 M	6 00 05	29 34 23	18 30 54	24 39 07	19D 52.4	0♑03.4	6 38.7	22 55.6	8 44.2	0 19.1	0 24.2	6 58.5	18 18.1	23 50.3
22 Tu	6 04 02	0♑35 30	0♈43 38	6♈45 01	19 52.1	1 38.6	7 53.8	23 18.0	9 01.2	0 32.3	0 30.7	6 57.3	18 18.9	23 52.1
23 W	6 07 58	1 36 37	12 43 32	18 40 48	19 52.4	3 13.9	9 08.8	23 40.8	9 18.3	0 45.5	0 37.2	6 56.1	18 19.7	23 54.0
24 Th	6 11 55	2 37 43	24 36 23	0♉31 14	19 53.2	4 49.5	10 23.8	24 04.0	9 35.7	0 58.8	0 43.8	6 55.0	18 20.5	23 55.9
25 F	6 15 51	3 38 50	6♉25 54	12 20 56	19 54.5	6 25.3	11 38.9	24 27.5	9 53.1	1 12.2	0 50.4	6 54.0	18 21.4	23 57.8
26 Sa	6 19 48	4 39 58	18 16 50	24 14 05	19 55.9	8 01.3	12 54.0	24 51.4	10 10.8	1 25.6	0 57.0	6 53.0	18 22.3	23 59.7
27 Su	6 23 45	5 41 05	0♊13 07	6♊14 20	19 57.2	9 37.6	14 09.1	25 15.6	10 28.5	1 39.0	1 03.7	6 52.0	18 23.2	24 01.6
28 M	6 27 41	6 42 13	12 18 04	18 24 36	19R 58.1	11 14.1	15 24.1	25 40.2	10 46.5	1 52.5	1 10.4	6 51.1	18 24.2	24 03.5
29 Tu	6 31 34	7 43 20	24 34 12	0♋54 47	19 58.2	12 50.9	16 39.2	26 05.0	11 04.5	2 06.1	1 17.1	6 50.2	18 25.2	24 05.5
30 W	6 35 34	8 44 28	7♋03 18	13 22 02	19 57.3	14 28.0	17 54.4	26 30.2	11 22.7	2 19.7	1 23.9	6 49.4	18 26.2	24 07.4
31 Th	6 39 31	9 45 36	19 46 19	26 13 08	19 55.5	16 05.9	19 09.5	26 55.7	11 41.1	2 33.3	1 30.7	6 48.7	18 27.3	24 09.3

Astro Data

	Dy Hr Mn
♀ D	3 17:51
♄⚷R	4 2:40
⚷R	8 14:00
⟩OS	12 10:34
4♂P	12 21:40
♂ D	14 0:37
⚷R	22 4:40
⟩ON	25 14:04
♀ D	29 0:37
⚷ D	1 7:42
⚷ D	6 0:53
⟩OS	9 19:22
⟩ D	11 11:37
⚷R	14 11:30

Planet Ingress

	Dy Hr Mn
♂ ⚷	9 14:49
♀ ♍	10 21:57
♀ ⚷	21 13:23
☉ ✗	21 20:41
♀ ♐	1 19:52
♀ ♑	15 16:22
⚷ ✗	17 5:05
♅ ♈	19 13:08
☉ ♑	21 10:02
⚷ ♑	21 18:22
4♂♑	21 18:22
♄♑ D	21 23:31
⚷ R	28 15:07

Last Aspect / ⟩ Ingress

Last Aspect Dy Hr Mn	⟩ Ingress Dy Hr Mn
2 2:31 ♀ △	II 2 10:01
4 13:50 ♀ △	♌ 4 21:47
7 1:28 ♀ □	♈ 7 7:19
9 11:06 ♂ ✶	♍ 9 19:51
11 11:00 ♀ △	≏ 11 16:11
13 11:34 ♄ □	♏ 13 16:20
15 11:14 ♀ ✶	✗ 15 15:48
17 7:56 ♀ ✶	♑ 17 16:31
19 16:31 ♀ ✶	≈ 19 20:26
21 0:50 ♂ ✶	♓ 21 4:07
23 6:33	♈ 24 15:06
26 23:47 ♄ □	♉ 27 3:44
29 12:50 ♀ △	II 29 16:17

Last Aspect / ⟩ Ingress

Last Aspect Dy Hr Mn	⟩ Ingress Dy Hr Mn
1 4:23 ♀ □	♊ 2 3:34
4 10:30 ♀ ♂	♋ 4 12:54
5 22:29 ♂ △	♌ 6 19:47
8 22:36 ♀ △	♍ 9 9:31
10 0:57 ♀ □	≏ 11 2:00
13 1:59 ♀ ✶	♏ 13 2:40
14 18:10 ☉ ♂	✗ 15 3:36
16 5:30 ♀ ✶	♑ 17 6:28
18 8:46 ♀ ✶	≈ 19 12:00
21 10:26 ♀ ✶	♓ 21 21:22
23 22:52 ♂ □	♈ 24 10:57
26 11:33 ♀ △	♉ 26 23:29
29 3:02 ♂ ✶	♊ 29 10:29
31 13:46 ♀ □	♋ 31 18:59

⟩ Phases & Eclipses

Dy Hr Mn	
8 13:47	◑ 16♌37
15 5:08	● 23♏18
22 4:46	◐ 0♒20
30 9:31	○ 8♊38
30 9:44	✦ A 0.828
8 0:38	◑ 16♍22
14 16:14:39	✦ T 02'10"
21 23:42	◐ 0♈35
30 3:29	○ 8♋53

Astro Data

1 November 2020
Julian Day # 44135
SVP 4♓58'26"
GC 27✗07.8 ♀ 19♌50.9
Eris 23♈51.2R ⚷ 5♉48.5R
 5♉48.5R ⚷ 3♏37.3
⟩ Mean Ω 22♑05.2

1 December 2020
Julian Day # 44165
SVP 4♓58'24"
GC 27✗07.9 ♀ 28♌01.3
Eris 23♈35.8R ⚷ 13♏29.1
 5♉02.6R ⚷ 13♏29.1
⟩ Mean Ω 20♑29.9

*Giving the positions of planets daily at midnight, Greenwich Mean Time (0:00 UT)
Each planet's retrograde period is shaded gray.

2020 ASTEROID EPHEMERIS

Ceres, Pallas, Juno, Vesta — Longitude

2020	Ceres	Pallas	Juno	Vesta
JAN 1	17♍54.2	22♐51.5	17♎21.8	12♑06.5
JAN 11	21 54.0	26 59.1	19 12.9	12♑36.6
JAN 21	25 53.6	1♑01.4	20 35.3	13 45.5
JAN 31	29 52.0	4 57.0	21 25.1	15 28.6
FEB 10	3♎48.2	8 44.4	21R39.0	17 40.9
FEB 20	7 41.2	12 22.0	21 15.1	20 17.3
MAR 1	11 30.1	15 48.1	20 13.1	23 14.2
MAR 11	15 13.7	19 00.4	18 36.5	26 27.9
MAR 21	18 51.0	21 56.7	16 32.6	29 56.3
MAR 31	22 20.5	24 34.2	14 13.0	3♒34.3
APR 10	25 40.7	26 49.6	11 51.3	7 22.8
APR 20	28 50.3	28 39.6	9 41.4	11 18.9
APR 30	1♏47.1	29 59.9	7 54.7	15 29.2
MAY 10	4 29.0	0♒46.6	6 38.8	19 41.8
MAY 20	6 53.8	0R55.8	5 57.1	23 41.2
MAY 30	8 58.2	0 24.5	5♎49.8	27 56.6
JUN 9	10 39.3	29♑12.0	6 15.0	2♓14.7
JUN 19	11 53.8	27 21.0	7 09.5	6 34.9
JUN 29	12 37.9	24 58.7	8 34.0	10 56.7
JUL 9	12R24.8	22 17.5	10 12.9	15 19.4
JUL 19	12 24.5	19 32.6	12 14.9	19 42.8
JUL 29	11 24.8	17 00.1	14 33.4	24 06.1
AUG 8	9 53.1	14 53.1	17 00.1	28 28.9
AUG 18	7 56.3	13 21.3	19 32.6	2♈50.7
AUG 28	5 45.4	12 12.6	22 07.7	7 10.9
SEP 7	3 34.1	12 33.6	24 44.6	11 28.6
SEP 17	1 35.9	13 27.0	27 25.5	15 43.2
SEP 27	0 02.4	14 48.7	0♏10.8	20 02.6
OCT 7	29♎01.5	16 34.5	2 57.2	24 17.7
OCT 17	28 36.7	18 41.0	5 47.3	28 29.3
OCT 27	28R04.6	21 04.7	8 38.2	2♉20.9
NOV 6	29 35.2	23 42.7	11 32.4	6 11.7
NOV 16	0♏53.4	26 32.6	14 29.0	9 14.1
NOV 26	2 39.7	29 32.1	17 29.1	12 01.3
DEC 6	4 50.2	2♒39.4	20 31.5	14 51.4
DEC 16	7 21.6	5 52.8	23 36.8	17 17.6
DEC 26	10 10.7	9 40.7	26♏41.0	19 14.6
JAN 5	13♏14.7	9♒40.7	—	—

Ceres, Pallas, Juno, Vesta — Declination

2020	Ceres	Pallas	Juno	Vesta
JAN 1	26S12.7	03N40.0	00S15.3	09N12.2
JAN 21	25 20.2	04 27.2	05 25.3	10 54.4
FEB 10	24 06.1	05 56.2	04 34.9	13 02.7
MAR 1	22 37.0	08 02.9	02 41.1	15 20.4
MAR 21	21 01.4	10 40.9	00 00.1	17 34.0
APR 10	19 28.9	13 40.3	02N45.9	19 33.0
APR 30	18 10.5	16 45.6	04 47.4	21 09.1
MAY 20	17 18.1	19 33.8	05 39.0	22 16.1
JUN 9	17 04.6	21 32.1	05 24.7	22 50.1
JUN 29	17 41.3	22 04.0	04 20.3	22 49.3
JUL 19	19 12.7	20 48.2	02 42.3	22 14.3
AUG 8	21 25.2	17 54.2	00 43.5	21 07.8
AUG 28	23 38.4	14 05.0	01S25.7	19 34.5
SEP 17	25 01.2	10 05.0	03 37.1	17 41.2
OCT 7	25 06.2	06 28.5	05 43.7	15 36.8
OCT 27	24 00.6	03 33.0	07 39.0	13 31.8
NOV 16	22 04.0	01 20.5	09 17.4	11 31.3
DEC 6	19 33.4	00 05.7	10 33.7	10 16.4
DEC 26	16S33.9	00S29.8	11S23.8	09N40.8

Psyche, Eros, Lilith, Toro — Longitude

2020	Psyche	Eros	Lilith	Toro
JAN 1	2♒05.5	27♑53.6	9♈45.2	6♏05.6
JAN 11	6 08.6	3♒47.0	13 05.9	11 08.1
JAN 21	10 22.2	9 42.3	16 20.0	16 09.7
JAN 31	14 42.9	15 39.7	19 26.0	21 10.3
FEB 10	19 09.4	21 39.5	22 21.9	26 10.1
FEB 20	23 40.3	27 41.9	25 06.0	1♐09.5
MAR 1	28 14.8	3♓47.5	27 35.8	6 08.8
MAR 11	2♓51.6	9 56.4	29 48.8	11 08.3
MAR 21	7 30.0	16 09.4	1♉42.2	16 09.1
MAR 31	12 09.3	22 27.2	3 12.9	21 11.9
APR 10	16 48.5	28 49.8	4 17.7	26 18.3
APR 20	21 27.0	5♈18.2	4R52.8	1♑30.8
APR 30	26 04.1	11 53.2	4 56.6	6 52.3
MAY 10	0♈58.9	18 35.7	4 25.5	12 25.3
MAY 20	5 11.0	25 26.9	3 21.7	18 25.3
MAY 30	9 39.5	2♉27.1	1 47.4	24 56.0
JUN 9	14 03.4	9 37.3	29♈49.7	2♒19.1
JUN 19	18 22.1	16 58.6	27 38.6	11 05.4
JUN 29	22 34.4	24 32.3	25 26.1	22 02.2
JUL 9	26 39.1	2♊17.4	23 25.6	6♓18.3
JUL 19	0♉35.6	10 16.2	21 48.9	24 54.2
JUL 29	4 20.4	18 28.3	20 41.5	17♈00.6
AUG 8	7 53.3	26 53.6	20 08.4	9♉00.6
AUG 18	11 11.6	5♋31.1	20D10.1	12♊16.0
AUG 28	14 12.3	14 22.0	20 45.6	15 16.0
SEP 7	16 52.5	23 22.7	21 52.3	24 21.3
SEP 17	19 08.4	2♌32.6	23 27.0	4♋56.9
SEP 27	20 55.7	11 49.2	25 26.7	14 42.4
OCT 7	22 10.2	21 06.0	27 48.2	23 55.7
OCT 17	22 47.7	0♍33.3	0♊31.2	2♍41.6
OCT 27	22R44.8	9 55.6	3 25.9	10 58.1
NOV 6	22 00.0	19 14.3	6 37.4	18 43.5
NOV 16	20 38.4	28 27.1	10 01.4	25 56.7
NOV 26	18 45.4	7♎31.0	13 26.2	2♎36.3
DEC 6	16 35.1	16 23.6	17 20.2	8 42.0
DEC 16	14 23.4	25 02.8	21 12.3	14 12.7
DEC 26	12 27.1	3♏26.1	25 11.1	19 06.0
JAN 5	10♒59.5	11♏31.5	29♊15.6	23♎19.0

Psyche, Eros, Lilith, Toro — Declination

2020	Psyche	Eros	Lilith	Toro
JAN 1	11S33.2	20S11.9	23S26.4	26S04.5
JAN 21	08 36.9	16 35.7	24 06.3	27 17.7
FEB 10	05 21.1	12 16.4	24 25.1	27 42.9
MAR 1	01 52.8	07 20.8	24 25.7	27 16.6
MAR 21	01N56.3	01 56.0	24 07.5	26 55.6
APR 10	05 09.2	03N44.9	23 53.0	23 34.7
APR 30	08 27.6	09 47.2	23 30.8	20 02.3
MAY 20	11 28.1	15 44.8	23 08.1	14 50.7
JUN 9	14 04.7	21 24.9	22 41.4	06 53.7
JUN 29	16 12.7	26 21.0	22 07.9	06N18.4
JUL 19	17 48.9	29 55.1	21 33.6	27 29.2
AUG 8	18 52.4	31 20.3	21 09.7	43 43.5
AUG 28	19 25.0	29 55.4	21 00.6	39 14.2
SEP 7	19 31.2	25 26.1	21 03.8	16 18.8
OCT 7	19 18.3	18 18.16.1	21 03.8	17 09.6
OCT 27	18 54.5	09 16.3	20 56.4	06 58.2
NOV 16	18 27.5	00S32.8	20 30.6	01S55.5
DEC 6	18 03.9	10 13.6	19 40.0	09 26.6
DEC 26	17N52.3	18S59.1	18S20.6	15S53.0

Saffo, Amor, Pandora, Icarus — Longitude

2020	Saffo	Amor	Pandora	Icarus
JAN 1	11♎44.4	25♎19.8	16♈18.3	5♑49.4
JAN 11	13 30.4	6♏16.7	14♉51.8	11 34.0
JAN 21	14 46.0	17 32.1	14 05.5	16 52.8
JAN 31	15 26.4	28 46.8	14D01.8	21 51.0
FEB 10	15R27.2	9♐49.6	14 38.9	26 31.7
FEB 20	14 47.0	20 28.8	15 52.5	0♒57.4
MAR 1	13 25.8	1♑00.0	17 38.0	5 09.2
MAR 11	11 27.5	10 00.9	19 50.5	9 07.8
MAR 21	9 07.0	18 41.4	22 25.1	12 53.5
MAR 31	6 25.0	26 35.8	25 18.2	16 25.7
APR 10	3 52.9	3♒41.9	28 26.3	19 43.3
APR 20	2 01.4	9 57.6	1♉46.4	22 44.9
APR 30	0 02.6	15 32.5	5 16.5	25 27.6
MAY 10	29♍03.0	19 50.5	8 52.6	27 47.9
MAY 20	28 04.4	23 20.9	12 38.3	29 40.3
MAY 30	29 04.8	25 46.6	16 27.2	0♓58.6
JUN 9	0♎01.5	27 00.7	20 19.1	1 31.1
JUN 19	1 29.8	26R58.0	24 11.4	1R04.2
JUN 29	3 26.5	25 34.7	28 11.6	29♒11.8
JUL 9	5 46.1	22 56.9	2♊09.4	25 47.9
JUL 19	8 26.5	19 21.7	6 07.5	22 10.3
JUL 29	11 24.7	15 19.1	10 05.5	19 12.6
AUG 8	14 38.0	11 26.0	14 01.9	17 24.7
AUG 18	18 04.4	8 11.8	17 56.8	22♒49.8
AUG 28	21 42.5	5 54.6	21 49.2	14 16.4
SEP 7	25 29.7	4D22.0	25 38.2	7 53.5
SEP 17	29 22.4	4 55.4	29 23.3	3 42.4
SEP 27	3♏32.3	5 23.3	3♋03.0	1 21.8
OCT 7	7 44.1	6 10.8	6 35.5	0D19.7
OCT 17	12 02.1	8 00.3	10 02.4	0 45.8
OCT 27	16 20.4	10 31.1	13 19.1	1♓07.2
NOV 6	20 54.3	12 57.2	16 17.8	16♒07.2
NOV 16	25 27.2	15 54.6	19 17.4	0 19.3
DEC 6	0♐03.8	19 06.4	21 54.6	25♒22.8
DEC 16	4 43.5	22 29.6	24 12.9	9 40.3
DEC 26	14 10.4	29 41.6	27 47.2	22 20.0
JAN 5	18♐56.4	3♈26.9	28♋44.1	0♓58.4

Saffo, Amor, Pandora, Icarus — Declination

2020	Saffo	Amor	Pandora	Icarus
JAN 1	10S58.5	14S12.6	33N29.4	24S22.1
JAN 21	12 29.0	17 17.8	32 28.5	24 52.3
FEB 10	13 03.1	19 09.1	31 33.8	24 38.2
MAR 1	12 22.1	19 10.9	31 00.5	23 22.7
MAR 21	11 02.3	17 07.8	30 29.5	21 36.5
APR 10	07 34.0	13 21.9	27 17.3	20 05.8
APR 30	04 57.4	09 07.7	22 52.4	19 51.4
MAY 20	03 18.2	03N14.4	17 44.9	22 42.8
JUN 9	02 48.0	05 21.8	12 28.3	30 33.8
JUN 29	03 04.9	13 03.0	08 31.8	22 02.0
JUL 19	04 18.0	15 39.3	06 40.0	06 17.1
AUG 8	06 23.9	02S24.8	06 55.6	05 11.5
AUG 28	08 34.0	07 24.9	08 19.8	06 26.6
SEP 17	10 54.4	10 05.6	10 38.4	52 54.4
OCT 7	13 15.4	12 56.1	13 16.6	39 37.8
OCT 27	15 27.3	13 59.5	15 45.4	24 03.8
NOV 16	17 21.0	13 45.4	18 01.4	04 36.0
DEC 6	18 49.5	12 43.4	19 55.0	09 23.0
DEC 26	19S49.7	11S03.5	04N44.4	18S56.7

Diana, Hidalgo, Urania, Chiron — Longitude

2020	Diana	Hidalgo	Urania	Chiron
JAN 1	28♍30.6	24♎52.9	17♍45.2	1♈35.8
JAN 11	0♎45.9	25 49.8	18 15.1	1 48.7
JAN 21	2 13.2	26 24.0	17R59.5	2 06.5
JAN 31	2 55.5	26R33.7	17 18.0	2 28.7
FEB 10	2R46.3	26 17.9	16 13.5	2 55.1
FEB 20	1 46.3	25 36.6	14 54.4	3 24.9
MAR 1	0 01.7	24 31.0	13 34.8	3 56.7
MAR 11	27♍47.6	23 04.4	12 30.1	4 30.5
MAR 21	25 24.0	21 21.7	11 54.4	5 05.5
MAR 31	23 12.8	19 29.2	11 52.0	5 40.8
APR 10	21 32.9	17 34.6	12 22.9	6 15.7
APR 20	20 34.8	15 45.1	13 22.5	6 49.4
APR 30	20D22.9	14 07.3	14 45.8	7 20.9
MAY 10	20 58.6	12 46.3	16 24.4	7 50.9
MAY 20	22 09.0	11 45.0	18 17.3	8 17.3
MAY 30	23 57.3	11 05.0	20 21.8	8 40.0
JUN 9	26 15.0	10 46.5	22 43.8	8 58.7
JUN 19	28 56.6	10 50.0	25 16.1	9 12.1
JUN 29	1♎59.0	11 16.9	27 57.6	9 21.3
JUL 9	5 17.3	11 46.8	0♎52.9	9 26.0
JUL 19	8 46.7	12 39.5	3 46.4	9R24.9
JUL 29	12 31.4	13 45.0	6 52.6	9 24.0
AUG 8	16 22.7	15 02.1	9 59.6	9 07.6
AUG 18	20 21.0	16 28.2	13 04.8	8 51.9
AUG 28	24 25.1	18 01.9	16 06.3	8 32.3
SEP 7	28 33.6	19 41.6	18 59.9	8 11.3
SEP 17	2♏46.5	21 26.0	21 45.0	7 49.9
SEP 27	7 00.3	23 13.5	24 18.1	7 29.6
OCT 7	11 16.6	25 02.8	26 32.8	7 11.6
OCT 17	15 34.0	26 52.6	28 23.3	6 57.0
OCT 27	19 51.7	28 41.5	29 45.3	6 46.5
NOV 6	24 08.9	0♏28.1	0♏44.1	6 41.2
NOV 16	28 25.9	2 11.2	1 13.0	6 41.2
DEC 6	6 50.7	5 20.4	1 23.4	6 49.5
DEC 16	10 58.7	6 45.3	0 48.6	7 01.8
DEC 26	15 02.2	7 57.4	29♍13.8	7 18.7
JAN 5	19♏00.3	8♏59.5	2♎41.2	7♈07.5

Diana, Hidalgo, Urania, Chiron — Declination

2020	Diana	Hidalgo	Urania	Chiron
JAN 1	01N30.0	01S19.1	04N04.1	03N18.9
JAN 21	01S47.7	01 55.6	04 09.9	03 23.3
FEB 10	03 39.7	03 24.6	04 22.9	03 43.3
MAR 1	04 55.1	05 39.4	04 39.3	04 10.3
MAR 21	05 07.1	07 39.2	04 47.7	04 41.7
APR 10	03 52.7	09 11.8	04 45.9	05 14.4
APR 30	01 11.6	09 45.6	04 33.3	05 45.7
MAY 20	02N07.2	09 10.9	04 11.3	06 13.0
JUN 9	04 28.0	07 31.8	03 41.6	06 34.3
JUN 29	05 42.6	05 04.2	03 05.4	06 46.0
JUL 19	05 43.5	02 01.2	02 26.1	06 47.0
AUG 8	04 23.2	01S41.5	01S45.9	06 36.1
AUG 28	01 50.2	05 25.0	01 05.4	06 14.1
SEP 17	01S12.6	08 32.4	00 28.4	05 43.0
OCT 7	04 36.8	11 14.0	00N04.0	05 06.1
OCT 27	08 18.4	13 25.1	00 30.7	04 28.6
NOV 16	11 46.8	14 56.0	00 48.6	03 56.0
DEC 6	14 44.3	15 27.4	00 52.1	03 34.3
DEC 26	17S04.7	15S17.4	00 41.2	03N28.8

Giving the positions of asteroids every ten days in LONGITUDE at 00:00 GMT

January

Sunday	Monday	Tuesday	Wednesday	Thursday	Friday	Saturday
			1	2	3	4
5	6	7	8	9	10	11
12	13	14	15	16	17	18
19	20	21	22	23	24	25
26	27	28	29	30	31	

February

Sunday	Monday	Tuesday	Wednesday	Thursday	Friday	Saturday
						1
2	3	4	5	6	7	8
9	10	11	12	13	14	15
16	17	18	19	20	21	22
23	24	25	26	27	28	29

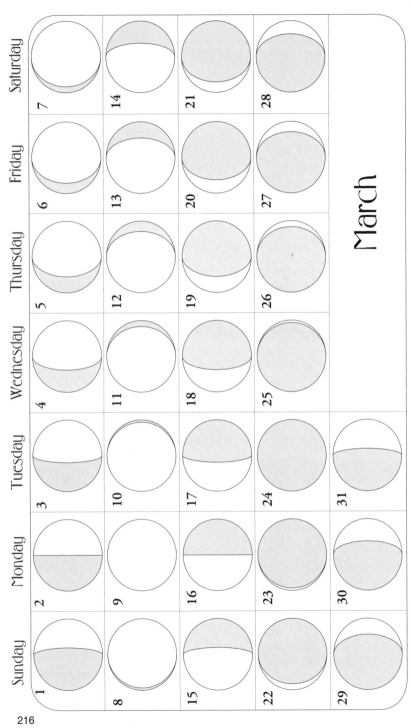

March

April

Sunday	Monday	Tuesday	Wednesday	Thursday	Friday	Saturday
			1	2	3	4
5	6	7	8	9	10	11
12	13	14	15	16	17	18
19	20	21	22	23	24	25
26	27	28	29	30		

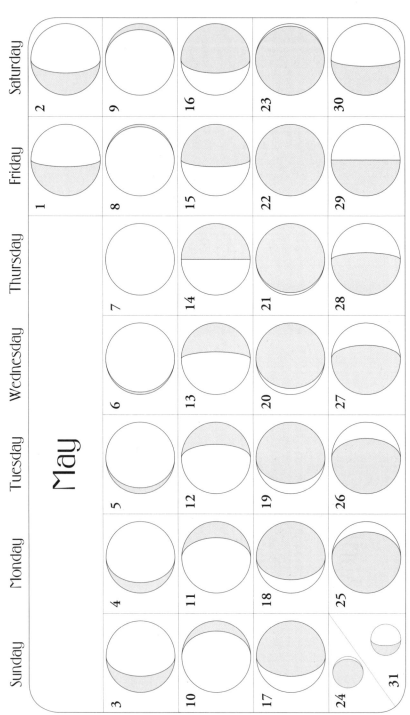

May

Sunday	Monday	Tuesday	Wednesday	Thursday	Friday	Saturday
					1	2
3	4	5	6	7	8	9
10	11	12	13	14	15	16
17	18	19	20	21	22	23
24	25	26	27	28	29	30
31						

218

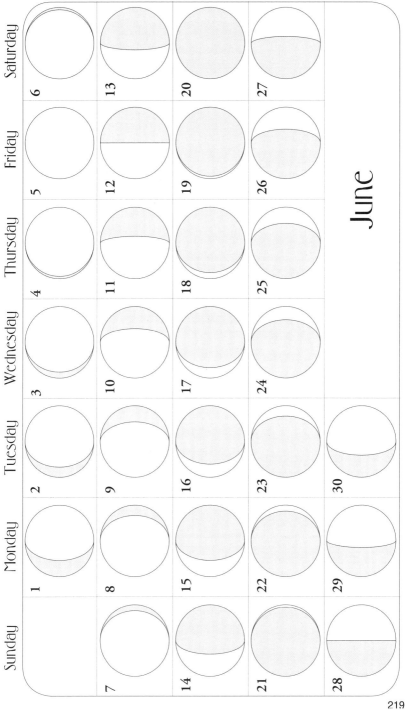

June

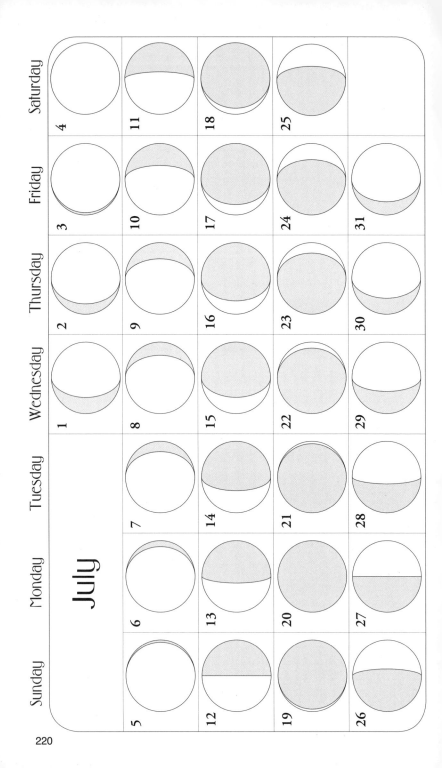

July

Sunday	Monday	Tuesday	Wednesday	Thursday	Friday	Saturday
			1	2	3	4
5	6	7	8	9	10	11
12	13	14	15	16	17	18
19	20	21	22	23	24	25
26	27	28	29	30	31	

220

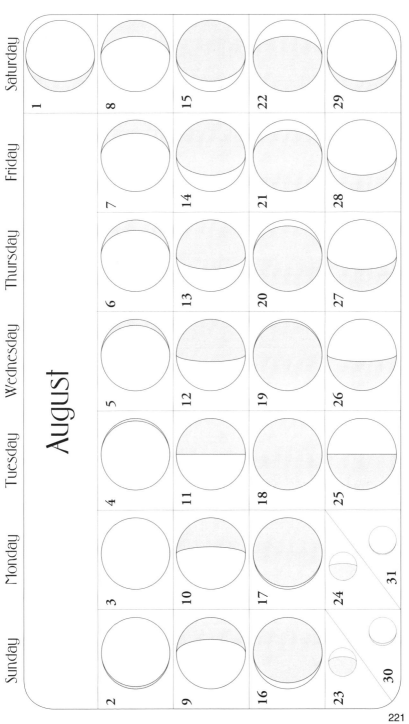

August

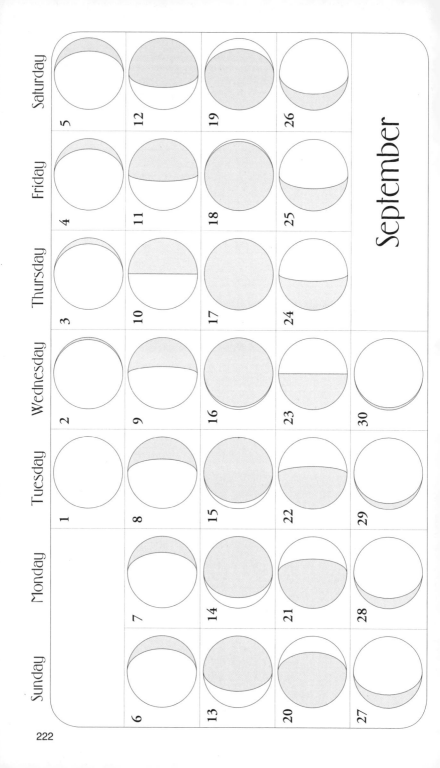

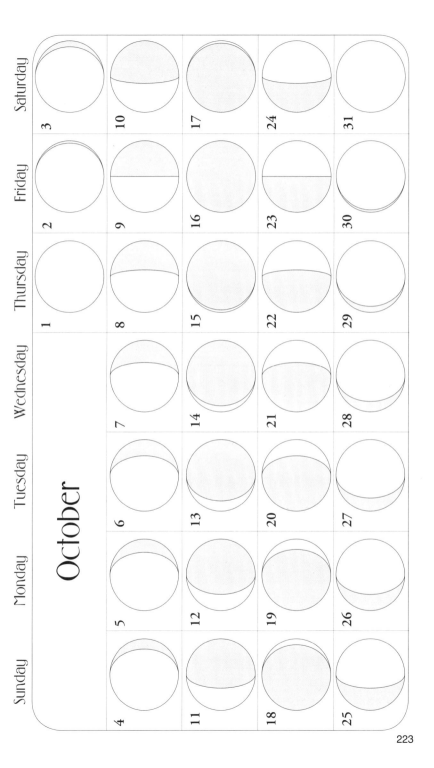

October

Sunday	Monday	Tuesday	Wednesday	Thursday	Friday	Saturday
				1	2	3
4	5	6	7	8	9	10
11	12	13	14	15	16	17
18	19	20	21	22	23	24
25	26	27	28	29	30	31

223

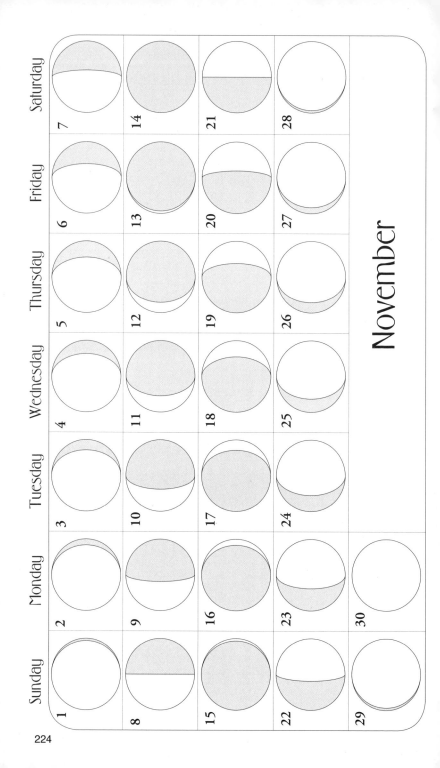

November

224

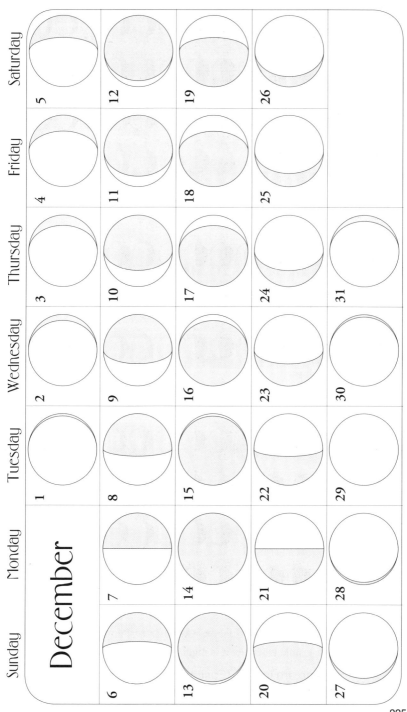

December

Sunday	Monday	Tuesday	Wednesday	Thursday	Friday	Saturday
		1	2	3	4	5
6	7	8	9	10	11	12
13	14	15	16	17	18	19
20	21	22	23	24	25	26
27	28	29	30	31		

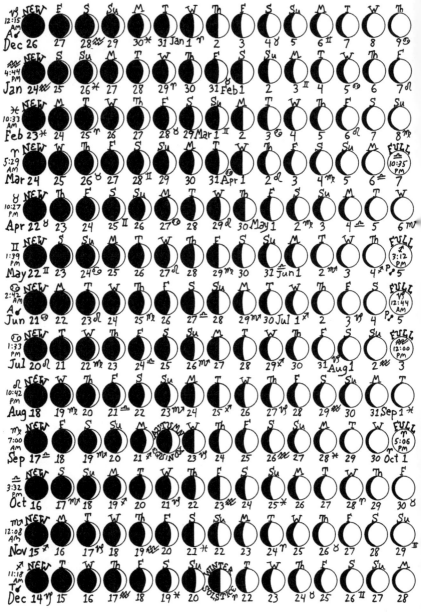

Eclipse Key:

☌ = Solar ☾ = Lunar T = Total A = Annular n = Penumbral P = Partial

Lunar Eclipses are visible wherever it is night and cloud free during full moon time.

Times on this page are in EST (Eastern Standard Time -5 from GMT)
or DST, Daylight Saving Time (Mar 8 - Nov 1, 2020)

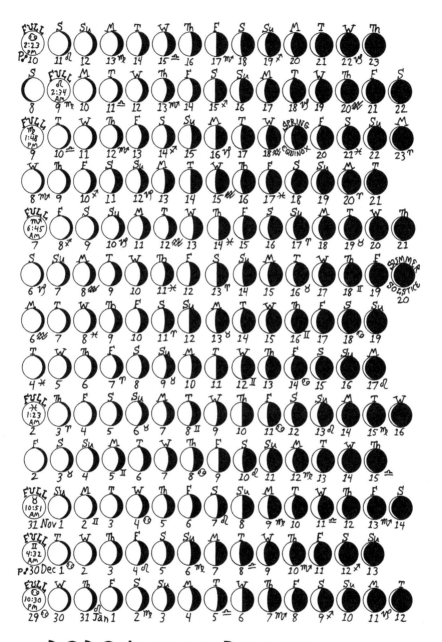

2020 Lunar Phases

© Susan Baylies, reproduced with permission

This format available on cards from: **http://snakeandsnake.com**

Snake and Snake Productions 3037 Dixon Rd Durham, NC 27707

2021

JANUARY

S	M	T	W	T	F	S
					1	2
3	4	5	6	7	8	9
10	11	12	13	14	15	16
17	18	19	20	21	22	23
24	25	26	27	28	29	30
31						

FEBRUARY

S	M	T	W	T	F	S
	1	2	3	4	5	6
7	8	9	10	11	12	13
14	15	16	17	18	19	20
21	22	23	24	25	26	27
28						

MARCH

S	M	T	W	T	F	S
	1	2	3	4	5	6
7	8	9	10	11	12	13
14	15	16	17	18	19	20
21	22	23	24	25	26	27
28	29	30	31			

APRIL

S	M	T	W	T	F	S
				1	2	3
4	5	6	7	8	9	10
11	12	13	14	15	16	17
18	19	20	21	22	23	24
25	26	27	28	29	30	

MAY

S	M	T	W	T	F	S
						1
2	3	4	5	6	7	8
9	10	11	12	13	14	15
16	17	18	19	20	21	22
23	24	25	26	27	28	29
30	31					

JUNE

S	M	T	W	T	F	S
		1	2	3	4	5
6	7	8	9	10	11	12
13	14	15	16	17	18	19
20	21	22	23	24	25	26
27	28	29	30			

JULY

S	M	T	W	T	F	S
				1	2	3
4	5	6	7	8	9	10
11	12	13	14	15	16	17
18	19	20	21	22	23	24
25	26	27	28	29	30	31

AUGUST

S	M	T	W	T	F	S
1	2	3	4	5	6	7
8	9	10	11	12	13	14
15	16	17	18	19	20	21
22	23	24	25	26	27	28
29	30	31				

SEPTEMBER

S	M	T	W	T	F	S
			1	2	3	4
5	6	7	8	9	10	11
12	13	14	15	16	17	18
19	20	21	22	23	24	25
26	27	28	29	30		

OCTOBER

S	M	T	W	T	F	S
					1	2
3	4	5	6	7	8	9
10	11	12	13	14	15	16
17	18	19	20	21	22	23
24	25	26	27	28	29	30
31						

NOVEMBER

S	M	T	W	T	F	S
	1	2	3	4	5	6
7	8	9	10	11	12	13
14	15	16	17	18	19	20
21	22	23	24	25	26	27
28	29	30				

DECEMBER

S	M	T	W	T	F	S
			1	2	3	4
5	6	7	8	9	10	11
12	13	14	15	16	17	18
19	20	21	22	23	24	25
26	27	28	29	30	31	

Shakti Rising
© *Heather L. Crowley 2011*

● = NEW MOON, PST/PDT ○ = FULL MOON, PST/PDT

PreacherWoman for the Goddess:
Poems, Invocations, Plays and Other Holy Writ

A spirit-filled word feast puzzling on life and death mysteries—rich with metaphor, surprise, earth-passion: a harvest of decades among women who build their own houses, bury their own dead, invent their own ceremonies.

By Bethroot Gwynn—poet, theaterwoman, temple keeper on women's land, and a longtime editor for the We'Moon Datebook.

Softbound, 6x9, 120 pages with 7 full color art features, $16

IN THE SPIRIT OF WE'MOON
CELEBRATING 30 YEARS:
AN ANTHOLOGY OF WE'MOON ART AND WRITING

This unique Anthology showcases three decades of We'Moon art, writing and herstory from 1981–2011. The anthology includes new insights from founding editor Musawa and other writers who share stories about We'Moon's colorful 30-year evolution. Now in its third printing!

256 full color pages, paperback, 8x10, $26.95

The Last Wild Witch

by Starhawk, illustrated by Lindy Kehoe

In the very heart of the last magic forest lived the last wild Witch...

In this story, the children of a perfect town found their joy and courage, and saved the last wild Witch and the forest from destruction. A Silver Nautilus Award winner, this book is recognized internationally for helping readers imagine a world as it could be with abundant possibilities.

34 full color pages, 8x10, Softbound, $9.95

An Eco-Fable for Kids and Other Free Spirits.

WE'MOON 2020: WAKE UP CALL

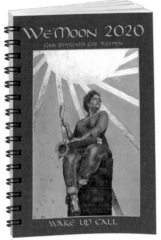

• **Datebook** The best-selling astrological moon calendar, earth-spirited handbook in natural rhythms, and visionary collection of women's creative work. Week-at-a-glance format. Choice of 3 bindings: Spiral, Sturdy Paperback Binding or Unbound. 8x5¼, 240 pages, $21.95

NEW! • *We'Moon en Español!*
We are proud to offer a full translation of the classic datebook, in Spanish! Spiral Bound, 240 pages, 8x5¼, $21.95

• **Cover Poster** featuring art by Saba Taj: "*Lioness,*" radiating confidence and awakened wisdom. 11x17, $10

• **We'Moon on the Wall**
A beautiful full color wall calendar featuring inspired art and writing from *We'Moon 2020,* with key astrological information, interpretive articles, lunar phases and signs. 12x12, $16.95

• **We'Moon 2020 Tote Bag** 100% Organic Cotton tote, proudly displaying the cover of *We'Moon 2020.* Perfect for stowing all of your goodies in style. 13x14, $13

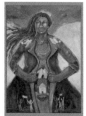

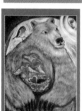

• Greeting Cards An assortment of six gorgeous note cards featuring art from *We'Moon 2020*, with writings from each artist on the back. Wonderful to send for any occasion: Holy Day, Birthday, Anniversary, Sympathy, or just to say hello. Each pack is wrapped in biodegradable cellophane. Blank inside. 5x7, $11.95

More Offerings!
Check out page 229 for details on these books:

• *The Last Wild Witch* by Starhawk, illustrated by Lindy Kehoe.

• *In the Spirit of We'Moon ~ Celebrating 30 Years: An Anthology of We'Moon Art and Writing*

• *Preacher Woman for the Goddess: Poems, Invocations, Plays and Other Holy Writ* by We'Moon Special Editor Bethroot Gwynn.

ORDER NOW—WHILE THEY LAST!
Take advantage of our
Special Discounts:
• We'll ship orders of $50 or more for **FREE** within the US!
• Use promo code: **20Awake** to get 10% off orders of $100 or more!
We often have great package deals and discounts.
Look for details, and sign up to receive regular email updates at
www.wemoon.ws
Email weorder@wemoon.ws Toll free in US 877-693-6666
Local & International 541-956-6052 Wholesale 503-288-3588
SHIPPING AND HANDLING
Prices vary depending on what you order and where you live.
See website or call for specifics.
To pay with check or money-order,
please call us first for address and shipping costs.

All products printed in full color on recycled paper with low VOC soy-based ink.

WORLD TIME ZONES

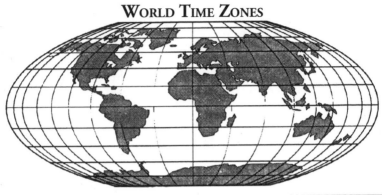

ID LW	NT BT	CA HT	YST	PST	MST	CST	EST	AST	BST	AT	WAT	GMT	CET	EET	BT	USSR Z3	USSR Z4	USSR Z5	SST	CCT	JST	GST	USSR Z10	ID LE
-12	-11	-10	-9	-8	-7	-6	-5	-4	-3	-2	-1	0	+1	+2	+3	+4	+5	+6	+7	+8	+9	+10	+11	+12
-4	-3	-2	-1	0	+1	+2	+3	+4	+5	+6	+7	+8	+9	+10	+11	+12	+13	+14	+15	+16	+17	+18	+19	+20

STANDARD TIME ZONES FROM WEST TO EAST CALCULATED FROM PST AS ZERO POINT:

IDLW:	International Date Line West	-4	**BT:**	Bagdhad Time	+11
NT/BT:	Nome Time/Bering Time	-3	**IT:**	Iran Time	+11 1/2
CA/HT:	Central Alaska & Hawaiian Time	-2	**USSR**	Zone 3	+12
YST:	Yukon Standard Time	-1	**USSR**	Zone 4	+13
PST:	Pacific Standard Time	0	**IST:**	Indian Standard Time	+13 1/2
MST:	Mountain Standard Time	+1	**USSR**	Zone 5	+14
CST:	Central Standard Time	+2	**NST:**	North Sumatra Time	+14 1/2
EST:	Eastern Standard Time	+3	**SST:**	South Sumatra Time & USSR Zone 6	+15
AST:	Atlantic Standard Time	+4	**JT:**	Java Time	+15 1/2
NFT:	Newfoundland Time	+4 1/2	**CCT:**	China Coast Time	+16
BST:	Brazil Standard Time	+5	**MT:**	Moluccas Time	+16 1/2
AT:	Azores Time	+6	**JST:**	Japanese Standard Time	+17
WAT:	West African Time	+7	**SAST:**	South Australian Standard Time	+17 1/2
GMT:	Greenwich Mean Time	+8	**GST:**	Guam Standard Time	+18
WET:	Western European Time (England)	+8	**USSR**	Zone 10	+19
CET:	Central European Time	+9	**IDLE:**	International Date Line East	+20
EET:	Eastern European Time	+10			

HOW TO CALCULATE TIME ZONE CORRECTIONS IN YOUR AREA:

ADD if you are **east** of PST (Pacific Standard Time); **SUBTRACT** if you are **west** of PST on this map (see right-hand column of chart above).

All times in this calendar are calculated from the West Coast of North America where We'Moon is made. Pacific Standard Time (PST Zone 8) is zero point for this calendar, except during Daylight Saving Time (March 8–November 1, 2020, during which times are given for PDT Zone 7). If your time zone does not use Daylight Saving Time, add one hour to the standard correction during this time. At the bottom of each page, EST/EDT (Eastern Standard or Daylight Time) and GMT (Greenwich Mean Time) times are also given. For all other time zones, calculate your time zone correction(s) from this map and write it on the inside cover for easy reference.

CONVENTIONAL HOLIDAYS 2020

January 1	New Years Day*
January 20	Martin Luther King Jr. Day
January 25	Chinese/Lunar New Year
February 14	Valentines Day*
February 17	Presidents Day
February 26	Ash Wednesday
March 8	International Women's Day*
March 8	Daylight Saving Time Begins
March 12	Mexika New Year
March 17	St. Patrick's Day*
April 5	Palm Sunday
April 10	Good Friday
April 9–April 16	Passover
April 12	Easter
April 22	Earth Day*
April 24–May 23	Ramadan
May 5	Cinco De Mayo*
May 10	Mother's Day
May 25	Memorial Day
June 21	Father's Day
July 4	Independence Day*
September 7	Labor Day
Sept. 19–Sept. 20	Rosh Hashanah
September 28	Yom Kippur
October 12	Indigenous Peoples' Day
October 31	Halloween*
November 1	All Saints' Day*
November 1	Daylight Saving Time Ends
November 2	Day of the Dead*
November 11	Veteran's Day*
November 26	Thanksgiving Day
December 11–18	Chanukah/Hanukkah
December 25	Christmas Day*
December 26	Boxing Day*
Dec. 26–Jan. 1	Kwanzaa*
December 31	New Years Eve*

*Same date every year

Become a We'Moon Contributor!
Send submissions for
We'Moon 2022
the 41ˢᵗ edition!

Call for Contributions: Available in the spring of 2020
Postmark-by Date for all art and writing: August 1, 2020
Note: It is too late to contribute to
We'Moon 2021: The World

We'Moon is made up by writers and artists like you! We welcome creative work by women from around the world, and aim to amplify diverse perspectives. We especially encourage those of us who are women of color or who are marginalized by the mainstream, to participate in helping We'Moon reflect our unique visions and experiences. We are eager to publish more words and images depicting people of color created by WOC. By nurturing space for all women to share their gifts, we unleash insight and wisdom upon the world—a blessing to us all.

> **We invite you to send in your art and writing for the next edition of We'Moon!**

Here's how:

Step 1: Visit wemoon.ws to download a Call for Contributions or send your request for one with a SASE (legal size) to **We'Moon Submissions, PO Box 187, Wolf Creek, OR 97497.** (If you are not within the US, you do not need to include postage.) The Call contains current information about the theme, specifications about how to submit your art and writing, and terms of compensation. There are no jury fees. The Call comes out in the early Spring every year.

Step 2: Fill in the accompanying Contributor's License, giving all the requested information, and return it with your art/writing and a self addressed envelope by the due date. *No work will be accepted without a signed license!* **New!** We now accept email submissions. See our website for details.

Step 3: Plan ahead! To assure your work is considered for **We'Moon 2022**, get your submissions postmarked by August 1, 2020.

NOTES

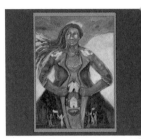

Sanctuary
© Kate Langlois 2018

Local Heroes
© Nancy Watterson 2016

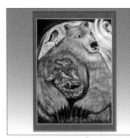

Love Awakens
© Denise Kester 2017

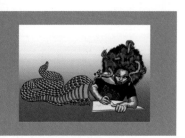

Nagakanya Artist at Work
© KT InfiniteArt 2018

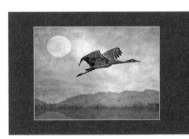

Morning Crane
© *Lyndia Radice 2018*

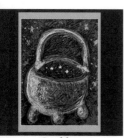

Cauldron
© *Sophia Rosenberg 2008*